THE ALTERNATIVE GUIDE TO LIVERPOOL

CAPITAL OF CULTURE

OR THERE'S MORE TO THE GREAT CITY THAN FOOTBALL, COMEDIANS AND POP MUSIC!

Laurie Weston & Ray Costello

ACKNOWLEDGEMENTS

The authors would like to thank Mike Cheeney, Anthony Glennon, Lesley Delves of Liverpool Culture Company, and Alena Tan of The Mersey Partnership for their practical help and kindness.

With special thanks to Alan Langley who helped formulate the idea for this book.

First Published 2008 by Countyvise Limited,
14 Appin Road, Birkenhead, Wirral CH41 9HH.
Copyright © 2008 Laurie Weston & Ray Costello.
The right of Laurie Weston & Ray Costello to be identified as the authors of this work has been asserted by them in accordance with the Copyright, Design and Patents Act 1988.
British Library Cataloguing in Publication Data.
A catalogue record for this book is available from the British Library.
ISBN 978 1 906823 04 7

INTRODUCTION

Would-be visitors to the City of Liverpool may know of its reputation of being the home of pop music, comedians and two much acclaimed football teams, but may not be aware that there is so much more to the great city.

On the front cover of this 'Alternative Guide to Liverpool' can be seen a brown tourist sign proclaiming 'Welcome to Liverpool - Birthplace of the Beatles', with 'Beatles' crossed out and the words 'Jeremiah Horrocks' superimposed. Almost everybody approaching the City on the motorways or trunk roads will see a 'Beatles'-related sign of some sort, but how many would associate the self-proclaimed 'Capital of Pop Music' with the birthplace and education of Jeremiah Horrocks, described by Sir Isaac Newton as the 'Founder of English Astronomy'? Horrocks is buried in St. Michael's Church, Park Road, better known as the Ancient Chapel of Toxteth, built around 1618 during the reign of James I by Edward Aspinall (see 'Horrocks, Jeremiah' in the following text).

When one thinks of such civic celebrations as the Edinburgh Fringe Festival, the term 'alternative' usually means presenting to the public those elements or events outside the normal aspects of the city's higher cultural offerings of theatres, art galleries, museums, classical orchestras, cathedrals, and other places of interest. For some reason, the City of Liverpool seems to have acquired an image, sometimes even promoted by Liverpudlians themselves, that is exactly the opposite of normal definitions of 'fringe'. Pop music, comedy and football have in some way become the norm in some people's minds, a cliché of all that the City has to offer, which could not be further from the truth. Liverpool has not one, but two cathedrals and no less than eight world-class museums, representing *JUST THE TIP OF THE ICEBERG* of an astonishing wealth of 'high culture' shown in

the following pages. In this easy, self-directed, guide, presented in the form of a simple dictionary, we aim to show in a light-hearted way that is in no way snobbish and pompous that Liverpool fully deserves its title 'European City of Culture'.

In 1846 Prince Albert said of Liverpool, "I have heard of the greatness of Liverpool, but the reality far surpasses the expectation."

HOW TO USE THE GUIDE

There is an index at the end of the book for those with particular interests. Otherwise, begin by choosing an area of Liverpool from the pages of the section on Area Groupings. Find the accompanying map and, using the Area Groupings, locate the first site to visit, for example, 'CASTLE STREET AREA (See Map B) 1. Rumford Place'. Having arrived at the site, look up 'Rumford Place' in the 'ALTERNATIVE GUIDE DICTIONARY'. Each successive number can then be found using the map to locate following sites in any particular Area Grouping. It is thus possible to find one's own way around Liverpool without the need for joining an organised tour group.

Nevertheless, for those interested in tours or visits, further information can be obtained from any Tourist Information Centre.

AREA GROUPINGS

WATERFRONT AREA (See Map A)

1. Titanic Memorial
2. Mersey River - Ferries - Pier Head - Goree Piazzas
3. St Nicholas' Church
4. Waterfront -Three Graces (Liver Building, Port of Liverpool Building, Cunard Building)
 Liver Birds - Ventilation Tower
5. National Museums Liverpool (NML)
 Museum of Liverpool
 Merseyside Maritime Museum
 Revenue and Customs National Museum
 International Slavery Museum
6. Tate Liverpool
7. Albert Dock
8. Echo Arena Liverpool
9. Cains Brewery

MAP A

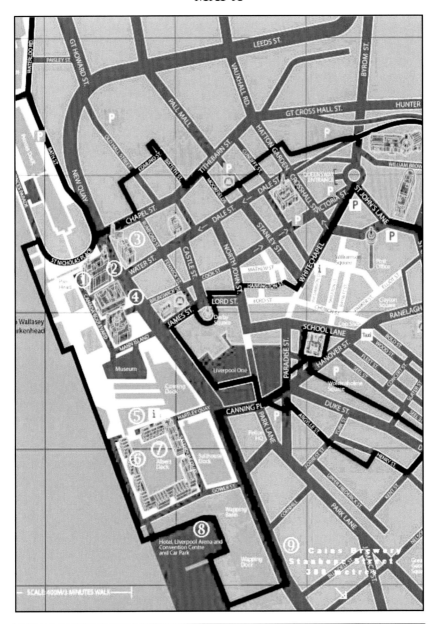

CASTLE STREET AREA (See Map B)

1. Rumford Place
2. Western Approaches Museum
3. Exchange Flags - Nelson Memorial - Newsroom
 Memorial
4. Town Hall
5. Ye Hole in Ye Wall
6. Sanctuary Stone
7. India Buildings
8. Waterfall
9. Queen Victoria Monument

MAP B

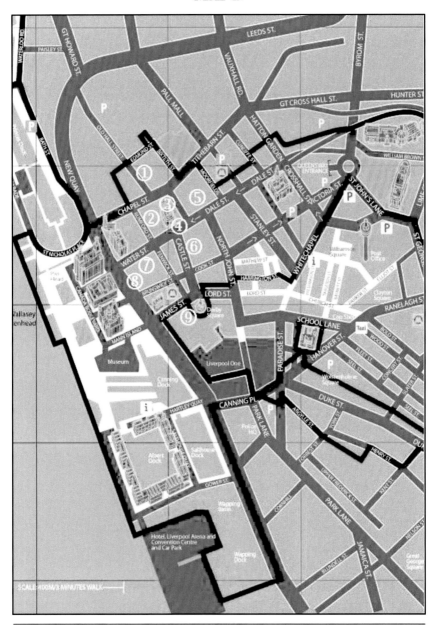

CITY CENTRE AREA (See Map C)

1. Playhouse Theatre
2. Church Street - St.Peter's Church Plaque – Zig Zag
3. Athenaeum
4. Bluecoat Chambers - Bluecoat School
5. Neptune Theatre
6. Open Eye Gallery
7. Lyceum
8. Epstein Statue
9. Adelphi Hotel
10. Roscoe Gardens
11. St. Luke's Church

MAP C

WILLAM BROWN STREET CONSERVATION AREA
(See Map D)

1. World Museum Liverpool
2. Central Library - Picton Reading Room
3. Walker Art gallery – Spirit of Liverpool
4. Steble Fountain - Wellington Column
5. Empire Theatre
6. St. George's Hall
7. St John's Gardens
8. Mersey Tunnels - Queensway Tunnel Entrance
9. Conservation Centre

MAP D

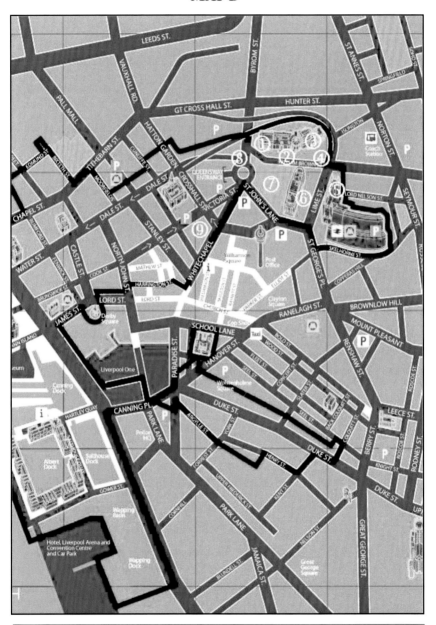

RODNEY STREET AREA (See Map E)

1. University of Liverpool - Victoria Gallery & Museum
2. Abercromby Square
3. Phiharmonic Hall
4. Philhamonic Dining Rooms
5. Pyramid (St. Andrew's Church)
6. Rodney Street
7. Liverpool Institute of Performing Arts (LIPA)
8. FACT Liverpool Arts Centre
9. Ropewalks
10. China Town Chinese Arch - The 'Blackie'

MAP E

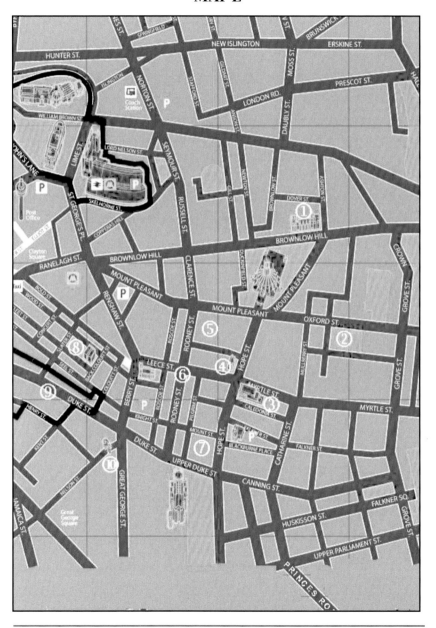

'CHURCHES' AREA (See Map F)

1. Metropolitan Cathedral of Christ the King
2. Everyman Theatre
3. Anglican Cathedral -Kitty Wilkinson -James'
 Mount and Gardens - Greek Temple
4. Gustav Adolfus Kyrka – Swedish Seaman's Church
5. Greek Orthodox Church of St Nikolas
6. Princes Road Synagogue
7. Al-Rahma Mosque

MAP F

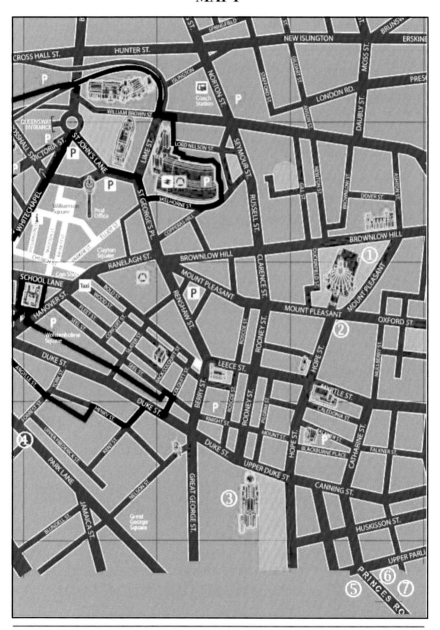

SOUTH LIVERPOOL PARKS AREA (See Map G)

1. Ancient Chapel of Toxteth - Jeremiah Horrocks
2. Princes Park - Parks and Gardens
3. Brodie, John
4. Ullet Road Unitarian Church
5. Sefton Park
6. Palm House

MAP G

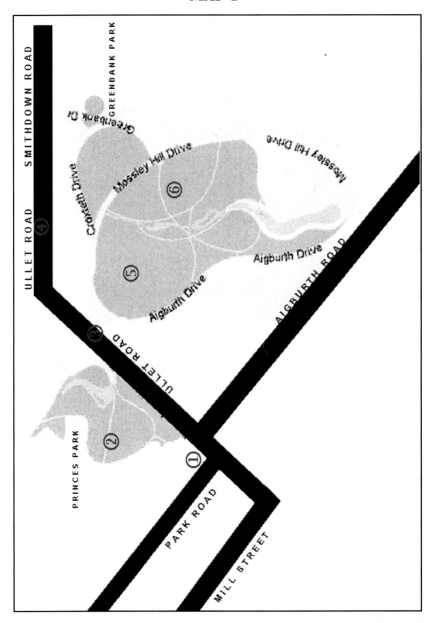

WAVERTREE AREA (See Map H)

1. Monk's Well
2. Smallest House in England
3. Picton Clock Tower
4. Wavertree Lock-Up
5. Mounting Steps
6. Blue Coat School
7. The Mystery

MAP H

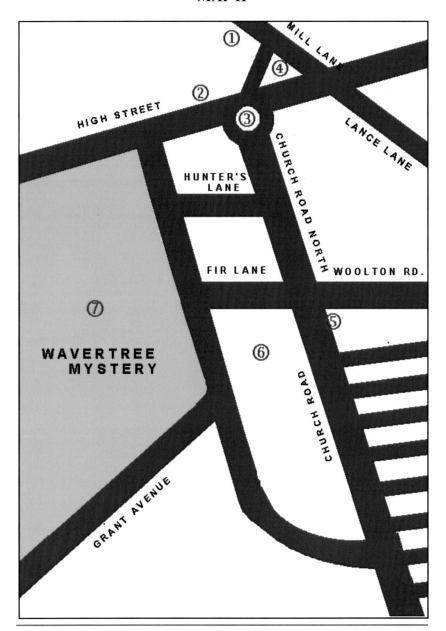

EXPLORING FURTHER AFIELD

AINTREE (See Map I)

1. Aintree Race Course - Grand National
 (Ormskirk Road, Liverpool)

KNOWSLEY AREA (See Map I)

2. Knowsley Hall (George Hale Avenue, Knowsley)
3. Knowsley Safari Park (Prescot By-Pass, A58)

CROXTETH AREA (See Map I)

4. Croxteth Country Park (Oak Lane, Croxteth)
5. Croxteth Hall (Croxteth Hall Lane, Croxteth)

EVERTON AREA (See Map I)

6. St. George's Church (Northumberland Terrace, Everton)
7. Stanley Park (Priory Road, Everton)
8. Everton Lockup (Everton Brow, Everton)

WEST DERBY (See Map I)

9. West Derby Courthouse (West Derby Village, Liverpool)

EDGE HILL AREA (See Map I)

10. Williamson Tunnels (Mole of Edge Hill)
 (Smithdown Lane)
11. Edge Hill Station (Tunnel Road, Edge Hill)

SOUTH EAST LIVERPOOL PARKS AREA (See Map I)

12. All Hallows Church (Allerton Road, Allerton)
13. Calderstones Park - Calderstones – Tennis Tournament
14. Camp Hill and Woolton Woods - St. Peter's Church
 (High Street)
15. Allerton Hall (Springwood Avenue, Allerton)

AIGBURTH AREA (See Map I)

16. Sudley House (Mossley Hill Road, Aigburth)
17. Robin Hood Stone (Archfield Road, Aigburth)
18. Otterspool Promenade (Otterspool Drive, Aigburth)

SPEKE AREA (See Map I)

19. Speke Hall (Speke Hall Avenue, Speke)
20. Fossil Tour (Liverpool John Lennon Airport)
 (Speke Hall Avenue, Speke)
21. Childe of Hale (Church Road, Hale)

WIRRAL AREA (See Map I)

22. Birkenhead Priory (Priory Street, Birkenhead)
23. Birkenhead Park (Park Road, North, Birkenhead)
24. Lady Lever Art Gallery (Lower Road, Port Sunlight)
25. Ness Botanic Gardens (Neston Road, Cheshire)

WIDNES AREA (See Map I)

26. Science Museum (Mersey Road, Widnes, Cheshire)

MAP I

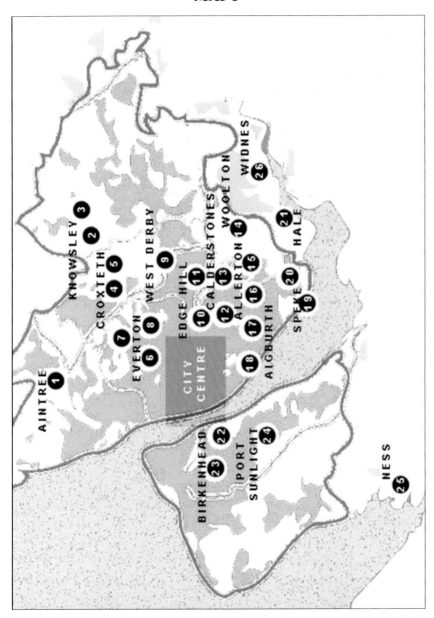

ALTERNATIVE GUIDE DICTIONARY

ABERCROMBY SQUARE
(Once the elegant residence of the bishops of Liverpool)

In 1800, a plan was put forward for the building of what was to be the fashionable and elegant Abercromby Square, although it was not until the 1820s that its actual construction began. This tranquil city centre square covers three and a half acres (1.4 hectares) of land, part of which had once been a lake. The houses, originally owned by wealthy merchants of Liverpool, are now the property of Liverpool University and many of them have a considerable history, the most notable of these being No. 19, The Old Bishop's Palace, the former grand residence of the bishops of Liverpool.

The Chavasse family were one-time residents of No.19 Abercromby Square, whose wall bears a blue wall plaque commemorating the fact that Captain Noel Chavasse, VC and bar (1884-1917), once lived there. Captain Chavasse had been a doctor in the army; the Medical Officer for 10th (Liverpool Scottish) Battalion of the King's (Liverpool) Regiment during the First World War. He was the only man to win the Victoria Cross twice during the so called 'war to end all wars'. To be presented with the Victoria Cross, British Military's highest award, is quite a rare occurrence, but to receive it twice is almost unheard of, an honour that has only ever been awarded to two other men. Chavasse and his twin brother, Christopher Maude, represented Britain in the 1908 Olympics.

The building of No. 19 Abercromby Square, 1862-1863 was commissioned by Charles Kuhn Prioleau of Savannah, Georgia.

At this time Liverpool had very strong connections with 'Dixie', the Southern States of America, as almost two thirds of its cotton production came through the port. The Confederacy effectively had its embassy a short distance away in 10 Rumford Place, the address of the firm of Fraser, Trenholm & Co. who managed the overseas funds for the Southern States. It was a branch of the Charleston cotton firm of John Fraser & Co., managed by Prioleau.

Prioleau obviously had an influence on the architecture of his new residence, No.19 being decorated with the stars of the secession flag, the *Bonnie Blue*, used by the Republic of Texas in 1836-1839. On the inside of the portico is a South Carolina palmetto tree with coiled serpents around the base and flags of the rebel states. Whilst his house was being constructed, Prioleau, perhaps the greatest supporter of the Confederacy, was living in Allerton Hall, owned by the father of Mary Elizabeth Wright, his wife.

Abercromby Square once housed the University Art Gallery (No.3, but now part of the Victoria Gallery and Museum, the Victoria Building) and the Historic Society of Lancashire and Cheshire (No.9). On the far side of the square is the famous Barbara Hepworth sculpture, *Square with Two Circles*. On your visit watch out for the female sphinx that guards the gate posts to the gardens of the square.

Abercromby Square was named after General Sir Ralph Abercromby (1734-1801), who was a British General in the French and Indian wars and later went on to be Commander of the British Army in Egypt, meeting his death in the battle of Alexandria, during the Napoleonic War.

See also: **Allerton Hall**; **Blue Plaques**; **Rumford Place** and **University of Liverpool.**

ADELPHI HOTEL
(With its famous Sefton Suite)

At the end of Lime Street, looking down Ranalagh Street towards Hanover Street, stands the world famous Adelphi Hotel, now the Britannia Adelphi. It remains a very popular establishment, but in its heyday this majestic building was 'the place to stay' in Liverpool, frequented by the rich and famous.

The screen cowboy Roy Rogers and his horse, Trigger, were one-time guests of the hotel and legend has it that the celebrated horse made an impressive entrance from the mezzanine floor into the lounge. According to the Evening Express, Trigger wandered up and down the stairs before retiring to Roy's chamber. Trigger even made his mark at the registration desk using a pencil held between his teeth.

Other famous patrons of the hotel include: Jefferson Davies; the first and only president of the American Confederacy forces, inaugurated in 1861 and who declared war on the Union, staying at the Adelphi with his family in 1868; the author Charles Dickens, who considered the Adelphi to be the best hotel in the world and Mark Twain, creator of *Huckleberry Finn*.

The original Adelphi hotel built on this site was opened in 1826 and soon acquired great acclaim throughout Europe. It was rebuilt in 1912 and was able to boast solid marble walls in many of the bedrooms, a heated indoor swimming pool, sauna and full central heating, making it one of the most luxurious hotels in Europe. Another example of this sumptuous living can be seen by popping into the Gentlemen's Toilet to view the magnificent Shoe Shine Chair or the Sefton Suite, which is said to be an exact replica of The First Class Smoking Lounge of the ill fated *Titanic*. It has been claimed that the wood panelling was taken directly out of the *Titanic*'s sister ship, the *Olympic*,

but, unfortunately this tale has yet to be substantiated. Another suggestion is that the woodwork was undertaken by the same carpenters that worked on the *Titanic*. It is said that it was built to serve passengers of the Titanic and, presumably, other ocean liners using the port

In 1997, the Grade II Listed Adelphi was the star of an eight part BBC television series which documented the trials and tribulations of running a prestigious hotel.

In 2007 the hotel underwent a total refurbishment which included the restoration of the original white marble swimming pool and the addition of a state of the art health club. The hotel's most recent claim to fame is the musical, 'Once Upon a Time at the Adelphi' opened at the Playhouse Theatre on the 28th June 2008 and celebrating its life in the 1930s in song and dance. Local myth says that Adolph Hitler stayed in Liverpool and worked in the kitchens of the Adelphi. It is unlikely, but, however, it is possible that his half-brother may have, as Hitler is said to have visited him in Liverpool's Stanhope Street.

See also: **Dickens, Charles** and **Playhouse Theatre**

AINTREE RACECOURSE
(Home of the world famous Grand National)

Every spring Aintree racecourse, in its peaceful rural setting, hosts the Grand National, the most celebrated horseracing event in the world. In the not so distant past, this annual steeplechase was in considerable jeopardy and could easily have been lost to the equine world, but, thankfully, Aintree Racecourse survived and is now experiencing its most successful period in modern times.

The Grand National three day event is not the only thing that happens at Aintree. The course is used for racing events of various kinds throughout the year and for those interested in a more leisurely sport, there is a golfing complex featuring a magnificent driving range. The venue has many buildings, including the prestigious Queen Mother Suite, opened by Queen Elizabeth II in 1991. In 2007, Aintree Racecourse was voted to have the best modern building in the north west of England. Besides racing events this meeting place is also used for conferences, exhibitions, banquets, promotions, weddings and general entertaining. The visitors centre is open from May to September. Here you can find out about famous characters associated with the course in the past, including the King of Afghanistan, and admire the paintings and photographs on display that capture the thrill of the race. You may even like to try the Grand National simulator.

In addition to being the home of the world famous Grand National steeplechase, Aintree was once a popular motor racing circuit which made use of some of the same grandstands as the famous horse race. It hosted the Formula 1 British Grand Prix five times during the 1950s and 1960s and sections of the course are still used for more modest motor racing events during the year.

At the entrance of the racecourse is a statue of Red Rum, the only horse ever to win the Grand National three times. To honour Red Rum, his grave is appropriately sited at the winning post of the course.

On non-race days, Aintree Racecourse is an international tourist attraction with its own helipad.

🖳 www.aintree.co.uk

See also: **Grand National**

ALBERT DOCK
(Britain's top heritage award winning attraction and part of the most famous docklands in the world)

Although the Albert Dock is by far the most famous dock in Liverpool, it is not the oldest. The Old Dock, the first closed integrated dock system in the world, makes that claim to fame, Canning Dock later forming the outer harbour to the original. One of the city's many claims to fame is that in 1648 the first recorded cargo from America landed at the Liverpool waterfront. The popularity of Liverpool as a port city was obviously instrumental in the building of the first integrated dock system in the world with a series of locks or floodgates which allowed ships to be loaded and unloaded even at low tide. When this system was built (1710-1716), it was an innovative idea which meant that ships could be loaded and unloaded in one and a half days. Prior to this the task could take up to 14 days, as the work was governed by the ebb and flow of the tide. This innovative system no doubt helped Liverpool to become Britain's greatest seaport during the mid 19th century. A section of this dock, built by the engineer Thomas Steers, can still be seen today. If you venture to the end of Thomas Steers Way at the junction of South John Street in the new Liverpool One area, you will find a viewing window, through which part of the original wall of this groundbreaking dock can be seen, in the floor outside John Lewis department store,

In the 19th century further warehouse buildings and docks were designed and built by Jesse Hartley for the sum of £514,475 8s 1d, a substantial amount of money at the time. It was built entirely of cast iron, brick and stone with no structural wood and was the first building in the country to be constructed in this way. Prince Albert, beloved husband of Queen Victoria, opened the Albert Dock in 1846.

Hartley, the first full-time professional dock engineer in the world, worked for the Liverpool Dock Trustees for 36 years and during this time he either built or altered every dock in the city. He may not have been particularly novel with his designs, but was thorough, supervising every stage of the docks design and construction and building models of the Albert Dock warehouses to test the strength of the brick arches. He also had large scale models made in order to investigate how iron, laid beneath a wooden floor, increased its fire resistance. He developed a number of new uses for iron in the construction of the warehouses, including the crane arches that can still be seen on the exterior walls of the building. The roof was constructed of wrought iron plates riveted together to make it sturdy yet light. It had the added advantage of being less of a target for thieves and much safer in the event of a fire. This 'stressed skin' structure was the first of its kind and quite an architectural innovation.

As Liverpool was still a thriving port, the Albert Dock soon filled with ships carrying precious cargoes from all over the world , but, as the dock was built to accommodate sailing ships, it did not have the depth of water for later steam ships. As time marched on, the Port of Liverpool was used less and less, losing trade to Manchester. Eventually the warehouses became surplus to requirements and finally, in 1972, the Albert Dock, with a capacity of 250,000 tons, was closed.

At a cost in excess of £100 million, the dock was redeveloped during the 1980s into one of Liverpool's most cosmopolitan centres. This involved the rebuilding of a top corner of one of the warehouses, which had been demolished by a bomb during the Second World War. In addition to being Britain's most popular heritage attraction and the largest group of Grade 1 Listed Buildings in the United Kingdom, it has received many prestigious national and international awards.

The dock, representing Britain's largest group of Grade 1 Listed Buildings, has the very best to offer in the North West, among its many attractions being the Tate Liverpool, the Merseyside Maritime Museum, the Museum of Liverpool, along with a gymnasium, shops, bars, restaurants and cafés.

Visitors to the waterfront in the summer months may be able to take part in the annual River Festival that has centred round the Albert Dock for over 25 years. Strolling around the exterior of the dock, watch out for the special post box. It is not easy to miss with its blue and gold crown. These special post boxes were authorised and introduced to meet the rather heavy postal requirements in certain parts of the city. This particular box was cast in 1863 and in September 1987 was placed in its new position in the Albert Dock.

As Liverpool docks are so old and have been so innovative, it is not too surprising to discover that they were the birthplace of the first tram system in the world, the trams being drawn by horses along wooden rails to make transporting cargo easier for the stevedores.

In 1840 Samuel Cunard's wooden paddle-steamer *Britannia* started the world's first scheduled transatlantic passenger service. In 1907 the *RMS Lusitania* left Liverpool on its maiden voyage to New York. The *Lusitania* was built for the Cunard Line whose former offices are one of the iconic buildings known as the Three Graces at the Pier Head.

In an attempt to alleviate congestion problems caused by the traffic that used the dock roads, the world's first electric overhead railway was constructed. It also had the honour of being the first to be protected by automatic electric signals. Building took from October 1889 to January 1893 and the Overhead was formally opened by the Marquis of Salisbury on 4th February. Sadly, in

September 1957 the dismantling of the system began despite considerable public protest.

Stanley Dock Tobacco Warehouse is said to be the largest brick building in the world with 27 million bricks, 30,000 panes of glass and 8,000 tons of steel. The warehouse is capable of holding a staggering 7 million pounds (3.175 million kg) of tobacco.

In their heyday the docks made Liverpool the world's greatest port city and the first global city.

See also: **Calderstones Park**; **Merseyside Maritime Museum**; **Museum of Liverpool**; **Pier Head**; **River Festival**; **Tate Liverpool**; **Three Graces** and **Waterfront**.

ALLERTON HALL
(The former home of William Roscoe, a prominent Liverpudlian)

Like many of the suburbs of Liverpool, Allerton is much older than the city itself and is mentioned in the Doomsday Book. Records show that there have been Lords of the Manor at Allerton since the 12th Century.

William Roscoe, a prominent local abolitionist, lived in the current manor house building from 1798 to 1813 and whilst there made extensive alterations to it, mainly to accommodate his vast library. The building with its large Palladian façade was built with local sandstone. When Roscoe became bankrupt, part of his book collection was purchased by his friends and presented to the Athenaeum.

During the American Civil War, Allerton Hall was leased by Charles Kuhn Prioleau of Savannah, Georgia. He was manager of the firm of Fraser Trenholm & Co., his firm managing the Confederate funds abroad and acting as the commercial and financial agent for the Southern Government. This made their premises, 10 Rumford Place, effectively the 'Confederate Embassy'. It was while he was residing at Allerton Hall that Prioleau commissioned the design and building of No.19 Abercromby Square, bringing the influence of the southern states of America to Liverpool.

The last inhabitant of this Grade II listed building was Thomas Clarke. In 1926 the estate, now known as Clarke Gardens, was given to the city by his family. This once stately 19th century country house is now called 'The Pub in the Park', complete with restaurant.

Totally unrelated to Allerton Hall, but of some interest, is the fact that within the grounds of Clarke Gardens is a relic from the Second World War. Close to the railings on Springwood Avenue where it joins Woolton Road is a soldier's pillbox, a point from which a sniper could fire upon the enemy in relative safety.

See also: **Abercromby Square, Athenaeum** and **Roscoe Gardens**

ALL HALLOWS CHURCH
(Famous for its pre-Raphaelite stained glass windows)

All Hallows Church was built by John Bibby of Hart Hill, Allerton and was constructed in memory of his first wife, born on All Hallows Eve, the daughter of the dock engineer Jesse Hartley, designer of the famous Albert Dock. The foundation stone was laid in Allerton Road on All Hallows Eve, 1872. The

church was consecrated on 10ᵗʰ August 1876 and is now a Grade I Listed Building.

Of particular interest to art lovers are the famous stained glass windows by the celebrated pre-Raphaelite artists, William Morris and Edward Burne-Jones that adorn this building. These two have obviously been popular in Liverpool, as they are also responsible for the stained glass windows in Ullet Road Unitarian Church. William Morris designed two of the stained glass windows in St. Peter's Church, Woolton, and his wallpaper can still be seen on the walls of the magnificent Tudor manor house, Speke Hall.

☎ 0151 724 1561
🖥 vicar@allhallowsallerton.org.uk

See also: **Albert Dock**; **St. Peter's Church**, **Speke Hall** and **Ullet Road Unitarian Church**

AL RAHMA MOSQUE
(Home of the Liverpool Muslim Society)

The purpose built Al-Rahma Mosque and Islamic Cultural Centre, situated at 29-31 Hatherley Street, Liverpool L8, is the only mosque in the city and is a place of worship for the oldest Muslim community in the UK., which dates from the 1880s. Many of the earliest members were lascars, sailors hailing from the East Indies, Muslim soldiers and students also arriving in Britain at this time.

The Al-Rahma Mosque, with its extension, has been on its present site since the 1960s and is the home of the Liverpool Muslim Society, founded in 1953. In 2008 a newly refurbished mosque, topped with a golden dome and crescent, was opened.

At first glance you could be forgiven for thinking it a modest construction, but it is deceptive, accommodating up to 1,000 worshippers at any one time. On any given Friday, up to 2,500 Muslims visit the mosque as part of their devotions.

Although it is a characteristic building, this was not the first mosque to be set up in Liverpool. That distinction belongs to the Islamic Institute and Liverpool Mosque, once situated in Brougham Terrace. On Christmas Day in 1899, Liverpool's first mosque in 8-12 Brougham Terrace was opened by local solicitor and Muslim convert, William Abdullah Quilliam (1851-1932). On the day of opening, 250 homeless children were brought inside and given Christmas dinner. Not only was this the first mosque in Liverpool , but was also the first mosque and Islamic Centre in England.

Quilliam was the son of a wealthy watch manufacturer who, after qualifying as a solicitor, went to Morocco to convalesce after an illness. Here he learnt about Islam and was soon converted, taking his Shahadah, a declaration of faith, and changing his name to Abdullah.

William Abdullah Quilliam initiated the 'Crescent', a weekly journal which was in circulation from 1893 to 1908 and was printed on the mosque's own printing press. He also wrote the first book in English by a Muslim, 'Faith of Islam' which was translated into thirteen languages, gaining him considerable fame in the Islamic world. This brought Quilliam many honours and secured funding of £2,500 from the Sultan of Afghanistan for the purchase of property and the establishment of a mosque in Liverpool.

Sheik Abdullah Quilliam spread Islam and converted many, including his Methodist mother, his sons and many prominent intellectuals. He set up a Muslim college within the Brougham

Terrace complex, which held various courses for both Muslims and non-Muslims.

When the mosque closed in 1908, Brougham Terrace was taken over as council premises and for some unknown reason the employees always referred to the strong room at the rear of the building as the 'little mosque'. It is hoped that a heritage centre will be founded within the original premises of the mosque.

Brougham Terrace was designed by the prominent Liverpool architect, James Allanson Picton, a local benefactor.

☎ 0151 709 2560
🖳 liverpoolmuslimsociety@hotmail.co.uk

See also: **Central Library** and **Picton Clock Tower**

ANCIENT CHAPEL OF TOXTETH
(The resting place of Jeremiah Horrocks, the founder of English astronomy)

Unfortunately, whenever Toxteth is mentioned it frequently evokes memories of the 1981 riots. However, this district of Liverpool has a history that goes much further back than the late twentieth century. It pre-dates the city itself, as it is mentioned in the Doomsday Book. As you might expect, the Ancient Chapel of Toxteth also goes back further than the 20th century. St. Michael's Church, Park Road, better known as the Ancient Chapel of Toxteth, was built around 1618 during the reign of James I. It is thought to have been built by Edward Aspinall as a church for Presbyterians or Independents, but later became a Unitarian church. In 1774 the chapel was restored and modified and later, in 1841, the porch was added. Some good examples of 18th furnishings can still be seen inside this ancient building.

Jeremiah Horrocks was taught by the local school master and first preacher at the Ancient Chapel, Richard Mather. He returned to Toxteth to preach in the chapel after leaving Cambridge without taking his degree.

Jeremiah Horrocks, described by Sir Isaac Newton as the 'Founder of English Astronomy', is buried in churchyard in an unmarked grave, but inside the church itself, there is a commemorative stone in his name.

☎ 0151 263 4899

See also: **Horrocks, Jeremiah**

ANGLICAN CATHEDRAL
(Possibly the largest Anglican Cathedral in the world)

At the south end of Hope Street , stands Liverpool's Anglican Cathedral, said by some to be the largest Anglican Cathedral in the world, though there is some dispute over the matter. The Guinness Book of World Records list the cathedral of St. John the Divine in New York City , as yet unfinished, as the largest in the world. The one thing for sure is that the Cathedral Church of Christ in Liverpool, to use its official title, is the largest cathedral in Europe and the only Anglican Cathedral to be built in the Northern UK since the Reformation.

Construction of this Gothic revival style principal church began in 1904, with the sandstone being quarried from the local district of Woolton, which also supplied building material for many of Liverpool's historic buildings. The quarry was closed in 1978, when the cathedral was finally completed. The design for the cathedral was open to competition and was won by Giles Gilbert Scott, who was 21 at the time. He is also famous for

designing the classic red telephone boxes that once adorned our streets in their multitudes and the controversial and now defunct Battersea Power Station. One of his famous telephone boxes is preserved within the grounds of the cathedral.

The construction of such an imposing structure, one of the greatest buildings of the 20th century, took some considerable time, especially as its building was interrupted by two world wars. Giles Gilbert Scott was long dead before the cathedral was consecrated in 1978, but his memory is preserved in the Layman's Window, where he is depicted at the bottom left, wearing a blue coat. Ironically, Giles Gilbert Scott was a catholic whilst Sir Frederick Gilbert, designer of the Catholic Metropolitan Cathedral of Christ the King, was an Anglican.

The West Front of the cathedral, faced by the sculpture, 'Christ', dominates the approach from the city centre. This sculpture was installed at the cathedral in 1993 and is the work of the celebrated artist Dame Elizabeth Frink.

The magnificent pipe organ in the cathedral is the second largest in the United Kingdom, only outdone by the Albert Hall organ. It is, however, the largest working church organ in the world with over 9,750 pipes. Among the other claims to fame that the cathedral can make is the fact that it has both the highest vaulted roof in the world and the highest and heaviest peal of bells in the world. They weigh 31 tons (31,497.6kg) and are 219 feet (67m) above the ground.

The cathedral's gothic arches tower a tremendous 175 feet (53.3m), making them the highest ever built. Those who do not suffer from acrophobia can make use of the lifts and stairs to reach the roof of the cathedral for an unequalled panoramic view of the splendours of the city. In a 1970 BBC broadcast, John Betjeman, the poet laureate, said, "Liverpool Cathedral is

one of the greatest buildings of the world. Suddenly one realises that the greatest art of architecture, that compels reverence, but also lifts one up and turns one into a king, is the art of enclosing space"

Below the cathedral is St. James's Mount and Gardens, formerly St. James's Cemetery. It was created from an old stone quarry and contains huge ramps wide enough to take funeral carriages. They had to have raised walls to prevent the carriages from falling over the edge and spilling their load. The cemetery contains in excess of 100 catacombs, cut into the sandstone walls. It also contains the memorial and mausoleum of William Huskisson MP, who became the first railway accident fatality.

Kitty Wilkinson, the inventor of the public wash house is buried in the cemetery and is commemorated with a picture in the stained glass window of the Lady Chapel.

The last burial took place on 11th June 1829 and in 1972 the cemetery was converted into a public garden, now known as St. James Mount and Gardens. In order to accomplish this many of the headstones and coffins were relocated.

In addition to being a place of worship the cathedral is also used for concerts, displays, exhibitions, functions and recitals. Guided tours for adults and children can be arranged.

See also: **Metropolitan Cathedral of Christ the King** and **St. James' Mount and Gardens**

ANTHONY WALKER FESTIVAL
(Promoting community relations among young people)

The two day festival began in August 2006, following the huge success of the 2005 Anthony Walker basketball Tournament. It is held in Sefton Park and the Greenbank Sports Academy and has included activities such as:

- various workshops designed to promote life skills and social skills within art, education, music and sport;
- a basketball tournament;
- a five-a-side football tournament;
- art workshops;
- toddler activities;
- food reflecting the varied cultural influences within the city;
- guest speakers.

The festival is organised by the Anthony Walker Foundation, created to help eliminate racial discrimination within the community. It organises activities to develop community relations between young people in Liverpool and across the nation of all racial origins, especially those who are disadvantaged, disaffected and suffer from social exclusion.

Anthony Walker was an 18 year old black A-Level student who was a devout Christian, an enthusiastic basketball player and had ambitions of studying law at university. He was the victim of a horrific racial attack when he was killed on the outskirts of Liverpool. Prior to the unprovoked physical attack, Anthony and his companions received a torrent of racial abuse which they walked away from, but they were followed. They were attacked and Anthony was left with an ice-pick embedded in his skull. In the early hours of 30th July 2005 the mild mannered young man died from his wounds. His killers were caught and jailed.

In August 2007 National Museums Liverpool honoured Anthony by dedicating the Learning Centre in the new International Slavery Museum in his memory.

See also: **International Slavery Museum** and **Sefton Park**

ATHENAEUM
(Liverpool's premier gentleman's club)

The Athenaeum was founded on 22^{nd} November 1797 as a meeting place where gentlemen could exchange ideas and information in surroundings that reflected their status. Like the Lyceum, the founding of this establishment may have been from a desire to avoid the rowdy coffee houses that were frequented by people involved in the Slave Trade. The present building in Church Alley was completed in 1928 and is not far from the Blue Coat Chambers.

The Athenaeum library is considerable, containing a vast amount of books, prints, maps and charts, and is said to be one of the most important regional history resources in the United Kingdom. One of the most notable sections of the library is the William Roscoe Collection, once housed in Allerton Hall, which is kept in the Committee Room with other rare volumes. The Reading Room has been described as 'one of the handsomest rooms in Europe' and has been used as both film and television locations.

The Athenaeum has always had distinguished proprietors from all walks of life that has included Nobel Laureates. Some of the early proprietors played a major part in the national campaign to abolish slavery.

The building is usually open from 10am to 4pm, but bear in mind the fact that you have to be invited to tour this prestigious establishment.

☎ 0151 709 7770
💻 www.athena.force9.co.uk

See also: **Allerton Hall**; **Blue Coat Chambers**; **Lyceum** and **Roscoe Gardens.**

BIRKENHEAD PARK
(The first public park in the world)

Drive through the Mersey tunnel or take one of our world famous ferries and you will be in Birkenhead, once home of the famous Cammell Laird shipbuilders (formerly Laird & Sons), where *HMS Ark Royal*, *RMS Lusitania* and *CSS Alabama* were all built. Make your way to the junction of Park Road East and Park Road and you will see the Grand Entrance to Birkenhead Park, which had a great deal of influence on the design of many of the parks of Liverpool.

The park opened in 1847 and was the world's first public park. The building of this world trend-setting park was funded entirely at public expense. It is an outstanding example of the work of the celebrated Victorian garden designer, Sir Joseph Paxton, and has been influential in the design of parks both nationally and internationally, with New York's Central Park being, perhaps, the most famous example. Sir Joseph also designed the Crystal Palace for the 1851 Great Exhibition. He shaped the lakes in a serpentine fashion ensuring visitors pleasant views. As you take a leisurely stroll around the park you will see a sunken garden, the Swiss Bridge, the Italian Lodge, the Castellated Lodge and many more items of interest and beauty.

The park boasts many interesting facts including:

- It's a Grade 1 Listed Landscape;
- It has 8 acres (3.2 hectares) of lakes;
- French prisoners of war were used for part of the labour;
- The hills within the park are all man-made;
- It contains 5 Listed Buildings;
- There is an Spitfire aircraft engine buried within the park, the result of a aeroplane having crashed into the Tower Park during Word War II;
- Rocks excavated in the building of Birkenhead docks were used in the construction of the park, a shrewd move to get rid of the unwanted stone.

See also: **Ferries**; **Mersey Tunnels** and **Mersey River**

BIRKENHEAD PRIORY
(The oldest standing building on Merseyside)

Around 1150, Benedictine monks established a priory in Birkenhead (Priory Street) on an isolated headland that overlooked the River Mersey. It was from here that the monks would row over to Liverpool to trade at the markets, later taking passengers, thus creating the first ferry service on the Mersey.

Now the remains of the priory are hemmed in by an industrial estate and what is left of the local shipyard graving docks. Birkenhead Priory incorporates museum displays, a meeting or concert space and a chapel dedicated to the submariners who lost their lives aboard the *HMS Thetis* which sank in Liverpool Bay with the loss of 99 lives on its maiden voyage in 1939.

In the grounds of the priory you can see: the cloister, without its arcades; monastic buildings, the red sandstone chapter house, the only remaining part of the original foundation; the vaulted undercroft that was part of the refectory; lodgings for guests and the prior's lodging. There is also the tower from St. Mary's Church, the first parish church of Birkenhead, which offers excellent views of the Mersey and Liverpool.

The priory was purchased in 1896 by public subscription with Birkenhead Borough Council taking responsibility for it. Restoration took place between 1896 and 1898 and then again from 1913 to 1919, when it was dedicated as a chapel.

☎ 0151 666 1249

See also: **Ferries** and **Mersey River**

THE 'BLACKIE'
(Britain's first community arts project)

After the Great George Street Congregational Church ceased to function as such, it eventually became the home of the country's first community arts project. The Great Georges Community Cultural Project is known locally as the 'Blackie' (the Black Church, so called because of the urban grime that until recently darkened its stonework) and is only a short stroll away from the largest Chinese arch outside of Asia.

The Blackie was established in 1968, after a change of use, and plays host to community groups and playgroups. It boasts a cultural programme of art workshops, exhibitions, performances, residencies and youth projects and lays emphasis on cultural diversity and shared experiences. Since its initiation, artist-led,

multi-culturally inspired and disabled friendly games have been played at the venue.

The Blackie, a not-for-profit charity, has been at the cultural heart of Liverpool and many local artists have benefited from an association. Originally, only the converted ground floor and basement of this Grade II Listed Building were used as performance space, but in 2003 a £4 million refit with the help of European Objective One funding created additional performance space and galleries on the first, second and third floors and workshops on the fourth floor. Changing rooms and offices were created in the annexe. The extra space created enabled the Blackie to host a wide range of events including dance, martial arts, sports and theatre.

The elegant building, designed by Joseph Franklin, was constructed in 1840-1841 on the site of an earlier chapel and has frequently been described as one of the city's finest classical buildings with its splendid circular Corinthian portico, dome and oval-shaped gallery supported on palm leaf cast iron columns.

The Blackie is open from 10am to midnight for 362 days of the year.

☎ 0151 709 5109
💻 staff@theblackie.org.uk

See also: **Chinese Arch**

BLUECOAT CHAMBERS
(The original Blue Coat Hospital)

The Bluecoat Chambers, formerly the home of the Blue Coat School or, to use its original and formal title, Blue Coat Hospital, was built in 1716-1717, making this Queen Anne construction the

oldest building in the city centre. It was built by Bryan Blundell and the Reverend Robert Styth in order to help alleviate the problem of growing concern regarding destitute orphans in the city.

The brick building originally had a hall and chapel, but now consists of two storeys, a five bay centre, two long three storey wings of eleven bays and a cobbled courtyard at the front of the building. The main entrance in School Lane has a broken pediment bearing a cartouche of Liverpool's coat of arms. The Latin inscription above the main entrance reads 'Dedicated to the promotion of Christian charity and the training of poor boys in the principles of the Anglican Church'. In fact the school took in girls as well as boys. Liver bird icons can be seen on the broken pediments of the middle doorways and topping the building is a cupola, one of the local area landmarks.

After the school transferred to Church Road in the then new and leafy suburb of Wavertree, the city centre building was eventually purchased by the Bluecoat Society of Arts and became the Britain's first arts centre. It now houses the Bluecoat Art Centre, one of the major venues of the Liverpool Biennial Festival, along with the Bluecoat Gallery, the Bluecoat Display Centre, a small number of shops and a café. The Bluecoat Chambers is a Grade I Listed Building.

See also: **Blue Coat School** and **Liverpool Biennial**

BLUE COAT SCHOOL
(A one time orphanage for the destitute children of Liverpool)

Bryan Blundell was a merchant, privateer and a slave trader. It is thought he owned the first ship to enter the town's first dock in 1715. He joined forces with Reverend Robert Styth and, in 1708,

founded the Blue Coat School. Both men were conscious of the fact that large numbers of children were left destitute after the death of their fathers at sea. The school, originally called the Blue Coat Hospital, grew very quickly and a new building was opened in 1718. The present day Bluecoat Chambers in School Lane. The Latin inscription above the main entrance reads 'Dedicated to the promotion of Christian charity and the training of poor boys in the principles of the Anglican Church'.

The school remained in this building until 1906 when it moved to its present location in Church Road, at that time still considered to be the countryside. The school ceased its role as an orphanage in the late 1940s and is currently a grant maintained school, selecting its pupils on their academic ability. Although it was originally for boys and girls of Liverpool, for a period, it was until recently a school for boys only. The school and its magnificent domed chapel are both Grade II* Listed Buildings. The back of the school, on Prince Alfred Road, facing The Mystery, is well worth viewing.

With the decline in the number of children of school age in the city and the fact that the school no longer has pupil boarders, it has been able to convert part of the Bluecoat building into luxury apartments.

See also: **Bluecoat Chambers** and **The Mystery**

BLUE PLAQUES
(The first outside London)

If you're a fan of blue plaques, you're in for a real treat. In 1998, English Heritage decided that Liverpool would be the first city outside of the capital to have plaques erected to commemorate the home or birthplace of famous people.

Fifteen nominations were originally made to acknowledge local figures with the prestigious 20 inch (51cm) blue plaque with white lettering. Since then further blue plaques have been erected. We have listed a selection of people who have been honoured with a commemorative plaque - there are many more.

We are aware that not all of the buildings are strictly in Liverpool, but remember they had a Liverpool postcode at one point.

Sir Patrick Abercromby (1879-1957)
Town and Country Planner
Plaque at: **18 Village Road, Oxton, Wirral**

Bessie Braddock (1899–1970)
Labour MP for Liverpool Exchange between 1945 and 1970
Plaque at: **2 Zig Zag Road, Liverpool 12**

John Brodie (1858–1934)
City Engineer and inventor of the goal net
Plaque at: **28 Ullet Road, Liverpool 17**

See also: **Brodie, John**

Captain Noel Chavasse VC (1884–1917)
Doctor and war hero, awarded the VC twice in 1917
Plaque at: **19 Abercromby Square, Liverpool 7**

See also: **Abercromby Square**

Peter Ellis (1804-1884)
Architect
Plaque at: **40 Falkner Square, Liverpool 8**

See also: **Buildings Worthy of a Second Look (16 Cook Street** and **Oriel Chambers)**

Frank Hornby (1863-1936)
Toy manufacturer and inventor of Meccano and maker of the
famous model clockwork trains and Dinky toys
Plaque at: **The Hollies, Station Road, Maghull**

Thomas Henry Ismay (1837-1899)
Shipowner and founder of the White Star Line
Plaque at: **Winchester House, 13 Beach Lawn, Waterloo**

Wilfred Owen (1893-1918)
War poet
Plaque at: **7 Elm Grove, Birkenhead**

William Rathbone (1819-1902)
Liverpool merchant and champion of nursing reforms
Plaque at: **Greenbank House, Greenbank Lane, Liverpool 17**

Eleanor Rathbone MP (1872-1946)
Feminist and reformer
Plaque at: **Greenbank House, Greenbank Lane, Liverpool 17**

Sir Charles Reilly (1874-1948)
Architect
Plaque at: **171 Chatham Street, Liverpool 7**

Sir Ronald Ross (1857-1932)
Discoverer of the mosquito transmission of malaria
Plaque at: **The Johnson Building, The Quadrangle, University
of Liverpool, Liverpool 8**

See also: **University of Liverpool**

Sir Henry Tate (1819-1899)
Sugar magnate, art patron and philanthropist
Plaque at: **42 Hamilton Street, Birkenhead**

For the truly dedicated and devoted plaque spotter, Liverpool is also the home of plaques of other hues. For example, the stone plaque commemorating the fact that former Prime Minister William Gladstone was born in Rodney Street and the bronze coloured plaque commemorating James 'Jim' Clarke.

Jim was a local hero, who, as a young boy of fourteen, left his native Guyana to move to Liverpool. He was a natural athlete and swimmer and swam for many Liverpool clubs. He also performed many exhibitions. His favourite party piece was to sit on the bottom of a swimming pool with a bucket on his head and sing 'Oh My Darling Clementine'. During his life here he saved many children and dock workers from drowning in the River Mersey and the Leeds to Liverpool canal. He was instrumental in ensuring that all local schoolchildren were taken to the public baths where he could teach them to swim. His plaque can be seen in James Clarke Street.

See also; **Rodney Street**

BRODIE, JOHN
(Famous for inventing the Goal Post Net)

Brodie Avenue was named in honour of John Brodie (1858–1934). He was Liverpool's City Engineer between 1898 and 1926 and is best known for constructing the Mersey Tunnel. Brodie was also a pioneer of prefabricated houses and built many prefabricated tenements. He also came up with the idea of creating a promenade at Otterspool 30 years before it was actually built. Besides his work as a city engineer he also spent time lecturing at Liverpool University on topics such as hygiene and housing, road design and traffic sanitation.

Without doubt, his greatest engineering achievement was the

Mersey Tunnel, completed in the year of his death, but John Alexander Brodie is now forever remembered by sports fans as the inventor of the 'goal net pocket'. In 1899 he was watching a local team playing, sporting their favoured blue strip, when an altercation erupted over whether the ball had passed through the posts or not. This gave Brodie the idea of attaching a 'goal net pocket' to the posts to prevent such disputes. It was an instant success and soon became compulsory in the game. Goalkeepers must have been particularly pleased with this invention, as it meant not going so far to retrieve the ball after a goal.

John Brodie lived in 28 Ullet Road, Liverpool 17, where there is a commemorative Blue Plaque in his honour.

See also: **Blue Plaques**; **Mersey Tunnel**; **Otterspool Promenade** and **University of Liverpool**

BUILDINGS WORTHY OF A SECOND LOOK
(As Liverpool city centre is compact, it is so easy to walk past architectural delights and hardly notice them)

Liverpool's city centre has a plethora of fine architecture, much of which is often missed. A good many of these magnificent buildings are Victorian, though others were designed much later.

The Albany, Old Street.
Designed by J.K. Colling
Built in 1856.

The Albany is, perhaps, one of the earliest and finest examples of large Victorian office buildings within the city centre. This Renaissance style building has a sizeable courtyard crossed by two cast iron bridges, each approached by a spiral staircase.

City Airport (former), Speke Road
Designed by R. Arthur Landstein
Grade II* Listed

Liverpool City Airport was the first municipal airport building in Europe and one of the first purpose-built airport terminals in the world. It was opened in July 1933 , but the airport terminal building was not completed until 1937. The symmetrical construction is flanked by two massive hangars. . The hanger on the right of the building is now a sports centre while the hangar on the left is used for business premises.

A new airport terminal was built close to the new runway and after lying derelict for several years this beautiful Art Deco building was transformed into a hotel.

16 Cook Street
Designed by Peter Ellis
Built c1864, completed 1866, Grade II* Listed

The front elevation is made up of three bays with Venetian headed windows. Venture to the rear and you will see the most outstanding feature of this building. In the narrow courtyard is a glazed cast iron spiral staircase without a central support. It appears to be cantilevered from each floor.

See also: **Blue Plaques**

Everton Waterworks, Aubrey Street Liverpool 6
Designed by Thomas Duncan
Built 1854-1857

Thomas Duncan, Liverpool Corporation's first water engineer, certainly left his mark on the city with the design of this

spectacular feature. The Victorian construction consists of a one and a half acre (0.6 hectare) reservoir, 12 feet (3.6m) deep with a high level circular tank supported on stone arches with brick and masonry cross arches. The cast iron tank can hold a staggering 2,700 gallons (12,274l) of water 90 feet (27m) above ground level.

Hargreaves Building, corner of Chapel Street and Covent Garden
Designed by Sir James Picton
Built in 1859, Grade II Listed

This three storey building is built in the Venetian palazzo style. The round-headed windows on the ground floor each contain a semi-circular pane of glass supported on decorated cast iron mullions. The carved plaques above the windows are in the style of Brunelleschi and, like the statues at Sefton Park's Palm House, depict people who were involved in the exploration of the New World: Anacona Bermeja, Christopher Columbus, Hernando Cortez, Ferdinand III, Isabella I, Francisco Pizarro and Amerigo Vespucci, after whom America was named.

The Hargreaves Building was built for the Liverpool merchant and benefactor Sir William Brown. The architect, Sir James Allanson Picton, was chairman of Liverpool's Libraries and Museums Committee.

See also: **Palm House**; **Picton Clock Tower**; **Sefton Park** and **William Brown Street**

Lime Street Station,
Designed by John Fowler
Built 1836-1879, Grade II Listed

Lime Street was originally called Limekiln Lane, owing to the presence of limekilns in the 18th century. The station was built in three stages, the third part of which included the northern train shed with a ceiling span of 200 feet (61cm) which, at the time of construction, made it the largest in the world.

In 1845 members of the general public were able to embark on the world's first package tour alighting at this station.

Martins Bank (former), corner of Water Street and Rumford Street
Designed by Herbert Rowse
Built in 1932, Grade II* Listed

Martins Bank had its origins in the Slave Trade. The doorway of the present building makes no secret of the fact, as it has a bas-relief showing two African boys manacled at the feet and neck. Now a Barclays Bank, this enormous building exhibits an American-French influence in its design. Gigantic bronze doors lead into the bank, which has been described as 'Jazz Age Parisian' with superb Egyptian motifs. Travertine and bronze have been used lavishly in the banking hall and on the top floor is a banqueting hall of distinction. During World War II, the country's gold reserve was moved from London and stored in the vaults of this bank.

The architect, Herbert Rowse was commissioned for a good deal of work in Liverpool with some of his more famous designs being India Buildings, the Philharmonic Hall and Queensway Tunnel with its ventilation tower and George's Dock Building.

See also: **India Building**; **Philharmonic Hall**; **Queensway** and **Ventilation Tower**

Municipal Buildings, Dale Street.
Designed by John Weightman
Built 1860-1866, Grade II* Listed

Built in a mixture of Italian and French Renaissance styles, the Municipal Building has symmetrical French pavilion roofs, in the centre of which can be seen a tower with an unusual spire.

The interior is well worth inspection. The dominating Rates Hall has colossal Corinthian columns and pilasters with a different design to each capital. On the second floor level there are an additional 16 allegorical figures ranging in subject. The Dale Street elevation displays imagery of the African Continent, the European Continent, Agriculture, Engineering, and Astronomy. The Cross Street elevation shows Industry and The Arts.

North Western Hotel, Lime Street.
Designed by Alfred Waterhouse
Built in 1871

Standing next to Lime Street Station, this 330 room hotel was built in the French Renaissance style. The façade of this enormous seven storey symmetrical building is faced with Caen and Storeton stone. As this hotel was considered to be of such great importance to the city of Liverpool, the Corporation contributed towards the cost of its building. After lying empty for several years it has now been converted into accommodation for students of the Liverpool John Moores University.

Better known for his design of the Natural History Museum in London, Alfred Waterhouse also designed the Prudential Building in Dale Street, University of Liverpool Victoria Building, Balliol College, Oxford and Gonville and Caius College, Cambridge.

See also: **Liverpool John Moores University** and **University of Liverpool**

Oriel Chambers, corner of Water Street and Covent Garden.
Designed by Peter Ellis
Built in 1864, Grade I Listed

One of the most influential buildings of its age, Oriel Chambers is also one of the finest buildings in the city. Ellis chose not to employ the small window patterns used in so many building of this time. Instead he decided on projecting oriel windows to flood the offices with light. The simplified elevations of the courtyard at the rear were years ahead of their time. The elegance of his work was not fully appreciated at the time and provoked a good deal of adverse comment. When it was first built it was described as 'a great abortion' and 'an agglomeration of glass bubbles'.

See also: **Blue Plaques**

Royal Insurance Building (former), corner of Dale Street and North John Street
Designed by J. Francis Doyle
Built in 1897-1903, Grade I Listed

Sessions House, William Brown Street.
Designed by F. and G. Holme
Built in 1884, Grade II* Listed

Sessions House is built in a free Classical style with five bays to the front with a portico of four paired Corinthian columns. On the pediment is the coat of arms of Lancashire County Council, of which Liverpool was once part before being incorporated into Merseyside. A rather ornate Italian Renaissance staircase

adorns the interior. There are two courtrooms in the building with cells in the basement.

See also: **William Brown Street Conservation Area**

Tower Buildings, The Strand.
Designed by W. Aubrey Thomas
Built in 1908

Tower Buildings was one of the earliest steel framed buildings in the country. Although lacking architectural refinements, it is very functional with large windows and a self cleaning white tile exterior. The crenellated turrets are an allusion to the Tower of Liverpool, which originally stood on this site. The original tower was a fortified house, later becoming a debtor's jail.

White Star Line Building, corner of The Strand and James Street. Designed by Richard Norman Shaw with J. Francis Doyle in 1897.

Albion House, as it is now known, was built using red brick and Portland stone bands in the same style used for Shaw's New Scotland Yard Building in Westminster. In 1912 the sinking of the *Titanic* was announced from a balcony of this building to the worried and angry crowds below.

The White Star line eventually merged with Cunard.

See also: **Cunard Building** and **Titanic Memorial**

CAINS BREWERY
('Liverpool in a pint')

Robert Cain, an Irish immigrant, started brewing in Liverpool at the age of 24 and his beer soon became very popular. This was

thought to be the reason why, in 1858, he was in a position to be able to purchase an established brewery in Stanhope Street, but, in fact, he had married well and was able to use his wife's money to fund his enterprise. He quickly became famous throughout the city for the outstanding quality of his beverages and, upon his death in 1907, many mourners attended his funeral. Claims have been made that between three and five thousand people were present at the event.

As a result of his phenomenal success, Robert Cain was able to commission the building of 200 public houses throughout the city. He insisted on architectural excellence for the interior and exterior of all of these pubs which included The Philharmonic in Hope Street, a well known and loved city centre pub. His firm was also able to take over pubs of architectural excellence such as Dr. Duncan's, another city centre establishment in St. John's Lane, named after Britain's first Medical Officer of Health, a resident of Rodney Street.

By the time of his death, the brewery had expanded to be the largest in Europe. Another claim to fame is that it was the first lager brewery in England. During the 20th century the brewery underwent a merger with Walkers of Warrington. In its time it has been owned by Higson's, Boddington's and Whitbread, who closed it down. Luckily, it was soon re-opened by the Danish Brewery Group who re-named it Robert Cain & Co. Ltd., thus preserving the name. It is now owned by Sudarghara and Ajmail Dusanj, the first Asian family to run a British brewery and who are affectionately known as 'Bill' and 'Sid'. Under their command it was rescued from the brink of closure to become one of the fastest growing breweries in the United Kingdom.

This grade II Listed building red brick Victorian brewery still bears many references to its ownership by Higson's, which cannot be removed because of the status of the building. A tour of the premises gives you insight to a splendid example of the

tower brewing principle. In addition to seeing beer fermenting, visitors will also have the opportunity to see the Hops Room, the Brewing Room, the Canning Room, the Storage Bay and the Courtyard.

The brewery is still producing a variety of fine quality beers using water from its own well just as it did in Robert Cain's day.

As the brewery is a lofty Victorian building, visitors have to negotiate quite a few flights of stairs. Tours of this VAQAS Accredited Tourist Attraction are available seven days a week, though they must be pre-booked. There is a charge for the tour, but it does include two complimentary pints of award winning ale along with a light buffet.

☎ 0151 709 8734
🖥 tours@cains.co.uk

See also: **Philharmonic Dining Rooms** and **Rodney Street**

CALDER STONES
(The remains of a megalithic tomb)

The Calder stones are six blocks of sandstone that once formed part of a megalithic tomb close to what is now Calderstones Park. The tumulus (mound) and the other stones were removed from the ancient site in the early 19th century.

Since they were originally discovered the stones have been moved on more than one occasion. They can be seen marked on a plan made in the Wavertree and Allerton dispute of 1568. In 1964 they were finally moved to their present position, in what was the vestibule of the remains of the Harthill Greenhouse, in Calderstones Park.

Much further away, in Booker Avenue, is the Robin Hood Stone. Some local historians believe this stone may have been part of the original bronze-age burial mound, but others think that this is improbable.

See also **Calderstones Park** and **Robin Hood Stone**

CALDERSTONES PARK
(Home of the Calder Stones)

Calderstones Park was originally part of the estate of the Manor of Allerton. After changing hands several times the estate was eventually sold to Liverpool Corporation in 1902 for the princely sum of £43,000. The grounds were extended with the addition of the 32 acre (13 hectares) Harthill estate which helped create the 121 acre (49 hectare) park.

There are many entrances to the park, but the most impressive by far is the Four Seasons Gate in Yew Tree Road, which opens up to the estate's original long driveway. After the planting of trees along its length to commemorate the Silver Jubilee of King George V and Queen Mary in 1935, it became known as 'Jubilee Drive'. The park contains many rare and important tree specimens and is a recognised Botanic Garden.

Calderstones is one of the city's largest and most beautiful parks and achieved Green Flag status in 2002 and 2003. Watch out for the tree sculpture close to the Menlove Avenue side of the park, which is something not seen often in a busy city.

The Rangers give regular tours of the park, which, like most of the parks of Liverpool, is open 24 hours a day for 365 days a year.

Calderstones Park boasts many features:

- **The Allerton Oak** - according to local legend the ancient 'Hundred Court' sat beneath the branches of this 1000 year old tree. Its slightly decrepit state is said to be result of the explosion of the *Lotty Sleigh* gunpowder ship in 1864. It must have been rather a large bang as the ship was three miles away on the River Mersey
- **The Bidston Gates** – the intricate wrought iron gates originally stood at Bidston Court in Birkenhead, which was demolished in 1930. They were donated to the city and were erected at one end of the Rhododendron Walk in 1974.
- **The Boating Lake** – opened in April 1933.
- **The Bog Garden** – this was originally a natural pond, later used as a dumping ground for Blitz debris. The site was developed into a garden and opened in 1955;
- **The Calder Stones** – relics of a megalithic burial mound are now sited in the vestibule of what is left of the Harthill Greenhouse. The Robin Hood Stone may have also been part of the burial mound;
- **The Children's Playground** – this was opened in June 2000 by a famous native of the city, Sir Paul McCartney, who was instrumental in starting the Liverpool Institute for Performing Arts. The playground is dedicated to his late wife, Linda;
- **The Ha Ha** – a sunken wall with a ditch in front of the Mansion House. This is a device that many large houses used to mark a boundary without interrupting the landscape and to keep grazing cattle off the ornamental lawns;
- **The Japanese Garden** – created in the 1970s as an apprentice scheme;
- **The Mansion House** - this Georgian style residence was built in 1828;

- **The Ornamental Gardens** – a peaceful area at the centre of the park;
- **The Pinetum** - A plantation of pine trees or conifers holding a unique collection of dwarf conifers presented to the city by the Government of West Germany.
- **The Rose Garden** – overlooked by the **Camellia Veranda**;
- **The Stable Block**, **Coach House** and **Lancastrian Barn** - these buildings are used as a centre for the park staff and the frequent arts and crafts exhibitions held in the park;
- **The Tennis Courts** – they play host to the annual Liverpool Parks Tennis Tournament;
- **The Text Garden** – letters planted in yew and box as part of the 'Artranspennine '98 Contemporary Art Exhibition' spell the names of common wild flowers;
- **The Walled Kitchen Garden** – now displaying an outdoor botanical collection.

Strolling through the formal garden in the park the visitor may come upon the memorial to Jet, a Liverpool rescue dog buried there. Jet took part in the rescue attempts made after the William pit disaster in Whitehaven, Cumbria. In August 1947, firedamp in the coal pit ignited, causing an explosion that resulted in the loss of 104 lives. Another animal connection with the park is the location of horses' graves near the Allerton Oak.

Try and see if you can spot a truncated stone pillar planted in Harthill Gardens in memory of Jesse Hartley, the dock engineer.. This piece of Scottish stone was a sample to be tested for the building of the Albert Dock.

As with the Princes Park and Sefton Park Route, the Trans-Pennine (Route 561) passes through part of the park.

See also: **Albert Dock; Blue Plaques**; **Calder Stones**; **Parks and Gardens**; **Princes Park**; **Robin Hood Stone**; **Sefton Park**; and **Tennis Tournament**

CAMP HILL AND WOOLTON WOODS
(The site of an Iron Age Fort, circa 150BC)

The land that makes up this 30 hectare (74 acre) park lies within a conservation area. It has been the property of the city since Woolton Woods was purchased in 1920, Camp Hill being bequeathed in 1921. The land has been used for a variety of purposes, one of the earliest being that of an Iron Age fort on the crest of Camp Hill. It is believed that the camp occupied the land from 150BC.

Amongst its features Woolton Woods and Camp Hill boasts:

- **The Floral Cuckoo Clock** – found in the Old English Rose Garden within the Walled Garden, the clock is planted with traditional bedding plants. It was presented to the public in 1927 in memory of James Bellhouse Gaskell who had a long connection with the woods.
- **The Old English Rose Garden** – found within the Walled Garden.
- **The Sunken Garden** – this tranquil spot was created in 1928 as the Dutch Garden of Meditation. The pool and garden ornaments it contained have long gone, but it remains a sheltered spot favoured by many visitors;
- **The Walled Ornamental Garden** – this award winning garden was originally the kitchen garden of the former mansion on the site. This quiet area is open from 10am to 4.30pm in the winter and 10am to 6.30pm in the summer.

The main entrance to the 22 hectare (54 acre) Woolton Woods is on High Street and is known as Coronation Drive, being dedicated to King George V on his accession to the throne. This delightful park, given Green Flag status in 2003, has many wild animal habitats and is a source of food for wild birds ensuring a year round variety of wildlife.

There are regular Ranger led walks and talks informing visitors of the fauna and flora of the park along with a history of the park and its environs. Woolton Woods can also be accessed by walking up Camp Hill from Menlove Avenue. The main park is open 24 hours a day all year round.

See also: **Parks and Gardens**

CENTRAL LIBRARY
(The first city centre public library in the United Kingdom)

Liverpool's Victorian Central Library was built in the 1850s, making it the first city centre public lending library in the UK. At that time it was known as the William Brown Library.

William Brown, a local Member of Parliament, was instrumental in the building of the library and museum. In 1855 he donated the sum of £6,000, with the Town Council adding a further £10,000 towards the cost. When the project encountered financial difficulties, Brown donated a further £35,000 to ensure its completion. Along with a high concentration of notable public buildings, the library is situated on William Brown Street, now in the principal cultural quarter of the city.

The library is now a complex of three buildings and is one of the largest libraries in the country. From 1875-1879, work was

undertaken to add the magnificent Picton Reading Room. It has a drum-like structure, earning it the unfair early nickname of 'Picton's Gasometer', and is surrounded by detached Corinthian columns with an elegant entablature (the part above the columns having an architrave, a frieze and a cornice) and a domed roof. The reading room was intended to function like the British Museum Reading Room and the interior dome is said to be second only to that of the British Museum. It was named after Sir James Allanson Picton, chairman of the Libraries and Museums Committee and designer of Picton Clock Tower, High Street, Wavertree.

In 1906 the Hornby Library was added to the rear and, like the rest of the library, is now a Grade II* Listed Building. It was named after Hugh Frederick Hornby (1826-1899), a local merchant whose book collection, along with a sum of money to house it, was donated to the city on his death.

In the 1970s, a seven floor extension was added to the library to create more space, especially for its archives and exhibitions. The archives consist of millions of documents including Liverpool's charter, birth certificates, school registers and details of people who emigrated from the city. The archives have been digitised and are available on the internet.

☎ 0151 233 5835
🖥 central.library@liverpool.gov.uk

See also: **Blue Plaques**; **Picton Clock Tower**; **Picton Reading Room** and **William Brown Street**

CHILDE OF HALE
(John Middleton – a giant of a man)

On the outskirts of Liverpool lies the old and picturesque village of Hale and, although it is in the county of Cheshire, it does have a Liverpool post code.

John Middleton, the Childe of Hale, was born in Hale some time in the 1570s. Legend has it that he was a normal sized young man who grew to the height of nine feet three inches (2.82m) in a single night. One version of this folk tale is that he sketched the outline of an enormous figure in the sand on the bank of the River Mersey, just a short walk away from the village. He then lay down in the figure and fell asleep and when he awoke he found, to his amazement, that he had grown to fill the outline of his sketch.

John Middleton's enormous height brought him some local celebrity and he attracted the attention of the local landlord, Gilbert Ireland who, according to legend, employed him in various capacities including that of a bodyguard. In 1617 the newly knighted Sir Gilbert took the Childe to London. There he was taken to the court of King James I and invited to fight the king's champion, a wrestler. As might have been expected, the Childe was the victor and the king's champion was not only beaten by this newcomer, but he had his thumb put out as well.

King James rewarded the victorious Childe with a gift of £20, which was a substantial sum in the 17th century, but sadly not as much as Sir Gilbert had hoped would be bestowed on his rather tall protégé. John Middleton was allegedly robbed on his homeward journey, no doubt by a number of men.

Over the years there has been much debate about the Childe's actual height. In 1768 a certain Mr. Bushell, the parish clerk and local schoolmaster, exhumed the bones of the Childe in an attempt to verify his height. He recorded the length of the thighbone as

'from the hip of an average sized man to his foot'. If you want to get an idea of the Childe's vast size, visit Speke Hall, a nearby National Trust property, where there is a life-sized portrait of John Middleton in his extravagant outfit with lace ruffles round his neck and hands, a striped doublet, a blue girdle embroidered in gold and a broad blue and gold belt, worn over shoulder to support a sword. He also wore green stockings, large white plush breeches covered with blue flowers and shoes with red heels and shoe laces.

In 1623 John Middleton died in the village where he was born and his grave can be seen in the local churchyard of St. Mary's. As the Childe had his winnings stolen from him on his return to Cheshire, it is said that he ploughed the fields for the rest of his life.

From the pub, appropriately named 'The Childe of Hale', take a short stroll into the old village and you will come upon the house where the Childe actually lived. There are two small windows on the upper floor from where, according to local legend, his feet protruded as he lay in bed. You will also see a modern tree carving of him opposite the churchyard where he is buried in a suitably large grave.

If you do venture into the graveyard whilst visiting Hale, look out for a tombstone bearing a skull and cross bones on one of the graves, that of Richard Norris, one time owner of Speke Hall.

See also: **Speke Hall**

CHINATOWN
(The oldest Chinese community in Europe)

Liverpool's Chinese community is the oldest in Europe. It began as the result of the trade links between Britain and China, the first vessel arriving in 1834 directly from China carrying goods such

as silk and cotton wool. Sailings from Singapore to Liverpool increased when the Holt Ocean Shipping Company established the famous Blue Funnel Shipping Line. In the latter half of the 19th century many Chinese sailors decided to settle in Liverpool where they could start businesses that would, amongst other things, cater for their fellow countrymen arriving in the port.

The bombing of Liverpool during the Second World War was responsible for the destruction of a great part of Chinatown, but the community remained and established many new projects including the Chinese Language School and The Liverpool Chinese Gospel Mission. In 1944 Britain's first Chinese newspaper, the Hua Chow Pao (Chinese News Weekly), was published in Liverpool.

Chinese New year is always celebrated in style and provides great entertainment for the crowds who come to see the street entertainers, musicians and dancers along with parades featuring local people dressed in the mythical costumes of lions and dragons. At this time of year the houses and restaurants are traditionally cleaned and then decorated with flowers - "Kung Hey Fat Choy" (Happy New Year).

See also: **Chinese Arch**

CHINESE ARCH
(The biggest outside of Asia)

The building of the Chinese arch at the end of Nelson Street was a Liverpool initiative. Craftsmen from Liverpool's sister city, Shanghai, were imported to build this gateway to China Town. The construction was completed in 2000 and it is claimed to be the biggest Chinese arch outside of Asia.

See also: **Chinatown**

CHURCH STREET
(At the hub of the shopping centre)

Church Street is so named because St. Peter's Church, consecrated on 29th June 1704, stood here until 1922. It is said to have been the first church to be built in the newly formed Catholic Diocese of Liverpool and was used as its cathedral church. Before its demise, the churchyard was converted into a public garden after all the remains had been re-interred in Anfield Cemetery.

If you look carefully at the paving flags in Church Street you will find a stone slab from the original steps of the church. It has a small brass Maltese Cross set into it which marks the site of the Church. Once found, look at the top windows of the adjacent building and you will see the carved cross keys of St. Peter.

Church Street was the site of the very first 'F. W. Woolworth 3d and 6d Store' in the United Kingdom. Sadly, there is nothing to left to commemorate this fact, but a 'Woollies' still remains in the city centre.

CLAIMS TO FAME
(Things that no other city can boast)

Many of the towns and cities of Britain can make some sort of claim to fame , but Liverpool has an abundance of titles to its name. During the past several hundred years, the City of Liverpool has been associated with a wealth of 'firsts' in a variety of fields.

- In 1648 the first recorded cargo from America landed at Liverpool docks;
- Liverpool had the first integrated dock system in the world;
- The first tram system in the world operated in Liverpool docks;

- In 1840 the world's first scheduled transatlantic passenger service left Liverpool docks;
- In 1893 the world's first electric overhead railway was opened at Liverpool docks. It was also the first to be protected by automatic electric signals;
- The Albert Dock was the first building in the country to be built entirely of cast iron, brick and stone with no structural wood;
- With cargo being imported into Liverpool from all over the world it became the world's first truly global city.

See: **Albert Dock**

- The first mosque in England was built in Liverpool;
- Liverpool is the home to the oldest Muslim society in the country.

See: **Al-Rahma Mosque**

- The first public park in the world was built across the river from Liverpool.

See: **Birkenhead Park**

- Liverpool is the home of Britain's first community arts project. Great Georges Community Cultural Project was established in 1968 and is affectionately known to locals as the 'Blackie'.

See: **The 'Blackie'**

- Britain's first arts centre was opened in Liverpool.

See: **Bluecoat Chambers**

- Liverpool was chosen as the first city outside of London to have commemorative blue plaques placed on buildings.

See: **Blue Plaques**

- Liverpool was the destination of the world's first package tour;
- Liverpool Airport was the departure point for Britain's first package holiday flight.

See: **Buildings Worthy of a Second Look (Lime Street Station and Speke Airport)**

- Britain's first lager brewery was established in Liverpool.

See: **Cains Brewery**

- Liverpool's Central Library was the first city centre public lending library in the UK.

See: **Central Library**

- Britain's first Chinese newspaper, the Hua Chow Pao (Chinese News Weekly), was published in Liverpool.

See: **China Town**

- Britain's first branch of 'F.W. Woolworth's 3s and 6d Store' was opened in Liverpool.

See: **Church Street**

- Liverpool's Conservation Centre was the first of its kind in the world and is the only one open to the public.

See: **Conservation Centre**

- The first passenger railway station in the world was built in Liverpool;
- Liverpool was one of the termini of the very first passenger railway line;
- Liverpool had the world's first railway shed;
- Liverpool MP William Huskisson was the world's first railway fatality.

See: **Edge Hill Station**

- Liverpool is the home of Britain's first skyscraper, built using a revolutionary steel and reinforced concrete structure.

See: **Liver Building**

- Liverpool had the first lending library in Europe.

See: **Lyceum**

- The Transatlantic Slave Gallery in the Merseyside Maritime Museum was the first of its kind in the world.

See: **Merseyside Maritime Museum**

- The first car to come off the production line of the Ford Car Company, Halewood is preserved in the city of Liverpool.

See: **Museum of Liverpool**.

- Liverpool appointed the country's first Medical Officer of Health, Dr. W. H. Duncan;
- In 1790 the world's first American Consul, James Maury, was appointed to Liverpool by George Washington.

See: **Rodney Street**

- The world's first iron church was built in Liverpool.

See: **St. George's Church**

- The world's first air conditioning system was built into St. George's Hall;
- The world's first public reading of 'A Christmas Carol' was given in the Small Concert Hall of St. George's Hall by the author, Charles Dickens.

See: **St. George's Hall**

- Liverpool was chosen as the site of the first Tate Gallery outside of London;

- Liverpool was chosen as the venue for the first Turner Prize held outside of London.

See: **Tate Liverpool**

- The first School of Tropical Medicine in the world was built in Liverpool. It was founded in 1898 using a donation of £350 from a Liverpool shipowner;

- The first British Nobel Prize was awarded to Professor Ronald Ross of the Liverpool School of Tropical Medicine in 1902 for discovering that malaria is transmitted to humans by mosquitoes;
- The first drugs for treating malaria were developed at the Liverpool School of Tropical Medicine;
- Richard Caton discovered the existence of electrical brain signals, sometimes referred to as brainwaves, whilst working in the medical school;
- In 1896 an X-ray was used for surgical purposes for the first time in the country. It took place in the Physics Department of the University College of Liverpool when Professor Oliver Lodge used it to show a bullet in a boy's wrist;
- Professor Lodge also developed radio tuning and electric spark ignition for the internal combustion engine.

See: **University of Liverpool**

- In 1715 The 'Old Dock' was opened, becoming the first wet dock in the world.

See: **Waterfront**

- In 1842 the very first public baths and wash houses in the world were built in Liverpool.

See: **Wilkinson, Kitty**

- Britain's first public planetarium was built in Liverpool.

See: **World Museum**

Many of Liverpool's claims to fame are to do with dimensions of some sort.

- Liverpool has the largest brick building in the world;
- Britain's largest group of Grade I Listed Buildings is in Liverpool;
- In its heyday Liverpool was the world's greatest port city.

See: **Albert Dock**

- Liverpool is said by many to be the home of the largest Anglican Cathedral in the world though this fact is in dispute. It is, however, definitely the largest Anglican cathedral in Europe;
- Liverpool's Anglican cathedral is the largest cathedral in Britain and the fifth largest cathedral in the world:
- The largest working church organ in the world is in Liverpool's Anglican Cathedral;
- The Anglican Cathedral's ringing peal of bells is the heaviest and highest in the world;
- The highest gothic arches ever built can be found in the Anglican Cathedral.

See: **Anglican Cathedral**

- On its completion Lime Street Station's Northern Train Shed had the largest ceiling span in the world.

See: **Buildings Worthy of a Second Look (Lime Street Station)**

- On the completion of its expansion in 1907 Liverpool had the largest brewery in Europe.

See: **Cain's Brewery**

- Liverpool is the home of one of Europe's largest Chinese communities.

See: **Chinatown**

- The largest Chinese Arch outside of Asia can be found in Liverpool.

See: **Chinese Arch**

- When the present Empire Theatre opened in 1925 it had the largest stage in Britain;
- The Liverpool Empire is the largest two tier theatre in the country;

See: **Empire Theatre**

- It has been claimed that the clock in the Royal Liver Building is the largest in Britain.

See: **Liver Building**

- World's largest robotic telescope, the Liverpool Telescope is owned and operated by Liverpool John Moores University. It is used by schools throughout the UK and astronomers all over the world.

See: **Liverpool Telescope**

- The largest panel of stained glass in the world can be found in the Metropolitan Cathedral.

See: **Metropolitan Cathedral of Christ the King**

- At the time, the construction of the first Mersey road tunnel was the largest engineering feat in the world;
- When it was completed the Queensway road tunnel

under the Mersey was the longest underwater road tunnel in the world.

See: **Queensway**

- On its completion St. George's Hall housed the largest pipe organ in Britain.

See: **St. George's Hall**

- England's smallest house was built in the passageway between two Liverpool establishments.

See: **Smallest House in England**

- In its heyday, Liverpool's floating landing stage was the largest floating structure in the world.

See: **Waterfront**

Age has its part to play when it comes to some of the claims to fame that are made by the city.

- Liverpool Black Community is the oldest continuous black settlement in the country.

- Liverpool is the home of the UK's oldest Muslim society.

See: **Al-Rahma Mosque**

- Liverpool has oldest Chinese community in Europe.

See: **China Town**

- Liverpool has oldest ferry service in the world.

See: **Ferries**

- Liverpool is home to the oldest working Swedish church out side of Sweden.

See: **Gustav Adolfus Kyrka**

- The oldest concert-giving organisation in the world is the Royal Liverpool Philharmonic Orchestra.

See: **Philharmonic Hall**

- Liverpool was the home of the oldest repertory company in Britain until 1999 when it was wound up.

See: **Playhouse Theatre**

At times, the multitude of diverse claims to fame that this great city is able to make seem almost endless. Here, we offer you a few more of them to whet your appetite for exploring and discovering the city of Liverpool.

- Liverpool is the home of the most famous horse race in the world, the Grand National.

See: **Aintree Racecourse** and **Grand National**

- Britain's top heritage attraction is in Liverpool;
- The docks at Liverpool can claim to be the most famous in the world;
- During the mid 19th century, Liverpool was classed as the most important seaport in Britain.

See: **Albert Dock**

- Liverpool is one of the few cities in the country to have two cathedrals.

See: **Anglican Cathedral** and **Metropolitan Cathedral of Christ the King**

- During the Second World War Liverpool was used as the repository for the nations gold bullion.

See: **Buildings Worthy of a Second Look (Martins Bank)**

- Liverpool has over 2500 listed buildings, the largest number outside of London.

See: **Buildings Worthy of a Second Look**

- In the 18th century, Liverpool was the heart of the country's watch making industry and it was here that Peter Litherland invented and patented the rack lever escapement. It was centred on the site of Lewis's, a large department store, now the home of our famous Epstein statue.

See: **Epstein Statue**

- The only major public gallery that still houses the collection it was originally built for is not far from the other end of Liverpool's first road tunnel under the Mersey.

See: **Lady Lever Art Gallery**

- The UK's largest festival of contemporary visual art is held in Liverpool.

See: **Liverpool Biennial**

- Outside of the capital, Liverpool has the most monuments and statues in the country.

See: **Monuments and Statues**

- Liverpool has the only national collection of museums and galleries based outside of London.

See: **National Museums Liverpool**

- Liverpool has the finest orchestral hall in Europe.

See: **Philharmonic Hall**

- The UK's greatest maritime event is held annually in Liverpool.

See: **River Festival**

- Liverpool has more Georgian houses than Bath;

- Outside of the capital, Liverpool is the most used city film location in Britain.

See: **Rodney Street**

- Liverpool was the home of the 'Confederate Embassy' during the American Civil War.

See: **Rumford Place**

- Liverpool has the finest neo-classical building in Europe.

See: **St. George's Hall**

- Liverpool is the home of the Britain's only surviving merchant art collection.

See: **Sudley House**

- Liverpool claims to have, possibly the most beautiful synagogue interior in all of Europe.

See: **Princes Road Synagogue**

- The major centre for contemporary art in northern England is housed in Liverpool.

See: **Tate Liverpool**

- Liverpool is one of the few cities in the country to have three universities;
- In the late 1940s Liverpool University had the most powerful particle accelerator outside of America, a synchrocyclotron.

See: **University of Liverpool**

- The National Gallery of the North is based in Liverpool.

See: **Walker Art Gallery**

- Liverpool's waterfront, docks and parts of its commercial district have been designated a World Heritage Site by UNESCO.

See: **Waterfront**

- During WWII Winston Churchill had the headquarters of the Battle of the Atlantic transferred to Liverpool.

See: **Western Approaches Museum**

For those who enjoy trivia we offer you a few more titbits of information.

- In 1679 the world's first charity for sailors is said to been founded by the Mayor of Liverpool;
- It is claimed that in 1776 the first public use of ether as an anaesthetic was made in Liverpool;
- In 1786 Liverpool had Europe's first purpose-built prison at Great Howard Street;
- In 1812 the first balloon ascent in Britain was made by the intrepid J. Sadler of Liverpool. He continued flying until 1824, when he was 'thrown out of his balloon near Blackburn, causing his death'. This was also the year when Spencer Percival was shot by John Bellingham, a bankrupt Liverpool merchant. Percival is the only British Prime Minister to have been assassinated;
- Liverpool opened the world's first school for the deaf in 1825;
- In 1841 the Society for the Prevention of Cruelty to Animals was founded in Liverpool. This was later to gain royal approval and become the RSPCA;
- In 1857 the Liverpool Chess Club was the first of its kind in Britain. This was the same year in which the *Niagra* sailed from Liverpool to lay the North Atlantic Telegraph Cable;

- It is claimed that in 1861 the first shot in the American Civil War was fired from a gun produced by Fawcett and Preston of Liverpool;
- It is said that Britain's first cycling club, the *Liverpool Velocipedes* was formed in 1867; in this same year Liverpool Corporation purchased Britain's first steamroller;
- In 1883 T.F. Agnew and Samuel Smith founded the Liverpool Society for the Prevention of Cruelty to Children. This went on to gain national status, becoming the NSPCC;
- It is claimed that in 1886 Liverpool's Northern Hospital took delivery of the first purpose-built ambulance in Britain;
- In 1889 Liverpool's Police Force is thought to have been the first to have been issued with rubber soled boots for night duty. This was presumably to prevent them waking slumbering law-abiding citizens, as well as enabling them to sneak up on any nefarious characters prowling the streets in the dark;
- Hatton Garden Fire Station is said to have taken possession of Britain's first motor fire tender in 1902;
- On 22nd February 1907 the world's first scout group, the Birkenhead 1st, was formed. This was the same year in which Cunard's *RMS Lusitania* made its maiden voyage from Liverpool to New York;
- In 1924 Britain's first hyperbolic cooling tower was constructed at Lister Drive Power Station;
- 1959 saw the opening of Britain's first drive-in bank in Prince's Road;
- In 1963 when Ford opened its assembly plant in Halewood it was the world's largest car factory under one roof;
- In February 2008 the country's highest restaurant was reopened in Liverpool's regenerated city centre.

Diners on the 30th floor have a panoramic view of the city skyline from a height of 100 metres (328ft);

- Liverpool Prison, Walton Jail, is the largest in Western Europe , but do bear in mind that this is because it takes criminals from all over the UK and not just from the city of Liverpool.

CONSERVATION CENTRE
(The first of its kind in the world)

Liverpool's Conservation Centre was created specifically for the conservation of the multitude of objects in the collections of its national museums. It is the first National Conservation Centre in Britain, the first of its kind in the world and the only one open to the public. The centre is housed in the former Midland Railway Goods Offices, a Grade II Listed Victorian warehouse in Whitechapel. After major conversion work the Conservation Centre was opened in December 1996 by HRH Charles, The Prince of Wales.

This award winning centre specialises in laser cleaning. The centre has undertaken many restoration and preservation tasks since it came into being, most notably the restoration of the Nelson Monument in Exchange Flags and the statue of Peter Pan in Sefton Park. The bas-reliefs on the exterior of St. George's Hall have been restored by the Conservation Centre, using a combination of traditional means and laser technology.

The centre not only conserves artefacts owned by National Museums Liverpool on Merseyside, but restores articles from all over the world. By the very nature of the work undertaken at the centre, the exhibitions are constantly changing, but there is always something interesting on display.

Conservation and restoration are not the only tasks completed at the centre. The Ship and Historic Models Conservators have recently restored and completed a model of the Catholic Cathedral, originally designed by Sir Edwin Lutyens for the city of Liverpool. The model is almost 15 feet (4.6m) high and over 20 feet (6m) long and is exact in every detail, with the smallest of details being replicated, making it one of the biggest and most elaborate architectural models ever made. Not surprisingly the construction is often referred to as Liverpool's third cathedral. The model is on a scale of 1 to 48 making every ¼ inch (0.64cm) represent 1 foot (30.5cm).The project, with its painstaking work, took thirteen years to complete and it is hoped that this will be put on permanent display in the Museum of Liverpool Life.

The model seems rather large, but if a lack of funds and the onset of the Second World War had not prevented the cathedral being constructed, it would have stood a majestic 520ft (158.5m) high making it larger than St. Peter's in Rome and St. Paul's in London.

The centre is open every day from 10am to 5pm and entry is free. It also hosts various open days during the year, when members of the public are allowed behind the scenes where the majority of the work is carried out. Booking is required for the open days.

☎ 0151 207 0001
💻 www.liverpoolmuseums.org.uk

See also: **Exchange Flags**, **Museum of Liverpool Life**; **National Museums and Galleries on Merseyside; Sefton Park; St. George's Hall** and **Walker Art Gallery**

CROXTETH COUNTRY PARK
(The country estate of the Earls of Sefton)

Croxteth Country Park is all that remains of the once vast estate of the Earls of Sefton. The park covers some 500 acres (202 hectares), but the estate originally stretched over hundreds of square miles. Apparently, the family were rather fond of gambling but, unfortunately, were not very successful, as over the generations portions of their land had to be sold off in order to generate an income and, presumably, pay off debts.
The estate has four main attractions:

- **Croxteth Hall** - a visit to the Grade II* Listed Hall gives you a flavour of how life was like 'upstairs and downstairs' in bygone years. Here you can see the opulence and luxury enjoyed by the family and take time to reflect on the life of the not so fortunate servants.

- **Croxteth Home Farm** – on this working traditional Victorian farm are cows, ducks, hens, horses, pigs and sheep. There are collections of rare farm breeds of the past and small animals and throughout the year there are demonstrations, displays and special events.

- **Victorian Walled Garden** – in this sheltered space surrounded by the heated flue walls, vegetables and soft fruit were grown for the household. The garden contains trained fruit trees, a mushroom house and greenhouses containing tropical fruit, exotic plants and cacti. The garden has hardly been touched by time and retains many of its original features. Throughout the year there are demonstrations, displays and special events including the Garden Society Flower Show held during August.

- **Croxteth Country Park** – an ideal place for a

countryside stroll though only six miles away from the bustling city centre. Here the landscape has remained much the same for the last hundred years. There are guided tours of the park on Wednesday and Thursday afternoons and the last Sunday afternoon of each month. There is an adventure playground for children under the age of thirteen. Admission to the park is free of charge.

The estate is one of the major heritage centres in the North West and is the home to four Grade II* Listed Buildings, including the Hall itself, and 15 Grade II Listed Buildings. Events held in the park include full scale historical enactments and a traditional country fair. Details of events and walks can be found on the parks events calendar.

There is a charge for entering the Hall, Home Farm and the Walled Garden, but for visitors who want to spend a day at the park and visit all the attractions, a saving can be made by purchasing an all inclusive ticket.

☎ 0151 233 6910
💻 www.croxteth. co.uk

See also: **Croxteth Hall** and **Parks and Gardens**

CROXTETH HALL
(Take a glimpse at life 'above' and 'below' stairs)

Since the 16th century, generations of the Molyneux family, the Earls of Sefton, have lived at Croxteth Hall. On the death of the last earl in 1972, the Hall and estate have been managed by Liverpool City Council. The building of the original Hall started in 1575 and, over the years, it has grown to the hall seen

today. In 1902, the last building work, other than maintenance, was finally completed and the Hall attracts thousands of visitors every year.

The Molyneux family often hosted country house parties, particularly in the Edwardian era, when royalty and society figures came to stay. This stately home featured in the filming of the popular television series of the 1960s, 'The Forsyte Saga'. Visiting the Hall shows how the family lived in luxurious surroundings, being waited on hand and foot by their many servants. It also lets you appreciate the completely different lifestyle of the hard-worked staff who had to rise early every morning in order to cater for the many needs of the family. Everything had to be done to the high standard that the housekeeper and butler demanded and the family expected. On Sunday and Wednesday afternoons, costumed heritage volunteers are in the hall to answer any questions.

Be careful with timing, as the Hall is closed to the public during winter months for essential maintenance work. There is an entrance charge to view the historic Croxteth Hall, which can also be hired for functions including conferences and weddings.

☎ 0151 233 6910
💻 www.croxteth. co.uk

See also: **Croxteth Country Park**

CUNARD BUILDING
(One of the Waterfront's Three Graces)

The Cunard Building, the third 'Grace' on the city's famous waterfront, was erected during World War I in the style of an Italian palazzo with Greek revival details. It was built as the

headquarters of the Cunard Steamship Company, which was initiated by the Canadian Samuel Cunard to service North America. Cunard's ships carried mail and passengers across the Atlantic, beginning with the paddle steamer Britannia in 1840 and continuing until 1966.

The impressive building is somewhat overshadowed by the other two 'Graces', the Liver Building and the Port of Liverpool Building, but you cannot fail to miss its impressive proportions, nor can you miss the Cunard Memorial outside.

It was in the boardroom of this Grade II* Listed Building that the decisions were made to build the *Queen Mary* and, subsequently, the *Queen Elizabeth*.

See also: **Liver Building, Port of Liverpool Building** and **Waterfront**

DICKENS, CHARLES
(A Special Constable in Liverpool)

The journalist and author Charles Dickens (1812-1870) often performed sell-out readings of extracts from his novel during his many visits to the city. Recitals and theatrical performances took place at venues such as the Philharmonic Hall and the prestigious St. George's Hall. To fill buildings such as these would have taken many people who were prepared to part with their money in order to see the great man himself. These performances became known as 'Penny Readings', as Dickens insisted that the entrance fee was just one penny (1^d, one pre-decimal penny, equivalent to 0.42p) so that all social classes could attend. A penny was still a considered quite an amount of money by many of Liverpool's poor.

Dickens's popularity was such that when he made his last visit to the city in 1869, a banquet was held in his honour at St. George's Hall to celebrate the fact that he was being made an honorary member of the Literary and Philosophical Society. On this auspicious occasion members of the public actually paid for the privilege of watching him dine.

On one of the occasions that Dickens visited Liverpool, which he described as "that rich and beautiful port", he enrolled as a special constable in the city centre to help him with his research for his novels. While in the city he preferred to stay at the Adelphi Hotel (the original building), which he thought to be the best in the world. No doubt he stayed there in 1844, when he was invited to chair the annual Christmas Soiree of the Mechanics School of Arts, now the Liverpool Institute for Performing Arts.

See also: **Adelphi Hotel, Jalon's Bridewell, Liverpool Institute for Performing Arts; Philharmonic Hall, Metropolitan Cathedral of Christ the King; Rumford Place** and **St. George's Hall**

ECHO ARENA LIVERPOOL
(A multi-use centre)

Planning permission for development of a site on the Kings Waterfront was granted by the City Council in December 2004, allowing the building of a world class arena and conference centre. The multi-use arena has seating for over 9000 people and is linked to the conference centre by a glazed Galleria. There is also a glazed concourse around the perimeter of this two building complex, along with a divisible auditorium that can to accommodate 1350 visitors and a total of 7500m^2 (8,970 square yards) exhibition space. A landscaped piazza was created for outdoor events and

performances. The whole complex, known as the 'Civic Facilities', is illuminated at night to help create a landmark addition to the spectacular Liverpool Waterfront. With the construction of the arena, the Summer Pops are now able to take place indoors. Prior to this they had been held on this former dock site for many years, making do with a temporary tent structure.

The development has office space, residential accommodation, retail and leisure floor space and a multi-storey car park. A pedestrian link provides easy access to the Albert Dock. The £164 million arena was officially opened on 12th January 2008.

See also: **Albert Dock**; **Summer Pops** and **Waterfront**

EDGE HILL STATION
(The first passenger railway station in the world)

Edge Hill Station, off Tunnel Road, may be a plain classical two storey sandstone building, but it is definitely worth seeing, even if it is just so that you can impress your friends and relations by claiming, "I've seen the first passenger railway station in the world."

Following the resounding success of his now famous black and yellow Rocket in the Rainhill trials of 1829, George Stephenson was given the task of constructing the Liverpool to Manchester railway. He decided to locate the terminus in Edge Hill and, consequently in 1836, Edge Hill Station, was built using ashlar (square-hewn stone). The twin buildings by the edge of the railway tracks was extended in 1847, no doubt as a result of the popularity of this new and successful mode of transport. The line was eventually extended to Lime Street through tunnels and deep stone cuttings. It was during the construction of his railway that George Stephenson allegedly encountered Joseph Williamson,

the 'Mole of Edge Hill'. This railway line was used by the passengers on the first package tour in the world. British Rail and the Historic Buildings Council restored the station in 1979, but, sadly, this Grade II* Listed Building is no longer in use.

Liverpool had the world's first railway train shed and the world's first published railway timetable, 'Lacy's'. A Liverpool MP, William Huskisson, became the world's first railway fatality when he was knocked down by George Stephenson's Rocket at the official opening of the Liverpool and Manchester Railway. He was apparently crossing the track to talk with the Duke of Wellington when the incident occurred. It is highly unlikely that we will ever find out what he wanted to say to the great and noble statesman or, indeed, if it was of any significance. Huskisson is buried in a mausoleum in St. John's Mount and Gardens.
In 1867 Liverpool was able to claim that it was the home of the world's largest train shed, measuring 200 ft (61m).

See also: **Lime Street Station**; **Mole of Edge Hill** and **St. John's Mount and Gardens**

EMPIRE THEATRE
(The largest two tier theatre in the country)

Being situated on Lime Street, part of the William Brown Conservation area, puts the Empire Theatre in the major cultural region of the city. The present Empire building is the largest theatre in the city and the largest two tier theatre in Britain.

The theatre opened as the Prince of Wales Theatre and Opera House in 1866, a significant time for the city as the Playhouse Theatre also dates from that year. In 1867 the theatre was renamed the Royal Alexandra Theatre and Opera House in honour of the Princess of Wales.

The theatre closed down in 1894 only to be re-opened in 1895. It still retained the Alexandra name, but it was now under the ownership of the Empire Theatre Limited. In 1896 the theatre was renamed the Empire by its new owners, Moss & Thornton. In 1924 the Empire closed and a new theatre was built on its site.

The present Grade II Listed Building opened in 1925, when it was able to claim that it had the largest stage in Britain, being 160 feet (48.8m) wide and 40 feet (12.2m) deep. During its long history the Empire has hosted many world famous artists and in 1963 was the venue for a Royal Command Performance. When the city was celebrating its 800th birthday in 2007, the theatre was once again chosen. The Empire Theatre is currently owned by Clear Channel Entertainment.
This popular venue continues to host a wide variety of entertainments, including plays and children's pantomines.

See also: **Playhouse Theatre**; **Theatres** and **William Brown Conservation Area**

EPSTEIN STATUE
('Liverpool Resurgent')

Leaving the old-world charm of the Adelphi Hotel, it is worth pausing to view the sculpture that adorns Lewis's Department Store on the corner of Ranelagh Street and Renshaw Street. This marvellous statue, 'The Spirit of Liverpool Resurgent', by Sir Jacob Epstein (1880-1959), is known affectionately to natives of Liverpool as 'Dickie Lewis'. It is also known as 'The Spirit of Youth.' As the statue is a rather large 18.5 feet (5.67m) in height, ponder on its wondrous proportions. The statue's obvious nakedness is celebrated in the popular folk song 'In My Liverpool Home'.

A black plaque on the Renshaw Street side of the store celebrates that Peter Litherland (1756-1805) had his work shop on the site of the building. He was a watchmaker and inventor and in 1791 patented the rack lever escapement for watches. This replaced the commonly used verge escapement, making timepieces more accurate. Presumably he was not the only watchmaker who had a workshop on the site, as at that time Liverpool was the heart of the watch making industry in the country.

See also: **Adelphi Hotel** and **Monuments and Statues**

EVERTON LOCKUP
(The oldest jail in Liverpool)

This conical roofed structure on Everton Brow, was built in 1787, making it the oldest building in Everton and the oldest jail in Liverpool. In its early days it stood at the west end of the village close to Shaw Street. It is also known as Rupert Hill Castle and legend has it that this name comes from the time when Prince Rupert fought with Oliver Cromwell's Roundheads, then in possession of the town.

Tradition has it that, like Wavertree Lockup, it was used to house for the night anyone who had imbibed a little too much alcohol and had become a nuisance.

See also: **Wavertree Lockup**

EVERYMAN THEATRE
(The cutting edge of theatre)

Hope Hall, originally a church in Hope Street, started life with a small horseshoe balcony, which made it ideal location for concerts

and various events. There came a time when need for this particular place of worship was not what it used to be and, in 1912, the church was converted into a cinema to cater for this latest craze.

In the early 1960s, the building was eventually made suitable for stage use. It was renamed the Everyman Theatre in 1964, when it had an apron stage installed, along with new seating and dressing rooms. The theatre received another makeover in 1977, when a section of the auditorium floor was excavated to create a flexible performance area. The chapel façade has been replaced with stone and glass panels. The theatre has a thrust stage with seating on three sides, with pews from the original Hope Hall forming part of the seating on the two sides.

Situated in an area of the city that has quite a bohemian atmosphere, the Everyman tries to promote plays written by and involving local people and has gained a reputation for staging ground breaking and cutting edge works.

If visiting the theatre gives you an appetite, there is a bistro beneath the stalls. Established in the early 1970s the bistro has gained a formidable reputation for good value for money fare.

💻 www.everymanplayhouse.com

See also: **Theatres**

FACT LIVERPOOL
(Foundation for Art and Creative Technology)

The contemporary arts centre, FACT, 88 Wood Street, Liverpool 1, was the first purpose built arts project to be undertaken in the city in over 60 years. It is dedicated to the promotion of film, video as well as new and emerging media forms and is the UK's

leading agency for the commissioning and presentation of media art. FACT, a registered charity, accommodates two impressive galleries specifically for temporary exhibitions by noteworthy international artists as well as Picturehouse, comprising three cinemas incorporating the most up to date technology, which screen Arthouse and independent films.

FACT is also the home of MITES, an acronym for the Moving Image Touring and Exhibition Service. MITES is a medialab providing artists with state of the art technology and is a resource that is used by museums and galleries throughout the country. Working in conjunction with the architects, FACT commissioned a number of artworks to form part of the building, act as a response to it. The zinc-panelled exterior with its interactive lighting system and the Singh Twin's lightbox portraits alongside the entrance are fine examples of this collaboration.

The building's café and bar hosts a film quiz every two weeks and monthly poetry evenings. It also offers a variety of board games with which to amuse yourself should the fancy take you. The centre is licensed throughout.

Like the Open Eye Gallery, situated on the same street in the trendy Ropewalks area, the FACT Centre plays host as one of the main venues for the UK's largest contemporary visual art festival, the Liverpool Biennial. The FACT Centre has facilities to cater for private functions and events.

☎ 0151 707 4450
💻 www.fact.co.uk

See also: **Liverpool Biennial**, **Open Eye Gallery** and **Ropewalks**

FERRIES
(The oldest ferry service in the world)

The very first ferries crossing the Mersey came from Birkenhead Priory in the 12th century, when the Benedictine monks who had settled there would row across the river to trade their goods in the markets of Liverpool. They also started taking people from Eastham across to Liverpool, creating a passenger ferry. Later on in the early 14th century, King Edward III granted the monks the first ferry rights. It is thought that the monks landed their boats near to Otterspool, an old fishing creek where the present day Otterspool Promenade is situated.

Over the years, the ferry services have carried passengers to and from Eastham, Egremont, New Brighton, New Ferry, Rock Ferry, Seacombe, Tranmere, Wallasey and Woodside (Birkenhead). The ferry service started of with wooden rowing boats and progressed through wooden sailing ships and wooden paddle steamers before moving on to steam vessels. The present day ferries that grace the waterfront are diesel-electric powered.

There is quite a history to the Mersey Ferries, with the *TSS Iris* and *TSS Daffodil* being put into military service during the First World War. When they resumed peacetime service, they were renamed *Royal Iris* and *Royal Daffodil*. Even though the boats have been replaced several times, these names have been preserved.

The *Royal Daffodil II* met its fate when it was sunk at its moorings in Seacombe during the Blitz of Liverpool during the Second World War. The 1950 *Royal Iris* was sold in 1991 and now spends her days on the River Thames in London. The 1958 *Royal Daffodil* is in service in Greek waters under the name of *Ioulis II*.

With the advent of railways and the Mersey Tunnels, the use of the ferry service gradually declined and at one point these world famous ferries were in grave danger of being completely

abandoned. Luckily the much loved ferries survived and now provide one of the most popular tourist attractions in the North West of England.

The present day ferries travel to Woodside in Birkenhead and Seacombe in Wallasey. They usually operate from a floating landing stage, but when it sank in March 2006, they transferred to the adjacent Isle of Man ferry landing stage while waiting for the construction of a temporary replacement. In 2007 the new landing stage was opened and it is hoped that this will not suffer the same fate as its predecessor.

In addition to providing a valuable passenger service, Mersey Ferries also have regular cruises presenting an excellent opportunity to see the sights and learn about Liverpool and the region's history. The River Explorer Cruise takes you along the waterfront past Birkenhead Priory, going as far as Otterspool on its 50 minute journey. From May to September you can take the six-hour Manchester Ship Canal Cruise, which travels along 35 miles of inland waterway to Salford Quays. Special cruises and events are also provided throughout the year.

Should you make your way to the ferry terminal at Seacombe, you will have the opportunity of visiting Spaceport, an interactive space experience which claims to be the ultimate journey through space and time, and the Aquarium dedicated to informing you about the marine life of the River Mersey.

For those with nautical tendencies or aspirations it is possible to charter one of the Mersey Ferries as a novel venue for a function of your choice.

🖥 www.merseyferries.co.uk

See also: **Birkenhead Priory**; **Mersey Tunnels**; **Mersey River**; **Otterspool Promenade** and **Waterfront**

FESTIVALS
(Annual local celebrations)

Throughout each year Liverpool plays host to a wide variety of events, festivals and celebrations, though it must be remembered that venues, dates and times can vary. If you want to attend any of theses contact local Tourist Information Centres. The activities include:

- Anthony Walker Festival;
- Arab Festival;
- Black History Month;
- Chinese New Year Festival;
- Grand National;
- Irish Festival;
- River Festival;
- Slavery Remembrance Day;
- Summer Pops;
- Tennis Tournament.

See also: Individual entries

FOSSIL TOUR
(Relieve the boredom of waiting for your flight)

If you are a scouser flying out of the city or a tourist returning home by plane leave yourself some time to participate in the Liverpool John Lennon Airport Fossil Mystery Tour.

Pick up a Fossil Mystery Tour guide from the airport's information desk and discover about the fossils which date back some 250 million years ago. They are preserved in the polished limestone slabs that have been used to floor the entire concourse in addition to decorating the walls.

Visitors to the airport once complained about the dirty marks on the floor, not realising what they were, so airport staff collaborated with a geologist from the Liverpool Geological Society to create the 'LJA Fossil Mystery Tour'. The fascinating continental fossils are in a very good state of preservation and are attractively displayed.

See also: **Ferries**; **Mersey River** and **Speke Hall**

GOREE PIAZZAS
(A place of safekeeping for your beer)

The Goree Piazzas were two gigantic blocks of warehouses. After fire destroyed the earlier buildings they were rebuilt in 1802, with each of the warehouses having an impressive arcade running the full length of the building. Washington Irving, the author of Rip Van Winkle, managed his brother's business from the Goree.

Local myth claims that slaves were once chained up at Goree Piazzas, but this is, in fact, completely untrue. The Piazzas had nothing to do with the Slave Trade, as they were built after slavery had been abolished. The large iron rings that were once there were actually used for chaining up hogsheads of beer, 54 imperial gallons (245.5l). The Goree is named after a slave island on the Senegalese coast of West Africa. Île de Gorée is close to the coast of Dakar lying approximately 1Km (0.6ml) from the city's harbour. It is part of Dakar itself, which is built on a small outcrop of land named Cap Vert. In 1978 it was designated a UNESCO World Heritage Sight and now serves as a memorial to the Slave Trade. This bare basalt island was used as a stopping off point for slaves before they were shipped to the plantations. It is only 45 acres (0.184km2) in area and at that time was practically devoid of drinking water.

The Goree Piazzas disappeared during the Blitz of Liverpool , but the iron rings survived for a while longer. The rings were eventually removed and all that remains is The Goree, a section of road, in front of the three Graces.

See also: **Three Graces**

GRAND NATIONAL
(The most famous horserace in the world)

Every spring, Aintree Racecourse hosts the most celebrated horse racing event in the world, the Grand National. Although nearly all the media attention is focused on the Saturday race, the meeting is actually a three day event:

- The Opening Day, on a Thursday, is usually held at a more relaxed pace and had a record attendance of 26,000 in 2004;
- Ladies Day has become one of the highlights of the northern social calendar, with everyone dressing to impress and possibly win the Style Contest;
- The Grand National is the climax of the three day meeting with the racecourse always being packed to capacity. The race attracts a global audience of over 600 million.

The very first Grand National in 1839 was not on the traditional Saturday , but took place on Tuesday 26th February. The idea for the race was conceived by Liverpool hotelier William Lynn and Captain Becher. The captain is commemorated with the jump known as 'Becher's Brook'.

The world famous course is just over 4½ miles (7.25km) long and takes approximately 10 minutes to complete. To facilitate

the race, Melling Road has to be closed to traffic and covered in sand to protect the horses' hooves. There are 30 fences to be jumped, 16 on the first circuit and 14 on the second. The tallest of the fences is 'The Chair', which is 5ft 2in (1.58m) in height with a six-foot (1.83m) ditch on the takeoff side.

The number of horses in the field has been as low as 10, in 1883, and as high as 66 in 1929. The least number of horses to complete this arduous race was two in 1928. In 1984 a record 23 horses made it to the finish line with their jockeys still in the saddle.

Many years ago, there was an additional attraction to the Grand National, known as Jump Sunday. On the Sunday before the actual meeting, members of the public were allowed onto the racetrack so that they could walk the famous course.

💻 www.aintree.co.uk
See also: **Aintree Racecourse**

GREEK ORTHODOX CHURCH OF ST. NIKOLAS
(A Byzantine style church)

As well as having our own Greek temple in Liverpool, we also have a more up to date Greek Church. In the heart of the Toxteth area of Liverpool can be found the splendid Byzantine style Greek Orthodox Church of St. Nikolas, designed by Henry Sumners and built in the latter half of the 1860's.

The Grade II Listed Building of brick with stone dressing is situated in Berkley Street very close to a major junction on Parliament Street and Britain's first drive-in bank. Although not tucked away, the church could very easily go unnoticed by the busy motorist. Pedestrians have a better opportunity to observe

the building and might be tempted to venture inside to view the magnificent décor.

See also: **Greek Temple**

GREEK TEMPLE
(Our own Hellenic mortuary chapel)

At St. James's Mount and Gardens at the Anglican Cathedral, you will see Liverpool's own 'Greek temple'. The Oratory, as it's called, was built in 1829 as the mortuary chapel of St. James Cemetery, long before it became dwarfed by the cathedral. It was designed in the Doric style by John Foster Junior. He was obviously heavily influenced by the ancient buildings he saw and admired when visiting Greece and decided to emulate their grandeur in his designs on his return to England.

The brick core building, faced with grey gritstone, has a portico of six Doric columns at each end. The ceiling is supported by four Ionic columns which enclose a glass fanlight, the only source of light for the interior, and simple stone slates were used for the roof.

See also: **Anglican Cathedral** and **St. James' Mount and Gardens**

GUSTAV ADOLFUS KYRKE
(Swedish Seaman's Church)

The building of the Swedish Seaman's Church in Park Lane, Liverpool 1 was a truly Scandinavian affair. The project took place between 1882 and 1883 with the architect being William Douglas Caroe. William Douglas might not sound Scandinavian, but he was the son of a Danish consul working in Liverpool.

Caroe's design resulted in a brick replica of a traditional timber Norwegian *Stavkirche* which was then used as a place of worship for Seamen from Sweden.

The Skandinavska Sjömanskyrkan, to use its correct name, is built in red brick with lancet windows and is the oldest working Swedish church outside of Sweden. It has a central octagonal tower and, on the south end, has a square tower with a tapering oval spire and belfry. The interior of the church is thought to be as equally impressive as the exterior.

As the plaque on the front of the church indicates, it is also used as a contact point for the Swedish Vice-Consulate.

See also: **Pyramid** and **Rodney Street**

HORROCKS, JEREMIAH
(Famous for recording the Transit of Venus)

Horrocks Avenue in Garston is named after Jeremiah Horrox (spelling was not considered of such importance in yesteryears) who was born in 1617 in Lower Lodge, off Toxteth Park. He proved to be such a good scholar that at the age of fourteen he was sent to Emmanuel College, Cambridge University. He studied as a sizar, an undergraduate receiving a grant from the college. However, he left the university without graduating and started working as a tutor and preacher in the Ancient Chapel of Toxteth.

He spent his spare time in indulging his passion for mathematics and astronomy, a self-taught subject. Using his home-made instruments he discovered many things, including the fact that the moon's orbit is elliptical. He also measured the size of the moon and his meticulous measurements of the sun confirmed

Kepler's theory that the Earth orbited the sun, a rather radical idea at the time. His measurements were later used as a partial basis for work by Newton.

Johannes Kepler, the renowned German astronomer and one of the founders of modern astronomy, predicted that the transit of Venus, visible as a small black dot moving across the sun, would occur in 1631 and then again in 1761, as his calculations led him to believe that it would happen every 130 years. Jeremiah did not agree with this. His calculations differed from Kepler's, leading him to believe that the discoverer of the three Planetary Laws of Motion had got it wrong. He asserted that the next transit of Venus would occur that same year. To be precise, November 24th 1639, at around 3 o'clock in the afternoon (Julian calendar).

Of course, he was right. It was fifteen miles north of Liverpool at Much Hoole, Preston, where he now lived, that Jeremiah used a simple telescope to project a solar image on to a piece of paper marked with six inch graduated circle, thus making the first recording of a transit of Venus.

At the time of Jeremiah's historic recording Liverpool had a population of less than 1000 and it has been claimed that it was a popular seaside resort. Many regard Jeremiah Horrocks as the founder of British astrophysics, but it was Sir Isaac Newton who named him the 'Founder of English Astronomy'. This brilliant man died in Otterspool at the tender age of 22 and was buried in the Ancient Chapel of Toxteth, Park Road, where a memorial tablet has been placed in his honour.

Three hundred years later, in commemoration of this historic observation by Jeremiah, it was proposed that a street in Garston should be named Horrocks Avenue.

See also: **Ancient Chapel of Toxteth** and **Otterspool**

INDIA BUILDINGS
(A literal building block)

This giant of a building on Water Street, faced with Portland stone, occupies an entire city block and merits a mention because of its marvellous interior. This imposing Grade II Listed building was commissioned by the Blue Funnel Line and in 1924 building of this immense office block began. It was finally completed in 1931 at a cost £1,250,000. Its design was heavily influence by 1920s North American architecture. A typical example of this is the barrel vaulted arcade lined with a plethora of shops that runs through the ground floor.

One of the architects of this steel-framed office block was Herbert J. Rowse, an influential Liverpool architect and the designer of the Philharmonic Hall, Queensway Tunnel and its main ventilation shaft. Like many downtown buildings, India Buildings suffered substantial bomb damage during the Second World War , but Rowse repaired the damage along with Queensway's main ventilation shaft, which also suffered bomb damage during the war.

India Buildings houses one of the only four Passport Offices in England.

See also: **Philharmonic Hall**; **Queensway** and **Ventilation Tower**

INTERNATIONAL SLAVERY MUSEUM
(The first of its kind in the world)

The new International Slavery Museum, the first of its kind in the world, was developed to replace the award winning Transatlantic Slave Gallery, which was also the first of its kind in the world. The first phase of the museum, housed within Merseyside Maritime

Museum, was opened on 22nd August 2007. Of particular significance is the fact that it was opened during the bicentenary of the abolition of the British Slave Trade.

The museum explores contemporary and historical aspects of slavery in addition to the legacies of the Slave Trade. It tells the stories of the bravery of the captured peoples and their rebellion against their captors. The aim of the museum is to focus on ignorance and misunderstanding by examining the impact of the Slave Trade on Africa, the Caribbean, South America, the United States of America and Western Europe. The displays cover topics such freedom and identity, racial discrimination, social justice, human rights and underdevelopment in Africa and the Caribbean.

The second phase of the museum will incorporate a visitor-focused resource centre which will be used for debate, performance and public lectures. National Museums Liverpool acquired the former Dock Traffic building for phase two, which will be linked to phase one by a walkway.

The museum honoured Anthony Walker (a teenager murdered in a racially motivated attack in 2007) by naming their Learning Centre after him.

See also: **Anthony Walker Festival** and **Merseyside Maritime Museum**

IRISH FESTIVAL
(Céad Mile Fáilte – a hundred thousand welcomes)

With the city of Liverpool being in such relatively close proximity to Ireland it is hardly surprising that it has an appreciable Irish heritage. The first festival took place in 2003 and the Liverpool

108

Irish Festival Society has now developed a permanent annual event taking place at numerous venues including The Everyman Theatre, the Everyman Bistro and The Philharmonic Hall, all in Hope Street.

It is the intention that the festivals demonstrate the importance of Irish heritage in the development of the city's culture and it aims to encourage people to explore their own cultural heritage and identity, promoting links with educational and historical organisations and providing access to related information. The festival traditionally includes the use of art; literature; music and theatre for entertainment and education in Irish traditions.

During the days of the festival, as on St. Patrick's Day, copious amounts of a world famous Irish stout may well be consumed, as many Liverpudlians can trace part of their family history back to Ireland.

It may not surprise the reader to discover that Liverpool, with its strong Irish connections, is twinned with Dublin, the capital of Eire. The city is also twinned with Shanghai, Cologne and Odessa.

⌨ www.liverpoolirishfestival.com

See also: **Festivals**

JALON'S BRIDEWELL
(A secure place to dine)

In 1860, Dickens signed up as a special constable at a city centre bridewell (local police lockup), now a restaurant in Cambell Street, to assist in his research for his novels dealing with the subject of abject poverty in cities. His interest in the

poor was obviously influenced by the fact that he spent some years working in a workhouse, after his father, a navy pay clerk, was imprisoned for debt. Dickens' novel, 'The Uncommercial Traveller' is based on the land sharks of the port and the observations he made during his visits to the workhouse situated on Brownlow Hill. The benevolent character in the novel 'Oliver Twist', Mr. Brownlow, is said to have been inspired by a person he encountered at the workhouse, the site of which is now occupied by the crypt of the Metropolitan Cathedral. The research that Dickens undertook in Liverpool and elsewhere, often undercover, was used to expose many of the horrors endured by the poor of the Victorian era.

Charles only kept the position of special constable for one day, but a plaque commemorating Dickens' association was recently erected at the Bridewell and bears his own words, 'Liverpool lies in my heart second only to London'. When the plaque was unveiled a gust of wind caught one of the curtains and brought the pole crashing down on to the head of the honoured guest, the writer Jimmy McGovern. The plaque is no longer in place.

The bridewell has now been converted to a restaurant, presently called Jalons Bridewell. Here you can actually eat in a cell if you should so wish, but, rest assured, the food is definitely of a better quality than that served to the non-paying guests of days gone by.

See also: **Dicken's Charles** and **Metropolitan Church of Christ the King.**

KINGSWAY
(Liverpool's second road tunnel under the Mersey)

By 1953, the original Queensway road tunnel was carrying 8 million vehicles annually and was causing considerable traffic

congestion at both ends. The increase was due to the post-war boom in motoring and significant growth in local industry. In 1958 a second tunnel was proposed to help alleviate the problem, but it was not until 1965 that it was approved by Parliament.

Construction commenced in 1966 and on 24th June 1971 the tunnel was formally opened by Queen Elizabeth II. It is named after her grandfather, King George V, who had opened the original road tunnel, Queensway, in 1934.

This new twin tube tunnel under the River Mersey was constructed using a giant boring machine weighing 340 tonnes which was specially built for the purpose in the USA.

See also: **Mersey River** and **Queensway**

KNOWSLEY HALL

(Ancestral home of the Earls of Derby)

The Knowsley estate has been in the Stanley family, the Earls of Derby, since 1385, but it is known that there has been some form of building there since the 12th century. The present Hall was built around about 1500 to mark a visit of the Earl's stepson, who happened to be Henry VII, the first Tudor monarch of England.

To celebrate their good fortune and to make their own mark on the building subsequent Earls made various alterations and additions to the Hall. The present Hall has a classic Georgian façade with the interior being in Jacobean, Baroque and Victorian styles. The State Dining Room with its carved oak panelling and figurative ceiling is an imposing 58 foot (17.68m) long.

This historic house has undergone extensive restoration and since 1999 has been available for hire, making it an excellent venue for all types of grand events including weddings, dinners, balls, launches, conferences, seminars, exhibitions and film location work.

The Hall and its grounds are hidden behind the longest parkland wall in the country. The 2500 acres (1011 hectare) of estate was created by Lancelot 'Capability' Brown, the eminent 18th century landscape gardener.

☎ 0151 489
🖥 events@knowsley.com

See also: **Knowsley Safari Park**

KNOWSLEY SAFARI PARK
(Wild animals just eight miles from the city centre)

In July 1971, the 18th Earl of Derby opened Knowsley Safari Park to the public. At the time there was understandable concern at the provision of a home to wild animals just a mere 8 miles (13 km) from a large city centre. Of course, fears were laid to rest and the park has been a resounding success ever since and, to the best of our knowledge, none of the animals have escaped and devoured any of the local residents.

The park contains around 30 species of mammal that are allowed to roam the 200 hectares (494 acres) of land plus a few birds, reptiles and invertebrates. The animals that have been introduced into the park include antelopes, baboons, bison, buffalo, camels, deer, elephants (said to be the largest herd in Europe), giraffes, lions, meerkats, ostrich, tigers, wallaby, white rhinoceros, wildebeest or gnu and Zebra. The park also houses

a bughouse, a bird display, a sea lion show, Mizzy Lake Farm and Lake Bird Hide.

In addition to beasts from exotic lands the woodlands of the park are managed in a manner to encourage native species of plants and animals. Among these indigenous plants are types of orchid and a variety of fungi. If you are very observant when touring the park, you may be lucky enough to catch a glimpse of hares, stoats, weasels and red and grey squirrels. It is possible for the keen-eyed to spot kestrels, buzzards, woodpeckers and kingfishers. In the spring, nesting birds arrive at the park, including lapwings, oystercatchers, geese, moorhens, coots and grebe (little and great crested). Let's just hope that these native species have enough common sense to keep away from the lion and tiger enclosures.

☎ 0151 430 9009
🖥 www.knowsley.com

See also: **Knowsley Hall**

LADY LEVER ART GALLERY
(A collection of fine and decorative arts)

William Hesketh Lever, later to be the first Lord Leverhulme, made his fortune by marketing soap and founding the firm of Lever Brothers. Like many wealthy Victorians he wanted his workforce to share in his wealth and prosperity and to this end he purchased a plot of land on the Wirral Peninsula in order to build a new factory and decent housing with open spaces for his workers. The village Lever wanted to build was to be named after his famous 'Sunlight Soap' and, on 3rd March 1888, the first sod of the development was cut by Mrs. W. H. Lever, later to be Lady Lever.

For the use of his employees Lever also built two schools, a hospital, a swimming pool and gymnasium, two village halls, social clubs and the Bridge Inn. The inclusion of a public house was a little surprising as he expected his employees to lead a life of sobriety. His gift to the people of the village was the magnificent Christ Church which now houses the tombs of Lord and Lady Leverhulme in its north annexe.

After Lord Leverhulme's wife died, he built an art gallery in her memory. The Lady Lever Art Gallery, Port Sunlight, was opened in 1922, by Queen Victoria's youngest daughter, Princess Beatrice. The gallery displays the works that Lord Leverhulme had collected throughout his life, especially on his many business trips and world tours. The gallery houses a collection of pre-Raphaelite works by John Everett Millais, Ford Maddox Brown and Dante Gabriel Rossetti, in addition to paintings by Turner and Constable. Among the attractions in the gallery are a large collection of Wedgewood, Chinese porcelain, a collection of Greek vases and Roman sculpture and a miscellany of other items including watches, sundials and various weapons that Leverhulme had acquired during his lifetime.

The Lady Lever Art Gallery was built from Portland stone and has four entrances, though only one of them is now in constant use. The gallery is arguably the best example of late Victorian and early Edwardian taste that still survives and it is the only major public gallery in the country that still houses the collection it was originally built for.

The collection also includes what would appear to have been some what of an obsession for Lord Leverhulme. He was a collector of commodes. On display in the gallery are at least 45 of the commodes that he acquired during his collecting days, with all of them being very ornate and obviously very expensive. It has been said that well-to-do Victorians purchased

items, such as commodes, in order to show how wealthy they really were. Improvements were made to the gallery in 2007 including the addition of a new exhibition chronicling the story of Lord Leverhulme.

The gallery is open every day from 10am to 5pm and, best of all, entry is completely free.

☎ 0151 207 0001
🖳 www.liverpoolmuseums.org.uk

See also: **National Museums Liverpool**

LIVER BIRDS
(The symbol of Liverpool)

The mythical Liver Birds are perched on the domed clock towers of the world famous Liver Building, one of the city's Three Graces. These copper birds are 18 feet (5.49m) high with a wingspan of 24 feet (7.3m). The Liver Birds are said to be a cross between a cormorant, the bird of good luck for sailors, and an eagle. The Liver Birds were designed by the German artist, Carl Bernard Bartels, who happened to be living in England at the time. Unluckily for him, he was in the country at the outbreak of the First World War and was consequently arrested and imprisoned in the Isle of Man.

A local legend is that the city of Liverpool will cease to exist if the Liver Birds ever fly away. A more humorous myth is that the Liver Bird facing the water is a female watching for the return of her mate and the one facing the city is male, looking to see if the pubs are open.

Ask most Liverpudlians how many freestanding Liver Birds there are and they will probably tell you, 'two', but in fact there are at least four. Opposite the Liver Buildings, at the side of St. Nicholas' Church in The Old Church Yard, is the considerably smaller white Liver Bird. It is perched upon the front of Mersey Chambers looking away from the city. On top of the Walker Art Gallery, by the left hand of 'The Spirit of Liverpool', sits another Liver Bird.

See also: **Liver Building**, **St. Nicholas' Church** and **Walker Art Gallery**.

LIVER BUILDING
(The first skyscraper in Britain)

The Royal Liver Friendly Society started life as a burial club which allowed many working class people to have respectable burials, provided they made regular contributions to the funds. As the business flourished a prestigious headquarters was required, so the Royal Liver Building was commissioned.

The Royal Liver Building, designed by Walter Aubrey Thomas, is arguably the most famous building in Liverpool and is one of the Three Graces on the city's waterfront. It is 295 feet (90 metres) in height with thirteen floors and its design is said to have been inspired by the skylines of Chicago. Construction started in 1908 and ended in 1911. This enormous structure is without equal in England and is regarded as Britain's first skyscraper though, by today's standards, it is not really that high. It is one of the earliest examples of multi-storey construction using a revolutionary steel and reinforced concrete structure.

A point of interest that often goes unnoticed is that there are no numerals on any of the clock faces of the Grade I Listed Liver

Building. The building has the largest electrically driven clocks in the United Kingdom, started on 22nd June at the moment of King George V's Coronation. They were designed to give seafarers the most accurate local time and are said to be accurate to within 30 seconds a year.

Each of the four clock faces are 25 feet (7.62m) in diameter making them bigger than the faces of the clock in the Tower of St. Stephen, London, where the famous bell, Big Ben is housed. Before one of the clock faces was put in place, it was used as a table when nearly forty people were served lunch.

Perched on top of the clock tower are the famous Liver Birds. Guided tours of the building are available.

See also: **Liver Birds; John Moores University** and **Walker Art Gallery**

LIVERPOOL BIENNIAL
(The UK's largest festival of contemporary visual art)

The Liverpool Biennial started life in 2000 and immediately became an acclaimed and major festival, attracting artists from all over the world. It has a deserved reputation that puts it on an equal footing with other Biennial cities such as Sao Paolo, Sydney and Venice.

The Biennial is hosted at a great many venues throughout the city including the Bluecoat Art Centre, the Foundation for Arts and Creative Technology (FACT), the Open Eye Gallery, Tate Liverpool and the Walker Art Gallery. The character and culture of Liverpool is at the heart of the Biennial, though at times some of the work on display has been controversial and does not always fit in with everyone's concept of art.

A major part of the biennial is the John Moores art exhibition held at the Walker Art Gallery. It is the best known painting competition in the country. Sir John Moores, an enthusiastic painter initiated the competition in 1957 and the event is held every two years. Acts of generosity such as this is one of the reasons that the city's second university was named after him.

The competition has a proven track record for identifying new talent and previous artists whose work has been exhibited include David Hockney, John Bratby, Chris Ofili and Callum Innes.

💻 www.biennial.com

See also: **Bluecoat Chambers**; **FACT**; **Tate Liverpool**; **Liverpool John Moores University** and **Walker Art Gallery**

LIVERPOOL HOPE UNIVERSITY
(One of the newest universities in the country)

The history of Liverpool Hope University goes back over 150 years, when two Colleges of Education for women were opened by the Church of England Diocese of Chester and the Roman Catholic Sisters of Notre Dame.

In 1844 the Church of England (Anglican) Institute for Elementary School Mistresses opened in Warrington, set up by Horace Powys. There were just two students in the first year, the following year's intake was 22 and from then on the number of students increased steadily. Things appeared to be going along fairly happily until 1923 when the institute, now referred to as the Warrington Training College, was totally destroyed by fire. The staff and students of the Anglican College were re-located to Battersea for seven years while a new building was being

constructed in the leafy suburb of Childwall in Liverpool. On taking over the new building, it was decided to change the name to S. Katharine's College and once again things appeared to be going along fairly happily until war broke out and the building was commandeered to be used as a military hospital. The staff and students were once again re-located, this time to picturesque Keswick in the Lake District until 1947, when the building was returned to the college.

The 1960s saw a period of expansion and the admission of male students. Three new buildings were constructed within the grounds and to reflect the history of the establishment they were named Keswick Hall, Powys Hall and the Warrington building. The Derwent Social Club was also opened at that time.

In 1856, The Sisters of Notre Dame opened Our Lady's Training College in Mount Pleasant. This was done as a response to an invitation from Monsignor James Nugent, a Catholic priest who was disturbed by the conditions endured by poor Irish children who were entering the city to escape the potato famine in Ireland. He asked the nuns to organise the establishment of orphanages and schools for the children. The college was required to train young pupil teachers and opened with an initial intake of 21 students. Monsignor Nugent accomplished a great deal of good work for the orphaned children of the city and he is commemorated with a statue in St. John' Gardens.

The college grew and prospered and in the 1960s it was renamed Notre Dame College of Education. In 1980 it joined forces with Christ's College of Education, an establishment that opened in 1964 directly opposite S. Katharine's College. The newly amalgamated college became Christ's and Notre Dame College of Education prior to joining forces with S. Katharine's College to form the Liverpool Institute of Higher Education.

The year 1995 brought another name change when the Institute was renamed Liverpool Hope University College and, ten years later, in 2005 it was awarded university status and was renamed Liverpool Hope University, making it the third of our three universities.

The playwright Willy Russell studied at S. Katharine's College of Education in the early 1970s and it is said that his film 'Educating Rita' was based on what was destined to become Liverpool Hope. The film, however, starring Michael Caine and Julie Walters, was actually filmed at Trinity College Dublin.

See also: **St. John's Gardens** and **Universities**

LIVERPOOL INSTITUTE OF PERFORMING ARTS
(A new school born out of an old school)

In 1844, the author and lover of Liverpool, Charles Dickens addressed the Christmas Soiree in the Assembly Hall of the Mechanics School of Arts, which was later to become the Liverpool Mechanics Institute before being renamed the Liverpool Institute and finally LIPA, Mount Street.

In January 1996 the Liverpool Institute of Performing Arts, LIPA, was inaugurated, though it was not officially opened until 7th June, with Queen Elizabeth performing the ceremony. However, the idea for this academy had started many years before this auspicious event actually took place.

Mark Featherstone-Witty had been excited by Alan Parker's 1980 film 'Fame', depicting the New York high School for the Performing Arts, and this is said to have given him the notion that performing artists needed to be trained in acting, dance and music, the three performing arts. He had already set up the

BRIT Performing Arts and Technology School in London and, obviously wanted to expand his ideas.

Record producer Sir George Martin knew of Mark Featherstoe-Witty's idea and thought he might be able to help him out. Sir George had another friend, Sir Paul McCartney who was looking for an idea to save his old school, the Liverpool Institute. The two collaborated and after seven years of hard work, with help from Liverpool City Council, LIPA was on the scene.

The institute offers a variety of degree programmes, validated by Liverpool John Moores University, in addition to postgraduate and diploma programmes.

See also: **Dickens, Charles** and **Liverpool John Moores University**

LIVERPOOL JOHN MOORES UNIVERSITY
(Owners of the world's largest robotic telescope)

In 1992, the Liverpool Polytechnic was awarded university status and so became the second and largest university in the city. It started life in 1825 as the Liverpool Mechanic's School of Arts, a somewhat small affair that, over the years expanded as it combined and merged with other local colleges creating Liverpool Polytechnic. When it was granted university status it took the name of Liverpool John Moores University (LJMU). Sir John Moores was the founder of the Littlewoods Empire, an organisation that started in 1923 and has always been associated with the city. The painting competition that he founded in 1957 also bears his name and plays an integral part of the Liverpool Biennial.

This contemporary university has six faculties: Arts and Social Science; Business and Law; Community and Leisure; Education; Health and Applied Social Sciences and Media. LJMU is based mainly over three campuses and its intake includes a significant number of overseas students.

Students of the university have the opportunity to reside in the former North Western Hotel on Lime Street, part of the William Brown Street Conservation Area. After remaining unused and neglected for many years LJMU had this majestic building converted into student accommodation. It was designed be Alfred Waterhouse who also designed the University of Liverpool's Victoria Building as well as colleges in Oxford and Cambridge.

LJMU, with the support of the UK's Particle Physics and Astronomy Research Council, established the National Schools Observatory which gives pupils the opportunity to observe the Universe via its website. This is made possible as LJMU owns and operates the world's largest robotic telescope, the Liverpool Telescope, based at La Palma in the Canary Islands. The telescope is also used by the Planetarium in the World Museum Liverpool and by astronomers all over the world.

A long distance learning programme in astronomy was first offered to students at LJMU. The Astrophysics Research Institute, an astronomy research group within the Faculty of Science works in collaboration with the Jodrell Bank Observatory, Cheshire (Manchester University) and has links with the Physics Department of the University of Liverpool. LJMU is also an established international centre for Maritime Programmes and operates the only 360^0 virtual ship simulator in the country, giving students a virtual full size ship's bridge. His holiness the Dalai Lama, Steven Spielberg and Phil Redmond (Honorary Professor of Media Studies) have all lectured at LJMU, whose motto is '*AudentesFortuna Juvat*', which translates to 'Fortune

assists the bold'. From 1999 to 2006 Cherie Booth QC, wife of the Prime Minister, The Right Honourable Tony Blair MP and a Merseyside local girl herself, was the Chancellor of LJMU. She was succeeded by the astronomer Dr. Brian May, who found fame as a guitarist in the group 'Queen'.

🖳 www.ljmu.ac.uk

See also: **Liverpool Biennial**; **Liverpool Telescope**; **Universities** and **University of Liverpool**

LIVERPOOL TELESCOPE
(The largest robotic telescope in the world)

Access to the Liverpool Telescope is easily made using the internet, but visitors to La Palma in the Canary Islands can ascend 2400 metres (7874 feet or 1.5 miles) of an extinct volcano to the Observatorio de Roque de Los Muchachos. It is here that you will find the world's largest robotic telescope, owned by the Liverpool John Moores University (LJMU).

LJMU gives pupils the opportunity to observe the heavenly bodies using the state-of-the-art Liverpool Telescope. Using the website, they can access and use the 2 metre (6.56 feet) fully robotic telescope in school or at home. Pupils are able to download telescope image data for analysis and image analysis software allows them to undertake tasks such as measuring the diameter of planets, the length of their days and the magnitude of distant galaxies. They can also identify the birthplace of stars, watch the activity around Black Holes and even discover asteroids.

LJMU has reserved observation time for the exclusive use of schools, though the telescope is used for research by astronomers

all over the world. The Planetarium at the World Museum Liverpool makes use of live image data from the telescope for its public talks.

🖳 telescope.livjm.ac.uk

See also: **Liverpool John Moores University** and **World Museum Liverpool**

LYCEUM
(The first lending library in Europe)

This Neo-classical building with its colonnaded front was built in 1800-1802 as a gentleman's club. Amongst its founders were a number of abolitionists, including William Roscoe, and it is said that the Lyceum was founded partly because of the merchants' coffee houses being too rowdy and often frequented by slave traders. The Lyceum became the home to Liverpool's first gentlemen's subscription library, founded in 1757, making it the first lending library in Europe.

The Lyceum is said to have inspired Manchester's Portico Library for which the same architect, Thomas Harrison of Chester, was commissioned. The building had separate entrances to the coffee house and library areas, which were described as the 'Lyceum Newsroom and Library', but, after a period of over 150 years, almost the entire building was taken over by the Gentlemen's Club.

Unlike the Athenaeum, the Lyceum did not continue to prosper and in recent years this Grade II* Listed Building at the end of Bold Street has been used for a variety of purposes including a Post Office, a building society, a café, a bar and a restaurant. Liverpool's first Public Lending Library was on the corner

of Duke Street and Slater Street and was in service from 18th October1852 until 1860. This was not considered to be in the city centre so this does not conflict with the claim to fame made by Central Library.

See also: **Athenaeum**; **Central Library** and **Roscoe Gardens**

MERSEY RIVER
(The world famous tidal river)

The world famous River Mersey starts near Stockport at the confluence of three tributaries, the River Etherow, the River Goyt and the River Tame. The name of the Mersey comes from the Anglo-Saxon Mǽres-ēa meaning border river as, at that time, it formed a border between the Saxon kingdoms of Mercia and Northumbria. The river flows westward for 70 miles before it finally reaches Liverpool Bay and the Irish Sea. This tidal river is always murky brown, but this is not a consequence of pollution, as is often thought, but the result of silt and sand being disturbed by the fast currents, the Mersey being colloidal in nature.

Fifty years ago the Mersey was described as one of the most polluted rivers in Europe, but, after an intensive clean up operation, it has recently won an award for cleanliness. There are now at least fifty types of fish, including salmon, along with crabs, mussels and starfish. There have been various sightings of grey seals, dolphins or porpoises swimming alongside the ferries. The river estuary has the largest number of wading birds in the country and, during the winter, over 50,000 live in the area. Swans have been seen on the Mersey, as have cormorants, the bird that the Liver Bird is believed to be based upon.
The Mersey can be crossed by ferry, two road tunnels and a railway tunnel under the river. If you prefer, the Mersey can also be crossed by the road bridge connecting Widnes and

Runcorn alongside a railway bridge. From 1905 to 1961 road traffic could only cross the river at this point using a transporter bridge. Passengers and vehicles were loaded onto a transporter car which was then hauled across the river by cable. Prior to this, passengers could make use of a local ferry.

In March 2006, after many years of debate, the Transport minister granted government funding towards the construction of a second road bridge to compliment the existing Runcorn Widnes Bridge. The cost of building and operating the bridge is expected to be met by a public/private partnership which, consequently, will result in a toll being levied for anyone wishing to make use of the new crossing from Runcorn to Widnes. Final approval for a second bridge is yet to be granted by the Secretary of State for Transport. It is hoped that the bridge will be completed by 2014.

Ships coming into the Mersey are steered by River Pilots who board the vessels at the river mouth. The pilots have a detailed knowledge of the hazards of where the silt and sandbanks lie, with Devils Bank being the largest silted area. They also know of the many wrecks that are strewn along the river bed; one section of the river being closed to all ships anchoring, because of the vast amount of wreckage from ships destroyed during the Second World War.

Without the Mersey, Liverpool would not have become such a prosperous city. It was a vital port for trading with America and formed part of the triangle in the appalling Slave Trade; goods being shipped out to Africa where they were exchanged for slaves. The slaves were then taken to the West Indies and from there sugar was brought back to Liverpool.

In July 2004 the City's waterfront was awarded World Heritage status by UNESCO putting in the same league as the pyramids of Egypt, the Great Wall of China and the Taj Mahal.

During the year many luxury liners, such as the *QEII*, have visited the Mersey, weighing anchor close to the Pier Head. Those wanting to take a closer look at these 'floating hotels' could embark on a River Explorer Cruise, conducted by Mersey Ferries, which take time to sail around the liners.

The River Mersey hit the headlines once again in May 2006 when an unexploded bomb was discovered in deep mud near Morpeth Dock, Birkenhead. The 1,000 lb (454 kg) penetration bomb, designed to penetrate fortified docks, submarine pens and concrete slipways, was discovered by the Royal Navy minesweeper *HMS Atherton* which was carrying out a routine survey. The 60 year old bomb was over 7 feet (2.1m) in length and was one of the largest dropped on the city. It is thought that the bomb may have been disturbed during a dredging operation. It was towed out into the Irish Sea by the Navy where a controlled explosion was carried out.

Over the years there have been several ideas put forward for using the flow of the river to generate electricity for the city using such things as giant water wheels and turbines. In 2005, work started on off shore wind turbines more than 6 kilometres (3.7 miles) off the coast of Crosby and New Brighton.
For those of you who interested in facts:

* the tidal river has a rise and fall of 10.5m (34.5ft);
* in certain parts the river Mersey has a current of up to 8 knots (15kph).

See also: **Ferries, Liver Building; Mersey Tunnels; River Festival; and Waterfront**

MERSEYSIDE MARITIME MUSEUM
(A celebration of Liverpool's maritime heritage)

This was opened in 1980 in a former bonded warehouse at the historic Albert Dock and the importance of Liverpool as a gateway to the rest of the world is reflected in the magnificent collections housed here. Visitors can see how life was for the millions who, between 1830 and 1930, emigrated to America, Australia, Canada, and New Zealand, and can discover Liverpool's seafaring heritage, the role of the Merchant Navy and visit the Pier Master's House and Offices.

The museum's largest exhibit is the pilot boat *Edmund Gardner* kept a short walk away in dry dock. It was ordered in July 1951, launched in July 1953 and handed over to her owners in December of that year. For almost thirty years she acted as a base in the Irish Sea for the Pilot Service, along with her two sister ships *Sir Thomas Brocklebank* and *Arnet Robinson* (all three named after chairmen of the Mersey Docks & Harbour Board). Anchored offshore she accommodated up to 32 pilots who would meet Liverpool bound ships to guide them into the dock system.

National Historic Ships, a public body reporting to the Department of Culture, Media and Sport, has recognised the importance of the *Edmund Gardner* by including it in its National Core Collection of Historic Ships. It is also recognised as an outstanding example of ship preservation, bestowed with a World Ship Trust's award.

In addition to the *Edmund Gardner*, the original shipbuilder's model of the ill-fated *RMS Titanic* and a propeller from the *Lusitania*, visitors to this award winning museum can see exhibits relating to the Battle of the Atlantic, life at sea, model ships and ship bottling.

One of the finest collections of merchant shipping records in the UK is housed in the Maritime Archive and Library. There are books and documents spanning three centuries covering every aspect of Liverpool's maritime history from the early 18th century. Admission to the archive and library is by free ticket, but you will need proof of identification.

Revenue & Customs National Museum and the International Slavery Museum are both housed within the Merseyside Maritime Museum and, like the Maritime Museum, both are open every day from 10am to 5pm and are, free to enter.

☎ 0151 207 0001
💻 www.liverpoolmuseums.org.uk

See also: **Revenue & Customs National Museum** and **International Slavery Museum**

MERSEY TUNNELS
(Taking a journey to the other side)

When referring to the Mersey Tunnels you automatically think of the road tunnels, but it must not be forgotten that the first tunnel under the River Mersey was built for trains.

In 1866 Parliament passed an Act allowing a railway tunnel to be built, linking Liverpool to Birkenhead on the other side of the Mersey. Construction started some 13 years later in 1879 and the tunnel was completed by the end of 1885. Driving through the tunnel must have been a rather unpleasant experience at first as all the trains were steam driven. Passengers could obviously close the windows of their carriages to protect themselves from the soot, smoke and steam, but the driver and his mates must

have had things pretty rough in their open locomotives. They were obviously much relieved in 1903 when electric trains were introduced.

The construction of the first road tunnel, Queensway, started at the end of 1925, with John Brodie being one of the engineers in charge. Most of the rock and gravel excavated during the tunnel's construction was used for land reclamation and to assist with the building of a river wall for Otterspool Promenade. John Brodie had the idea of building a river wall six years before the creation of the tunnel was started. The tunnel was completed in 1933 and was eventually brought into public use on 17th December. The Queensway tunnel was officially opened by King George V on 18th July 1934 amidst great ceremony. Like the railway tunnel, the Queensway tunnel links Liverpool to Birkenhead.

By 1958 the amount of traffic through Queensway had grown considerably and was giving considerable cause for concern, so it was decided to build a second tunnel, Kingsway, linking Liverpool to Wallasey. On 24th June 1971 Queen Elizabeth II opened Kingsway, the second road tunnel under the Mersey. A toll is charged for the use of the tunnels.

Before leaving this subject, there are some who believe that there was a much earlier tunnel built under the River Mersey. It has been claimed that during the reign of Henry VIII a group of monks excavated a four-mile long (6.4km) tunnel under the river linking what is now Speke with Bebington. Apparently it was made to help hide monastery treasures that were being raided during the reformation. The location of the tunnel is said to be kept a closely guarded secret.

See also: **Brodie, John**; **Kingsway**, **Otterspool Promenade** and **Queensway**

METROPOLITAN CATHEDRAL OF CHRIST THE KING ('Paddy's Wigwam')

At the north end of Hope Street, next to Liverpool University is Liverpool's Metropolitan Cathedral of Christ the King, known affectionately as Paddy's Wigwam, a reference to the large number of families of Irish Catholic descent that live in the city.

Building started in 1933 to a grand design by Sir Edwin Lutyen, but it did not come into fruition because of a shortage of funds and the interruption of the Second World War. Only the crypt of Sir Edwin's vision was ever completed and his grand design has often been referred to as 'the Greatest building Liverpool never had'. If it had been constructed it would have been 520ft (158.5m) in height and would have dominated the city's skyline. The proportions of the proposed cathedral would have dwarfed St. Peter's in Rome and St. Paul's in London.

The Ship and Historic Models Conservators at the Conservation Centre undertook a project to restore and complete the architect's model of the cathedral. It took over ten years to complete the task and it is exact in every aspect with the smallest of details being replicated. It hoped that it will be put on permanent display in the Museum of Liverpool, but it will require a good deal of space as it is almost 15 feet (4.6m) high and over 20 feet (6m) long.

After the original plan was abandoned, a competition was hosted in 1960 for a new, less expensive Catholic Cathedral. Sir Frederick Gibberd's pioneering design was victorious and building began in 1962, but, unlike the Anglican Cathedral, construction was rather swift and the completed cathedral was consecrated five years later in 1967. The cathedral is now acknowledged as one of Britain's finest twentieth century buildings and attracts visitors and worshippers from far and wide.

The Lantern Tower with its crowning pinnacles ensures that the cathedral stands out on the city's skyline. The interior's circular design, with the High Altar at its centre, is bathed in many colours as the cathedral has more coloured glass than any other in Europe and it also has the largest panel of stained glass in the world. The statue of 'Christ Risen' by local artist Arthur Dooley can be found on the left of the tabernacle in the Blessed Sacrament Chapel.

The cathedral, a Grade II* Listed Building, has recently undergone a renovation programme as it was suffering from some of the building methods and materials of the sixties. Access has been improved with the addition of new steps and a piazza. This new entrance to the cathedral won the Award for Religious Architecture 2005, which is rather pleasing as the design was inspired by a sketch that Sir Frederick Gibberd made over forty years ago. The granite slabs used to pave the piazza were imported from China. The piazza now benefits from a restaurant for those visitors who might be in need of refreshment.

Ironically, Sir Frederick Gibberd was an Anglican whilst Giles Gilbert Scott, designer of the Anglican Cathedral was a Catholic.

The cathedral's crypt was built on the site of the workhouse on Brownlow Hill, an institute that the author Charles Dickens chose to visit on several occasions.

☎ 0151 709 9227
🖳 enquiries@metcathedral.org.uk

See also: **Anglican Cathedral**; **Conservation Centre**; **Dickens, Charles**; **Monuments and Statues**; **Museum of Liverpool and University of Liverpool**

MONKS' WELL
(An ancient drinking well)

If you visit the Wavertree Lockup, Monks Well is but a short walk along Mill Lane, close to the end of the children's playground. The well is thought to be very old, possibly dating back as far as 1414, and it is claimed it has never been known to run dry. During times of drought, people from neighbouring districts could buy water from the well at a price of one penny (1^d in pre-decimal currency – worth approximately 0.4p) per can. In 1769 the site of the well was moved so as to be in closer proximity to Mill Lane, though by 1864 it had fallen into disuse as water was then being piped into Wavertree.

The present cross is a copy of the original and bears the Latin inscription, 'Deus Dedit Homo Bibit', 'God gave it, man drinks it'. On the cornice of the plinth is a further inscription, traditionally translated as 'He who hath and won't bestow, the Devil will reckon with below', alluding to the belief that travellers taking water from any well are required to give alms in payment, otherwise a chained devil lurking at the bottom would be heard to laugh at them. Dr William Moss' guide to Liverpool of 1797 suggests there was evidence of a previous 'monastic looking' building near this site and that the well may have been one of the order's means of raising income, though this cannot now be verified.

By 1932 the well, then in the ownership of a company who had built a housing estate close by, was donated to the City Council in recognition of its historic value, and in 1952 it was to become one of the first 'buildings' to be listed in the city.

See also: **Wavertree Lockup**

MONUMENTS AND STATUES
(The largest collection outside the capital)

Liverpool is second only to London as far as monuments and statues are concerned. There are approximately 250, with 90 of them being listed, and far too many for us to mention all of them. Here is a list of some statues and monuments that we suggest you may want to visit. Some are already mentioned under the headings of places where they happen to be sited and some have been mentioned elsewhere in this guide by name.

A Case History, Hope Street
Designer: John King

Christ, Anglican Cathedral, West Front
Sculptor: Dame Elizabeth Frink, installed 1993

Christ on an Ass, St. Nicholas' Church
Sculptor: Brian Burgess

Christ Risen, Blessed Sacrament Chapel, Metropolitan Cathedral of Christ the King
Sculptor: Arthur Dooley

Crucifix, Princes Avenue Methodist Centre
Sculptor: Arthur Dooley

Kissing Gate, Lime Street
Designer: Alain Ayers 1984

Mother and Child, New Women's Hospital
Sculptor: Terence M^cDonald 1999

Night and Day, George's Dock Building
Sculptor: Edmund C. Thompson

Our Lady on the Prow of a Ship, St. Nicholas' Church
Sculptor: Arthur Dooley

Palanzana, Byrom Street
Sculptor: Stephen Cox 1984

Ray and Julie, London Road
Artists: Alan Dunn and Brigitte Jurack

Reconciliation, Concert Street
Sculptor: Stephen Broadbent. Unveiled 1990
Identical statues are in Belfast and Glasgow

Red Between, Sydney Jones Library, Chatham Street
Sculptor: Phillip King

The River Mersey, The Cotton Exchange, Old Hall Street
Sculptors: William Birnie Rhind and E.O. Griffith

Roman Standard, Upper Duke Street by the gates of St. James'
Mount and Garden's.
Sculptor, Tracey Emin, 2005 (her first piece of public art)

Sea Circles, Seymour Street
Sculptor: Charlotte Meyer 1984

The 'Seed', Campbell Street,
Sculptor: Stephen Broadbent. Unveiled 2002

The Spirit of the Atlantic, (Seagulls Rising)
Atlantic Tower Hotel Courtyard
Sculptor: Seán Rice 1972

The Spirit of Youth (Resurgent) Lewis's Department Store
Sculptor: Sir Jacob Epstein

Tango, Concert Square
Sculptor: Allen Jones 1984

Waves, Sefton Street
Designer: David wake of Cass Associates 1989

Of course, it would be most remiss of us if we failed to mention Taro Chiero's controversial **Super Lambanana** (1998). This eight tonne work is currently sited in Tithebarn Street. During 2008, 120 facsimiles of this piece of public artwork, said to be a comment upon genetic modification, were placed in various and unusual venue around the city and further afield, each one with a unique design.

See also: **Epstein statue; Queen Victoria Monument** and **Waterfall**

MOUNTING STEPS
(One way of going up in the world)

If you've been to Picton Clock and Wavertree Lockup and are taking a stroll along Church Road to see the Blue Coat School, then stop a moment to view Holy Trinity Church as you pass it. This dates from 1794 and was described as the best Georgian church in Liverpool by Poet Laureate Sir John Betjeman, who was also fond of the Anglican Cathedral.

Across the road from the church is the parish hall and standing outside are some well-worn stone steps. These were used by the wealthier members of the parish, those who could afford a horse, to help them get back onto their steed ready for the ride home after attending a service.

See also: **Anglican Cathedral**, **Blue Coat School**; **Picton Clock** and **Wavertree Lockup**

MUSEUM OF LIVERPOOL
(A celebration of the city's culture)

Planned to be opened in 2010, the Museum of Liverpool will be Liverpool's first 21st century public building and will provide access to more than 10,000 artefacts from National Museums Liverpool's collection, currently in store. Many of these objects will be placed on public display for the first time ever. It is intended that the museum will provide an understanding of the development of the city within the wider British urban context.

The building will provide 8000 square metres (9568 square yards) of public space and a 200 seat theatre for audio/visual performances in addition to community theatre activities. There will also be a dedicated children's gallery, 'Liverpuddles', which will based on the impact of the River Mersey on the city of Liverpool. The model for the original design for Liverpool's Catholic cathedral will be put on permanent display in the Museum of Liverpool. When the construction of the museum is completed Ben Johnson's Liverpool Cityscape 2008 will be moved from the Walker Art Gallery and placed on permanent display.

One of the museum's many treasures will be a 1963 Ford Anglia, the first car to roll off the production line of the Ford Factory in Halewood, on the outskirts of the city.

☎ 0151 207 0001
🖳 www.liverpoolmuseums.org.uk

See also: **Albert Dock**; **Conservation Centre**; **Ferries**; **Mersey River**; **National Museums Liverpool** and **Pier Head**

THE MYSTERY
(More of a 'who was it?' than a 'who did it?')

Behind the Blue Coat School and alongside the railway embankment is Wavertree Playground. This large piece of land was donated to the people of Wavertree as a children's playground with a condition of the gift being that the identity of the very generous benefactor should be kept secret. We assume that there must have been a lot of speculation as to who made the gift which led to the large 108 acre (44 hectares) plot being nicknamed 'The Mystery'. However, it is widely thought that the donor was Philip Holt, a member of a local family of shipowners. Another condition the benefactor made was that the land would never be used for construction. If it was not for his benevolence the land would probably have been used for terraced housing. Philip Holt was related to George Holt who purchased Sudley House, which his daughter subsequently bequeathed to the City of Liverpool. The Victorian house is now one of our National Museums.

The site of Wavertree Playground had to be cleared of a derelict house and 5000 trees were planted around the perimeter. It was opened in 1895 with many attractions including morris dancing, gymnastic displays, a 1000 strong children's choir and a two hour firework display. The whole spectacular event is said to have drawn a crowd of 60,000. At the main entrance to the playground you can see two trees which were planted in 1902 to celebrate the coronations of King Edward VII and Queen Alexandra.

The Mystery has been used as the venue for many attractions, including the Liverpool Show and the Royal Lancashire Show. In 1930, a special railway track laid for the Liverpool & Manchester Railway Centenary Celebrations. The Wavertree Athletics Centre, a training venue for Olympic athletes, is based in the Mystery.

See also: **Parks and Gardens** and **Sudley House**

NATIONAL MUSEUMS LIVERPOOL
(One of the greatest groups of national museums in the world)

The Museums of Liverpool is England's only national collection based outside London and is one of the greatest groups of museums in the world. The nine superb venues give home to magnificent and varied collections covering everything, as NML rightly claim, from social history to space travel, entomology to ethnology, dinosaurs to docks and the arts to archaeology.

The nine unique venues, in alphabetical order, are:

- Conservation Centre, Whitechapel
- International Slavery Museum
- Lady Lever Art Gallery, Port Sunlight, Wirral
- Merseyside Maritime Museum, Albert Dock
- Museum of Liverpool, Albert Dock
- Revenue and Customs National Museum, Albert Dock
- Sudley House, Mossley Hill Road
- Walker Art Gallery, William Brown Street
- World Museum Liverpool, William Brown Street

☎ 0151 207 0001
🖥 www.liverpoolmuseums.org.uk

See also: **Individual entries**

NELSON MEMORIAL
(Liverpool's first free-standing outdoor sculpture)

In the centre of the square of Exchange Flags is the Nelson Memorial. The statue was erected in 1813 and has frequently

been subject to some controversy as the four chained figures at its base have been taken to be slaves. It is thought that they are meant to be allegorical figures representing the battles of Copenhagen, The Nile, Trafalgar and Cape St. Vincent. Some local historians believe the figures are merely meant to represent Englishmen's sense of duty to their country.

- 'Victory' is placing four crowns over Nelson to represent his four great victories;
- Nelson stands with one of his feet on a cannon and the other on a conquered enemy;
- The pedestal surrounded by the chained figures bears bronze reliefs with battle scenes from Trafalgar and the famous wording 'ENGLAND EXPECTS EVERY MAN TO DO HIS DUTY';
- A flag covers Nelson's missing right arm;
- A skeleton representing Death conceals a shroud and reaches out to touch him at the moment of his greatest victory.

This marble and bronze, Grade II* monument was Liverpool's first free-standing outdoor sculpture. Its chief instigator was William Roscoe who insisted on a design of the highest standard. The concept was by Matthew Cotes Wyatt and the sculptor was Richard Westmacott. It was funded by public subscription with the intention of celebrating Admiral Horatio Nelson and the growing prosperity and prestige of the city.

See also: **Exchange Flags** and **Roscoe Gardens**

NEPTUNE THEATRE
(The city centre civic theatre)

The Crane Brothers' music store was well established in the city centre when Crane's Music Hall was opened. It was situated

over their emporium in Hanover Street and numerous amateur dramatic groups chose it as the venue for their productions. It became so popular that, in 1938 it was renamed Crane Theatre.

Like many other theatrical establishments at the time, audiences started dwindling in the early 1960s and by 1966 the theatre was in danger of closing. Fortunately, in 1967 Liverpool Corporation purchased the theatre so that it could be run by local people for the city. In tribute to the city's maritime heritage the name was changed to the Neptune Theatre.

The new name did not secure the theatre's future and the decrease in the number of amateur dramatic groups using the Neptune continued to fall. In 1993 closure was, once again, looming on the horizon. This was met with great opposition from the people of the city as well as many prominent performers. In an effort to attract new and bigger audiences the theatre staged the pantomime 'Snow White' which proved to be so successful that the theatre now produces a pantomime on an annual basis.
The Grade II Listed Neptune Theatre seats 445 on two levels and, in July 2005 it closed for a two year major refurbishment.

🖳 www.neptunetheatre.co.uk

See also: **Theatres**

NESS BOTANIC GARDENS
(One of the major botanic gardens in the United Kingdom)

Although it is not on the Liverpool side of the River Mersey and is not one of Liverpool's parks and gardens, Ness Botanic Gardens merits a mention as it is part of Liverpool University. The gardens were started with Liverpool cotton merchant, Arthur Kilpin Bulley's passion for plants and his altruistic

desire to share with others. He began to create a garden in 1898 and was so pleased with the results that he decided to open part of it to local residents. This was to become the basis for Ness Gardens, one of the major botanical gardens in the UK.

The garden continued to prosper with Bulley constantly adding to his growing collection until the Second World War when the gardens understandably went into neglect. In 1942 Arthur Bulley died and, six years later, in 1948 Lois Bulley presented the gardens to Liverpool University with an endowment. Since then the gardens have, once again, prospered.

Since 1992 the gardens have been officially called 'Ness Botanical Gardens, University of Liverpool Environmental and Horticultural Research Station'.

The 62 acres (25 hectares) of land that Ness Gardens occupies has amongst its attractions: a visitors' centre; a conservatory; glasshouses; a rock garden; a woodland garden and a water garden. It also has a small folly and a purpose built belvedere which is available for civil weddings.

☎ 0151 236 7676
🖳 www.nessgardens.org.uk

See also: **Parks and Gardens** and **University of Liverpool**

NEWSROOM MEMORIAL
(A tribute to the men of the press who laid down their lives for their country)

Behind the Nelson Memorial in Exchange Flags, in a discrete little niche, is a memorial to the men of the Newsroom who died in the First World War. The bronze memorial, named Pro Patria,

dates from 1924 and is the work of Joseph Philips. It consists of Britannia protecting a child with her cloak and overlooking a scene of battle, where there is an officer holding a pistol, a private is kneeling and a nurse is tending a wounded soldier.

This memorial was moved to its present location in 1953 from what had been the old Exchange Newsroom when the new buildings, now enclosing three sides of the Flags were completed; the stone pillars to each side of the bronze date from this time. The Newsroom occupied the ground floor of the original building that stood on the east side of Exchange Flags and was used by the merchants and brokers who conducted their business there, although there may also have been limited public access.

See also: **Exchange Flags** and **Nelson Memorial**

OPEN EYE GALLERY
(A leading UK and European photographic gallery)

The Open Eye Gallery first started in September 1977 at the former Grapes Hotel on the corner of Whitechapel and Hood Street. Being housed in a former public house might not sound too salubrious, but, with grant aid from regional and national sources, including the Arts Council of England it was soon exhibiting local photographers as well as national tours and gaining renown. At this point in its existence it was known as the Merseyside Visual Communications Unit which promoted film, photography, video and sound recording for cultural, educational and social purposes. After several changes, including that of location, Open Eye was re-launched at its present location in Wood Street, Liverpool 1, where it has built a strong reputation both nationally and internationally.

143

The Open Eye Archives incorporates work by highly acclaimed contemporary photographers along with a multitude of images relating to Merseyside's cultural and social history, including scenes from the Blitz of Liverpool. Although the archives are not currently open to the public it is planned to show the works in future exhibitions and projects. Work that has been exhibited at this prestigious gallery has included that of the Liverpool photographer Edward Chambré Hardman, whose studio in Rodney Street is now owned by the National Trust.

Every two years the gallery is one of the major venues for the Liverpool Biennial, the UK's largest festival of contemporary visual art, as is the FACT Centre, also situated in Wood Street, part of the up and coming Ropewalks area of the city.

The gallery, the only one of its kind in the North West, is open Tuesday to Saturday from 10.30 to 17.30 and is available for private hire outside of these hours.
☎ 0151 709 9460
🖳 info@openeye.org.uk

See also: **FACT Liverpool**; **Liverpool Biennial**; **Rodney Street** and **Ropewalks**

OTHER PLACES OF INTEREST
(Within easy reach of Liverpool)

Anthony Gormley's 'Another Place' – Crosby Beach
Blue Planet Aquarium – Ellesmere Port
Catalyst Museum - Widnes
Ellesmere Port Boat Museum
Freshfields (with native red squirrels) - Formby
Jodrell Bank Observatory – near Knutsford, Cheshire
Martin Mere – near Ormskirk, Lancashire

National Wildflower Centre, Court Hey Park - Knowsley
North West Museum of Road transport – St. Helens
Norton Priory - Runcorn
Perch Fort Rock - New Brighton
Port Sunlight (home of the Lady Lever Art Gallery) - Wirral
Port Sunlight Heritage Centre – Wirral
Southport
Space Port - Seacombe Ferry Terminal, Wallasey
Sunlight Vision Museum, Port Sunlight
The Aquarium – Seacombe Ferry Terminal, Wallasey
Walton Hall Country Park – Warrington
World of Glass – St. Helens

See also: **Lady Lever Art Gallery**

OTTERSPOOL PROMENADE
(A load of old rubble)

If you ever fancy a pleasant stroll along the side of the River
Mersey, why not venture out to Otterspool and walk along
the promenade. Liverpudlians have been making use of this
Promenade since 1950 when it was first opened to the public.
Visit it on any day and you will see joggers, people out walking
their dogs, having a pleasant walk or just watching the ships go
by. Depending on the time of day that you decide to visit, you
may even see the occasional angler.

The original creek at Otterspool had been used by fishermen for
centuries, no doubt angling for the salmon that were once prolific
in the Mersey. It is thought that the monks from Birkenhead
Priory would land their ferries close to here when they were
taking goods to market or transporting passengers.

The idea for the promenade was first put forward in 1919 by the City Engineer, John Brodie. However, it was his successor, T. Peirson Frank, who actually submitted a series of plans for construction of a river wall and embankments during 1928 and 1929. Ask any native of the city how it was constructed and they will probably tell you that the excavations from the building of the first Mersey Tunnel, Queensway, were dumped on the site to create the promenade and to get rid of the rubbish. This is not totally accurate. The digging of the tunnel produced vast quantities of rock and gravel which had to be removed. This was obviously a mammoth task and a real problem until some bright spark realised that a river wall was already under construction at Otterspool as a preliminary to the building of the promenade and, close by, land reclamation was being undertaken in the district of Dingle. The solution was obvious and the unwanted rock and gravel was divided between the two sites. In 1982, as part of the Festival Gardens, the river wall was extended so that the two sites were at last joined.

The promenade has recently been refurbished and the 2.8m (9.2ft) tall sculpture 'Sitting Bull' by Dhruva Mistry (originally commissioned for the 1984 Garden Festival) has been brought out of storage and resides close by.

Otterspool Promenade and the river wall form part of the Mersey Way which is part of an alternative route of the Trans-Pennine Way.

See also: **Birkenhead Priory**; **Brodie, John**; **Ferries** and **Queensway**

PALM HOUSE
(A magnificent Victorian glass house)

Sefton Park's Palm House was a gift to the city from Henry Yates Thompson, the grand-nephew of Richard Vaughan Yates, the man who gave us Princes Park.

The Palm House was completed in 1896 and stocked with exotic plants from all around the world. On its completion it stood with nine marble statues and a marble bench on display inside. Standing on plinths around the outside of this magnificent Victorian glass house are eight bronze and marble statues by Chavailiaud (1858–1921). These depict famous explorers and naturalists. In the centre of the building is a wrought-iron spiral staircase leading to a platform around the edges and although very tempting, this is not available to the general public.

During World War II the Palm House became a danger to the city as its glass reflected moonlight and was likely to act as a guide for enemy aircraft. To remedy this, the outside of the building was painted with matt oil paint. The dome was painted green and adorned with grey paths so that it would blend in with the parkland. The glass was shattered when a bomb fell nearby in the Blitz of 1941. It was eventually re-glazed in 1950.

Sadly, the Palm House suffered a period of decline and deterioration and became dangerous. For this reason it was closed in the 1980's. The use of the Palm House was sorely missed, but the people of Liverpool were not going to take its demise lying down. Following a public meeting in June 1992 a petition calling for its restoration was presented to the City Council. The 'Save the Palm House' campaign had started. The Palm House, a Grade II* Listed Building was re-opened in 2001and is now run by the registered charity, Sefton Park Palm House Preservation Trust.

The statues within the glass house are:

- **Highland Mary** (1850) by Benjamin Spence. She was the favourite of Robert Burns. After their betrothal in 1787 she died in childbirth;

- **The Angels Whisper** (1857) by Benjamin Spence. This used to be on display in the Walker Art Gallery;

- **Two Goats** a marble statue by Giovita Lombardi (1707–1778)

- **Marble Bench** – it has an inlaid inscription commemorating the opening of the Palm House. It is 9 feet (2.74m) long with the head of a lioness on each arm.

The statues surrounding the exterior of the Palm House depict the following figures:

- **Carl Linnaeus (1707–1778)** The Swedish botanist who developed the system of classifying plants using two Latin names. This was first published in 1751;

- **John Parkinson (1567–1650)** Apothecary to King James I. He published his book (1629) detailing 1,000 plants to be grown in English Gardens;

- **Andre le Notre (1613–1700)** Designer of the Gardens of Versailles and St. James' Park in London. He was the first person to call himself a 'Landscape Architect';

- **Charles Darwin (1809–1882)** Plant collector and naturalist. He is best known for his book detailing his theory of evolution through natural selection 'On the Origin of Species';

- **Captain James Cook (1728–1779)** Explorer and Captain of HMS Endeavour. He charted the coasts of Australia and New Zealand;

- **Christopher Columbus (1451-1506)** Italian navigator (Cristoforo Colombo) credited with the discovery of the New World in 1492 and helping to establish the concept that the world was not flat.

- **Henry the Navigator (1394- 1460)** The 'Father of Atlantic Exploration' who inaugurated Portugal as a trading nation;

- **Gerardus Mercator (1512-1594)** Flemish cartographer and mathematician. He developed the method of making maps with lines of latitude and longitude.

The Palm house is used for various functions and recitals.

See also: **Princes Park** and **Sefton Park**

PARKS AND GARDENS
(Open spaces of tranquillity where you can relax in the city)

Liverpool enjoys a wealth of parks and gardens spread throughout the city. They are all free to visit and most are open all day, all year round. We offer you the following list of the major parks, but remember that there are other lesser known beauty spots dotted around the city.

Allerton Towers
The Black Woods
Calderstones Park*
Camp Hill and Woolton Woods*
Clarke Gardens
Childwall Woods
Croxteth Country Park
Devonfield Garden
Everton Park Nature Garden
Falkner Square
Greenbank Park
Newsham Park
Otterspool Park
Otterspool Promenade
Our Lady and St. Nicholas Church Garden
Princes Park*
Reynolds Park
Roscoe Gardens*
St. James' Mount and Gardens*
St. John's Garden
St. Nicholas' Church Gardens
Sefton Park*
Springwood Crematorium Garden of Remembrance
Stanley Park*
Walton Hall Park

See also: ***Individual entries**

Many of the parks and gardens of Liverpool are situated within easy walking distance of one another and, for intrepid walkers this gives the opportunity of an excellent day's ramble. For example Greenbank Park, Princes Park, Sefton Park, Otterspool Park and Otterspool Promenade could all be visited on the same day.

For the more enthusiastic park visitor there is a Green Belt Trail. Apparently first suggested on a BBC Radio 4 programme, the trail is practically all on hard surface or ground and there is very little chance of muddy conditions, even after a heavy rainfall, but it is recommended that all intrepid hikers have appropriate footwear. It starts at the magnificent Four Seasons Gate at the entrance to Calderstones Park, traverses entirely within the city boundary, hardly touching any roads and ends up at High Street, Woolton. On the journey you will have the opportunity to walk through Allerton Towers, Clarke Gardens, the home of Allerton Hall, and Springwood Crematorium Garden of Remembrance, finishing at Camp Hill and Woolton Woods.

Liverpool is very proud of its parks and gardens, especially as thirteen of them have been awarded Green Flag Status. The city has recently committed itself to a major regeneration of its parks, restoring some of them to their former Victorian glory.

See also: Birkenhead Park; and Individual entries

PHILHARMONIC DINING ROOMS
(The 'Phil' pub - famous for its Late Victorian Gentlemen's toilet)

The Philharmonic Dining Rooms, Hope Street, are affectionately referred to as the Philharmonic or the 'Phil' by most Liverpudlians, but it must not be confused with the Philharmonic Hall which lies diagonally opposite to it. This well-known pub, with its side rooms named Brahms and Lizst, is an absolute must for anyone venturing on a pub crawl in the city centre.

The building, opened in 1898, was designed by Aubrey Thomas with its exterior in the Art Nouveau style. Before entering do take time to take in the splendour of the marvellous wrought

iron gates that guard the entrance. When you go into this famous Liverpool landmark you immediately see the huge rounded bar, decorated with glass grapes and a golden eagle that is almost life-size, the mosaic floors and cosy alcoves. The Phil is decorated with dark wood-panelled walls with copper reliefs and retains its Art Deco lighting, The Grand Lounge has a magnificent ornate glass ceiling and the former billiard room retains its splendid chandeliers. It has recently been restored so that it is exactly as it would have been when first opened. The Brahms room is panelled with quarter sawn oak with satin wood inserts. The spectacular and well-preserved Edwardian interior is a deservedly famous tourist attraction, especially the mosaics and marble urinals in the gentlemen's toilet. Women are permitted to enter only as part of an organised tour. At present the dining room is situated on the first floor.

The Grade II* Listed Philharmonic Pub was one of 200 pubs of architectural excellence commissioned by Robert Cain, the founder of Liverpool's famous local brewery.

See also: **Cains Brewery** and **Philharmonic Hall**

PHILHARMONIC HALL
(The finest acoustics of any orchestral hall in Europe)

Approximately half way along Hope Street, at the junction of Myrtle Street, you will find the home of the Royal Liverpool Philharmonic Orchestra, the Philharmonic Hall. It is known affectionately to everyone as the 'Phil' and, unfortunately, this often leads to a little confusion amongst locals as the Philharmonic pub also enjoys that same abbreviation.

The original Philharmonic Hall was designed by John Cunningham and was opened on August 27th 1849 and, at that time, was considered

to be acoustically perfect with, Sir Thomas Beecham proclaiming it as the best in Europe. Perhaps this was one of the reasons why it was chosen as a venue for one of the 'Penny Readings' that Charles Dickens made during his visits to the city.

The acoustics of the hall may have been outstanding, but the fire protection must have been somewhat lacking as, on 5th July 1933 a loose spark in the organ loft started a blaze and the building was completely destroyed. The current hall was completed in 1939 to the design of Herbert J. Rowse who also designed India Buildings, the Queensway Tunnel entrance and George's Dock Ventilation Tower. Like the original hall, the present superb art deco hall has some of the best acoustic facilities in Europe and is one of the premier arts and entertainments venues in the UK.

The discovery and opening of the tomb of Tutenkhamen was said to have had significant influence on the design developed by Rowse, with the Mezzanine representing the outer tomb, the pharaoh's final place of rest, and the Auditorium symbolizing the inner tomb with its many treasures. The decoration within the hall is of a distinctly Ancient Egyptian style. The auditorium has six panels by Edmund Thompson and there are two more of his wall panels in the Grand Foyer bar. On the wall of the platform can be seen Marianne Forest's kinetic sculpture, 'Adagio'.

The Philharmonic Hall is home, rehearsal and concert venue of the world famous Royal Liverpool Philharmonic Orchestra (RLPO), which gave its first performance on 12th March 1840 making it one of the oldest concert giving organisations in the world. It is the second oldest orchestra in Britain, but it was not until 1957 that it was awarded its royal patronage.

The Philharmonic Orchestra was the first with its own hall and remains the only orchestral society in Britain that has the luxury of owning and operating its own hall. The RLPO, administered

by the Royal Liverpool Philharmonic Society perform about 60 concerts year and for nearly 50 years have made successful recordings there, with the greatly renowned Sir Malcolm Sargent conducting the first recordings. The RLPO are held in such world wide high esteem that, in 1993 they were the first non-Czech orchestra invited to open the prestigious Prague Spring Festival.

The hall also plays host to a broad programme of pop, rock and jazz concerts, as well as being a venue for world contemporary music, comedy, community concerts, graduation ceremonies and conferences. The Phil is used for showing classic cinema on the last remaining Walturdraw rising cinema screen in the world.

The Grade II* Listed hall was closed down from 1993-5 for essential repair work and an extension. At the same time work was undertaken to make the sound within the hall even clearer. It is now claimed that acoustically, it is the finest orchestral hall in Europe.

☎ 0151 709 3789
🖳 www.liverpoolphil.com

See also: **Dickens, Charles**; **India Buildings**; **Philharmonic Pub**; **Queensway** and **Ventilation Tower**

PICTON CLOCK TOWER
(A time piece for the smallest house in England)

The clock tower, High Street, close to Wavertree Lockup and the smallest house in England, was donated as a gift to the people of Wavertree in 1884 from Sir James Allanson Picton. He had the tower built as a memorial to his wife, Sarah, who died five years earlier.

In addition to being a distinguished local architect, Picton

was also a prominent member of Liverpool Town Council and Wavertree Local Board of Health. He was chairman of the Libraries and Museums Committee for nearly forty years and, in 1879, the new library reading room was named after him as a mark of respect. Sadly, 1879 was also the year of his wife's death.

Judging by the number of positions that Sir James held, he could well have been a workaholic, which would explain one of the inscriptions he had put on to the tower:

'Time wasted is existence; used is life'.

See also: **Picton Reading Room**; **Smallest House in England** and **Wavertree Lockup**

PICTON READING ROOM
(The pride of Central Library)

In 1875 work began on an extension to Central Library with the foundation stone being laid by Sir James Allanson Picton, who donated a clock tower to the people of Wavertree. The extension was for a new reading room, which was to be named after Sir James in honour of his long service.

The magnificent Picton Reading Room was designed by Cornelius Sherlock and completed in 1879. It is circular in design, copying the British Museum Reading Room and has two plaster statues mounted in niches to the front, The Lady of the Lake and Highland Mary, both by the sculptor Benjamin Edward Spence. Built with a domed roof, surrounded by Corinthian columns and an elegant entablature, the drum like appearance of the building earned it the nickname of "Picton's Gasometer".

☎ 0151 233 5835
💻 central.library@liverpool.gov.uk

See also: **Central Library** and **Picton Clock Tower**

PIER HEAD
(Home of the Three Graces)

The Pier Head, site of the listed buildings known as The Three Graces, is the focal point of the world famous waterfront and is one of the six areas of the city designated a UNESCO World Heritage site in 2004. This area of land was originally reclaimed from the river to form George's Dock, opened in 1771 after 9 years under construction to become Liverpool's 3^{rd} dock. In 1900 this dock was filled in, creating Pier Head and became the main point for passenger ferries to dock. These have included the Mersey ferries as well as those going to the Isle of Man and Ireland . It has also been the point of departure for millions of Europeans who have emigrated to North America and Australia.

In addition to the Three Graces you can also see the listed George's Dock Ventilation Tower and a diverse collection of monuments and statues, amongst which are:

- Cunard War Memorial;
- Edward VII statue;
- Canadian War Memorial;
- Heroes of the Maritime Engine Room Memorial;
- Merchant Navy War Memorial;
- The Titanic Memorial.

On 25th of September 1928 an unusual thing happened when Liverpool was married to the sea. The Lord Mayor and distinguished citizens paraded from the Town Hall to the Pier Head where they were joined with representatives from the local shipping companies and working and retired seamen. There was also a choir of 300 children to mark this auspicious occasion. The Lord Mayor spoke and, based on an old Venetian custom, a ring was cast into the water to mark the union of the city and the tide. In this way Liverpool was officially 'married to the sea'.

See also: **Cunard Building**; **Liver Building**; **Port of Liverpool Building**; **Three Graces**; **Titanic Memorial**; **Town Hall** and **Waterfront**

PLAYHOUSE THEATRE
(The oldest repertory theatre in the country)

Parts of this Grade II Listed Building in Williamson Square date back to 1844 though it was not until 1866 that the present theatre was built, opening as the Star Music Hall. Coincidentally, the Empire Theatre also opened in that year. The Liverpool Playhouse repertory company was established in 1911 and was the oldest repertory company in the country until 1999, when it was sadly disbanded.

The theatre was closed for a brief period in the late nineties, but is once again the home of many acclaimed productions. Many great actors have walked the boards of the Playhouse and it was here that Noel Coward first worked with Gertrude Lawrence, although they were child actors at the time and yet to reach the height of their fame. Dame Beryl Bainbridge started her career at the Playhouse.

During the Second World War the Old Vic Company decided to use the Playhouse as its wartime home. This seems to have been a rather strange choice as Liverpool was the second most bombarded city in the country.

💻 www.everymanplayhouse.com

See also: **Empire Theatre** and **Theatres**

PORT OF LIVERPOOL BUILDING
(One of the waterfront's Three Graces)

This was the first of the Three Graces to be built (1903-1907) and was home to the Mersey Docks & Harbour Board. It is now known as the Port Of Liverpool building. Designed by Sir Arnold Thornley in conjunction with firm of Briggs & Wolstenholme, it is Grade II Listed and built in the style of a renaissance palace with a large classical dome in the centre and cupola-topped towers at each corner, originally with lanterns. It is the southern most of the three iconic buildings that adorn the waterfront at the Pier Head and can be visited as part of a Pier Head Tour escorted by a Mersey Tourism Guide.

The building was severely damaged during the Blitz with the entire eastern wing being gutted by incendiaries, but was reconstructed in the early post war period at great cost, significantly more than the cost of the original building.

See also: **Cunard Building; Liver Building; Three Graces** and **Waterfront**

PRINCES PARK
(A gift from Richard Vaughan Yates)

Designed in 1843 by Joseph Paxton in collaboration with James Pennethorne, Princes Park did not become fully open to the public until 1918, when it was purchased by Liverpool City Council. Joseph Paxton also designed Birkenhead Park, the first publicly funded park in the world. He was knighted by Queen Victoria in 1851 for his design of Crystal Palace, the main exhibition hall for that year's Great Exhibition in Hyde Park.

The 40 acre (16 hectares) plot of land which Princes Park now occupies was originally part of the Royal Deer Park of Toxteth. It was purchased for £50,000 by Richard Vaughan Yates, a son of a prominent and wealthy Liverpool family, for the building of a private park. The additional plots of land around the park were intended to be used for the building of houses. The income from these properties was used for the upkeep of the park.

The park was landscaped and gradually opened to the public, though access was restricted to certain areas. The lake gardens were only open to the adjacent residents. At this time the Yates family were already well known for allowing public access to their grounds on two evenings a week. As their property was located in the Dingle these were referred to as Dingle Days.

An obelisk drinking fountain dedicated to Richard Vaughan Yates stands on the central path through this pleasant park which, amazingly, still has its original gates. The ornamental lake was created by constricting a tributary of the River Mersey. In 1918 the park was acquired by Liverpool City Council.

As you walk about the park, keep an eye out for the donkey graves situated within the grounds. As with Calderstones Park and Sefton Park the Trans-Pennine (Route 561) passes through part of the park.

See also: **Birkenhead Park**; **Calderstones Park**; **Parks** and **Gardens**; **Sefton Park**.

PRINCES ROAD SYNAGOGUE
(Possibly the finest synagogue interior in Europe)

Situated at the junction where Princes Road meets Princes Avenue, close to the Greek Orthodox Church of St. Nikolas, is the Princes Road Synagogue.

Entering through the considerable wooden doors, you will find yourself beneath the high ceiling of a hall, surrounded by rich colours and the magnificent glow of gold. The hall has large circular windows at both ends and marble has been used in abundance on the fixtures and in the columns. The highly decorated interior is said to be one of the finest examples of Moorish revival style of synagogue architecture and is in total contrast to the more subdued exterior.

The synagogue, a Grade I Listed Building, was designed by the brothers William and George Audsley of Edinburgh, who were well known for designing churches and places of worship in Liverpool and throughout the country. The ladies of the Liverpool Old Hebrew Congregation held a bazaar and luncheon in February 1874 to raise funds to help pay for the splendid interior of the synagogue. They managed to arrange for the Coldstream Guards to play at the event and invited many dignitaries. Their efforts were highly successful, with them raising in excess of £3,000. On 2nd September1874 the synagogue was consecrated. Princes Road Synagogue remains

the oldest orthodox synagogue in Liverpool and the oldest working synagogue in the North West.

When first built, the six towers of the synagogue were each topped with a minaret, but in 1960 these were taken down as they had fallen into disrepair and become dangerous. Further catastrophe befell the structure when, in May 1979, it was devastated by fire. It has now been restored to its full glory.

Tours of the synagogue are usually available Monday to Thursday of each week, but they must be booked in advance.

☎ 0151 709 3431
🖥 tours@princesroad.org

See also: **Greek Orthodox Church of St. Nikolas** and **Theatres**

PYRAMID
(Just like they have in Egypt)

Venture along to Rodney Street, the 'Harley Street' of the city, and you will come across the no longer used St. Andrew's Church. The Church was built in 1823 and is a Grade II Listed Building. Unfortunately, it has been left in a very poor state of repair following a devastating fire that occurred in 1988.

In the grounds of St. Andrew's Church and Sunday School you will see the city's Grade II Listed pyramid. It is a memorial to Liverpool's W. MacKenzie, a wealthy railway engineer and an ardent gambler who, according to local legend, insisted on being buried sitting at a card table holding a winning hand of cards. A variation to this legend says that MacKenzie lost his soul to the devil following a game of poker and, shortly before he died,

he reasoned that if he was not buried in the ground, the Prince of Darkness would not be able to claim his soul. Apparently, building a 15 foot (4.57m) pyramid seemed to be the most efficient way to comply with these somewhat eccentric last wishes. Whatever the reason for this unusual burial chamber, the ghost of William MacKenzie is said to haunt Rodney Street.

The church and its grounds have been bought by the city council and discussions are underway as to the future of the site. It is hoped they may be restored and possibly used as an entrance to the Liverpool John Moores University campus, whose other buildings dominate this part of the city.

See also: **Rodney Street** and **Liverpool John Moors University**

QUEENSWAY
(The first road tunnel under the Mersey)

When originally built the Queensway tunnel was the largest underwater road tunnel in the world being 2.13 miles (3.61km) in length. It was also the widest tunnel built making it a truly magnificent piece of engineering work.

Construction of the first road tunnel under the Mersey started at the end of 1925 with John Brodie being one of the engineers in charge of the work. Between 1926 and 1931 a massive 1.2 million tons of rock and gravel was excavated with much of it being used to help build Otterspool Promenade, an earlier idea of John Brodie, and to reclaim land in the Dingle area.

When the construction of the tunnel was underway it was claimed to be the largest engineering feat in the world. The task of building the tunnel involved 1,700 workers. There were

difficulties with drainage and excavation and, unfortunately, 17 men lost their lives. As part of the Queensway Tunnel Diamond Jubilee Celebrations a memorial was erected in remembrance of those who died during its construction. A plaque was attached to the Georges Dock Building, one of the tunnels ventilation towers, on Goree at the Pier Head listing the names of all who perished.

The tunnel isn't very deep with only 25 feet (7.62m) of solid rock above the tunnel at mid-river. At its lowest point it is only 170ft (52m) below the water. The original plans included a large space underneath the roadway, named Central Avenue, for the use of trams, but, for various reasons, this did not come to fruition.

The tunnel came into use on 17th December 1933 and was officially opened on 18th July 1934 by King George V and to Commemorate this statues of King George and Queen Mary were place at the Liverpool entrance of the tunnel. The toll for using the tunnel on opening was 1 shilling (5p). Prior to its opening pedestrians were invited to walk through the tunnel to admire its construction and raise money for charity. Similar events still happen occasionally.

Herbert J. Rowse was the architect of the art-deco tunnel entrances, toll booths and the ventilation buildings, including George's Dock Building. The tunnel entrances are now Grade II Listed structures. Rowse also designed the 60ft (20.5m) high lighting columns made from reinforced concrete and polished granite situated at either end of the tunnel. Unfortunately, the column at the Liverpool was removed in 1966 when the road entrance to the tunnel was redesigned. Rowse was also the designer of India Buildings and the Philharmonic Hall. The tunnel cost nearly £8 million pounds to build with its original lining consisting of a dado of dark purple Vitrolite glass, which appeared black framed in stainless steel. These were later removed.

The tunnel was always planned to be open 24 hours a day and to represent this fact two basalt statues, *Night* and *Day*, by Edmund C. Thompson adorn the George's Dock Building, one of the ventilation towers.

In 2007 tours of the Queensway Tunnel were launched. They take place four times a week and relate the history and workings of this under water roadway. Each tour includes access to the Engineering Control Room and an opportunity to observe one of the six enormous ventilation stations in addition to the recently constructed escape refuges.

There is a charge for the three hour tours which take place on Tuesday, Wednesday and Thursday evenings at 5pm and Saturday mornings at 10am. They include the ascending and descending of a great many steps making them unsuitable for people with breathing or walking difficulties.

See also: **Brodie, John**; **India Buildings**; **Otterspool Promenade**; **Philharmonic Hall** and **Ventilation Tower**

QUEEN VICTORIA MONUMENT
(On the site of Liverpool Castle)

The monument in Derby Square is built on the site of Liverpool Castle. The castle was erected during the early 13th century and survived until the early 18th century, by which time it had become somewhat of an eyesore and was demolished to the delight of many local people. St. George's Church was then built, more or less straight away, on the site of the castle in 1734 and that managed to survive until 1898.

The foundation stone for the monument was laid in 1902 and the completed work unveiled in 1906 by Princess Louise, the sixth

of Victoria's children. Victoria stands beneath the dome and is surrounded by allegories of her reign with personifications of Fame on top of the dome and Wisdom, Charity and Peace on the four corner columns. The design was by Professor F.M. Simpson of the Liverpool School of Architecture with Willink and Thicknesse, and the sculptor was C. J. Allen.

When it was erected the monument had a gold mosaic within the dome, but this was removed when it became insecure as a result of fire damage sustained during the Second World War. Plans are being made to re-install the gold mosaic to restore the monument to its former glory.

The neo-Baroque, Grade II Listed monument of Portland stone is now part of the Queen Elizabeth II Law Court Complex, where the curved lines in the paving trace out the walls of the castle. It has been described as one of the most ambitious monuments to Victoria to be found anywhere in the country. Queen Victoria is also depicted on the equestrian statue on the plateau of St. George's Hall. Apparently, the monument used to have public toilets underneath, but these are no longer evident.

See also: **St. George's Hall**

REVENUE AND CUSTOMS NATIONAL MUSEUM (Seized! Revenue and Customs uncovered)

The original museum opened in 1994 , but in 2008 a completely new museum, *Seized! Revenue and Customs Uncovered* was opened in the basement of the Merseyside Maritime Museum. It relates the tale of Customs & Excise officers' daily efforts to beat smugglers at their game from the 18th century to the present day. This is not about people trying to bring in an extra bottle of Duty Free alcohol without declaring it as some holidaymakers

do; it is about serious organised crime. This is an ongoing task to thwart major criminals.

The museum, working in partnership with National Museums Liverpool, holds the national collection of the Department of Customs and Excise, one of the most important collections of its kind in the world. On your visit you will be able to get an insight into the ongoing battle between smugglers and duty officers. The display of tools of the trade, prints, paintings and photographs is quite comprehensive.

☎ 0151 207 0001

💻 www.liverpoolmuseums.org.uk

See also: **Merseyside Maritime Museum**

RIVER FESTIVAL
(The greatest maritime event in the UK)

Every summer Liverpool, the greatest maritime city in the world, plays host to the annual Mersey River Festival, attracting hundreds of thousands of visitors from all over the region. The festival includes arts, events and entertainment themed around the river and its history. The events are centred around the Albert Dock, on the Liverpool side of the Mersey, and New Brighton, on the Wirral side.

Lasting several days, the festival, the greatest maritime event in the UK and one of the premier Maritime Festivals in Europe, has attractions such as historic tall ships, narrow boats, jet-ski races, street theatre, shanty festivals, al fresco concerts, children's activities and much more. There is no charge for visitors for this superb event.

Marking the festival's 25th anniversary in 2005, Liverpool hosted the start of the 35,000 mile Around the World Clipper Race with a ten strong fleet setting out for a gruelling eleven months on the ocean waves.

See also: **Albert Dock; Festivals; Mersey, River** and **Waterfront**

ROBIN HOOD STONE
(A curious standing stone)

Make your way along Booker Avenue to the corner of Archerfield Road you will see a large standing stone almost 8 feet high (2.4m), known as the Robin Hood Stone.

During the reign of Henry VIII an act of parliament was passed obliging all men under the age of 60, with the exception of judges and clergy, to practise archery. The stone is marked with long grooves running down its length and it is thought that archers sharpening their arrow heads could well have created these furrows. However, when the stone was dug up in 1910, no evidence of arrowheads or any other artefact connected with archery was found, It was discovered that the base of the stone had markings very similar to those of the Calder Stones, suggesting it may once have been a part of that group and therefore dating back to the Bronze Age. Another suggestion is that the stone was used as a Druid's altar and the grooves were made to drain away the blood from sacrificial victims.

The plaque beneath the stone reads:

This monolith known as "ROBIN HOOD STONE"
stood in a field named the Stone Hay at a spot
198 feet distant, and in the direction bearing

7 degrees east of true north from its present position
to which it was moved in August 1928.
The Arrow below indicates the direction of the original site.
This side of the stone formally faced south.

See also: **Calderstones** and **Calderstones Park**

RODNEY STREET
(Liverpool's 'Harley Street')

As it used to be predominantly the domain of doctors and consultants, Rodney Street was regarded as the Harley Street of Liverpool. The Georgian style houses date mainly from the late 18th and early 19th century, with each one having its own unique doorway.

A plaque commemorates the fact that James Maury lived at Number 4 Rodney Street. His claim to fame is that George Washington appointed him as the first American Consul in the world. He served as the US Consul at 22 Water Street, Liverpool from 1790 to 1829 in addition to being the President of the American Chamber of Commerce in Liverpool. One of his duties was to secure the release of American sailors, who had been involved in drunken altercations and then subsequently given temporary residence in the Tower of Liverpool. Maury's dispatches are now preserved in the US Federal Archives held in Washington.

Number 11 Rodney Street bears a plaque commemorating the fact that this was the birthplace of one of the 20th century's most successful authors, Nicholas Monserrat, son of a prominent dental surgeon. Monserrat studied at Cambridge before practising law in Liverpool and later decided to take a gamble,

giving up his practice in pursuit of a literary career. His most famous novel was 'The Cruel Sea', but it is often forgotten that, in 1948 he also wrote 'My Brother Denys', an autobiographical account of growing up in Liverpool. Monserrat was a Lieutenant Commander in the RNVR in the Battle of the Atlantic during the Second World War.

Number 35 is thought to have been the first of these elegant houses. It was started in 1783 and was completed in the following year. The land on which it stands was leased by the prominent Liverpudlian, William Roscoe.

Number 59 Rodney Street is now owned by the National Trust. It was the former home of Edward Chambré Hardman, a Liverpool photographer, who moved there in 1948. The house was converted into a photographic studio that was large enough to employ ten assistants. To leave sufficient room for the place of work the Hardman family lived in modest quarters at the rear of the house.

The house at Number 62 Rodney Street was built in the early 1790s for John Gladstone. It bears a plaque commemorating its distinctive claim to fame. In 1809 it became the birthplace of William Ewart Gladstone, leader of the Liberal Party and four times Prime Minister of Great Britain.

When admiring the splendours of Rodney Street look out for the plaques dedicated to:

- Number 9 - Arthur H. Clough, poet and Anne J. Clough, the first principal of Newnham College;
- Number 34 – Henry Booth, founder and director of the Liverpool and Manchester Railway Company;

- Number 43 - C. Thurstan Holland CHM FRCS LLD, pioneer of radiology;

- Number 54 - Dr. W. H. Duncan, the country's first Medical Officer of Health, after whom a well known Liverpool pub has been named;

- Number 80 - Lytton Stachey, biographer, historian and member of the Bloomsbury Group.

Please bear in mind that the plaques are not all the same and some are easier to see than others. The more observant may even find the stone plaque on No. 43 house saying that it is the Honorary Hungarian Consul.

Rodney Street was named after Admiral Lord George Rodney, First Baron Rodney (1719-1792), an illustrious character who achieved the Navy's highest honour by being made Vice Admiral of Great Britain. He was also an elected Member of Parliament, but is best known for defeating the French at Les Saintes, keeping Jamaica a British colony.

When visiting Rodney Street, bear in mind that the houses and street furniture in it are mostly Grade II Listed and take a little time to reflect upon the fact that Liverpool has more Georgian buildings than the city of Bath. Perhaps this is one of the reasons why, after London, it's claimed to be the most used city film location in Britain.

Do not forget that Rodney Street is the home of its own pyramid in the churchyard of St. Andrews.

See also: **Pyramid** and **Roscoe Gardens**

ROPEWALKS
(An up and coming area of the city)

This sector of the city, with its abundance of historic warehouses and merchants' homes derives its name from the industry that used to dominate the area. The long straight city streets were ideal for the twisting of the ropes needed by the many sailing ships using the busy port. The rope-making business in Liverpool was doing well until the late 19th century when sailing ships were being replaced by motor vessels. The rate of decline gradually worsened and eventually became severe. With the lack of business the area went into decline and it wasn't until the late 1990s that things started to look up when funding was allocated for the area's regeneration, development and conservation.

There are 95 listed building within the 37 hectares (91.4 acres) of Ropewalks. The long and narrow streets have remained mostly unchanged for the last two hundred years though a great many buildings have now been refurbished as apartments and penthouses with the return of the popularity of city centre living. New building has taken place wherever there's been a convenient gap as the area has become more popular.

This section of the city centre has become in vogue with design, media and publishing business. It has also become rather cosmopolitan and the many bars and cafés have made it an increasingly trendy spot. FACT, the UK's leading agency for the commissioning and presentation of film, video and media art is situated in the Ropewalks, as is the Open Eye Gallery, a leading UK and European photographic gallery.

Ropewalks, one of the six areas of the city given World Heritage status in 2004, is the home of Liverpool's Chinatown, the oldest in Europe, which started in the 19th century with an influx of

Chinese sailors passing through the port. It also contains the largest Chinese arch outside of Asia.

See also: **China Town**; **Chinese Arch**; **FACT** and **Open Eye Gallery**

ROSCOE GARDENS
(A pleasant little garden in a busy city centre)

Towards the bottom of Mount Pleasant, behind Renshaw Street and in sight of the Adelphi Hotel, you will find the small but pleasant and tranquil Roscoe Gardens. It is a memorial to the Renshaw Street Unitarian Chapel, built in 1811 and vacated in 1899, which had its graveyard on this site, a pillared gazebo-like structure which was erected in 1904. It bears two plaques dedicated to the writers William Roscoe (1753-1831) and Joseph Blanco White (1775-1841) both of whom were buried there.

William Roscoe was a poet, historian, solicitor, botanist and, at one time, a Member of Parliament. He was the first president of the Liverpool Royal Institution and an Honorary Associate of the Royal Society of Literature. He spoke English, French, Italian and Greek and he wrote tracts on legal jurisprudence. He was also a courageous and upright fellow as, in the face of much opposition, he publicly denounced the African Slave Trade. It is said his abolitionist stance outraged the city's merchants, heavily into the Slave Trade, and that this cost him his parliamentary seat.

In 1799 Roscoe acquired a herbarium which was to become part of the Liverpool Botanical Collection which he founded in 1802. In 1909 this was transferred to what is now the World Museum Liverpool.

When Roscoe became bankrupt in the early 19th century and was forced to sell his extensive library, his friends bought various books from his vast collection and presented them to the Athenaeum so that he, as a Proprietor, would still have access to them. In 1819 the Royal Institute acquired 37 paintings from the Roscoe collection and these were put on display in a purpose built gallery next to their premises. This eventually led on to the founding of the Walker Art Gallery.

Joseph Blanco White was in fact José Maria Blanco y Crespo. He was a poet who composed in both Spanish and English, a literary critic, a novelist, an essayist, a journalist and religious controversialist. He was ordained a Catholic priest , but later took Anglican orders when he was living in England. In his political writings he was an early advocate of Spanish American independence and in his religious writing he was a rationalistic critic of orthodox theology and his work influenced both Anglican and Unitarian thought.

In his later life White was befriended by William Rathbone who, by chance was a friend of William Roscoe. There are memorial plaques to both William Roscoe and Joseph Blanco White in the Ullet Road Unitarian Church.

See also: **Adelphi Hotel**; **Athenaeum**; **Ullet Road Unitarian Church**; **Walker Art Gallery** and **World Museum Liverpool**

RUMFORD PLACE
(Home of the 'Confederate' Embassy)

At the outset of the American Civil War in 1861, 60% of the cotton produced in the Southern States came through the Port of Liverpool on its journey to the mills of Lancashire. There are many reminders of the American influence in Britain with the biggest number being in Liverpool and Birkenhead. Examples

of this can be seen in the architecture of Abercromby Square, but of all Liverpool's connections with the Confederate States, Rumford Place is probably the most famous.

Many Liverpool businessmen and merchants supported the Southern (Confederate) states during the American Civil War. The firm of Fraser, Trenholm & Co. was managed by Charles Kuhn Prioleau of Savannah, Georgia, who was, perhaps, the greatest of these supporters. While he was in Liverpool Prioleau rented Allerton Hall, so that he could escape from the city to a quieter and more rural area. While he was residing here Prioleau commissioned the building of No. 19 Abercromby Square in the early 1860s, bringing further influence of the southern states of America to Liverpool.

The offices of Fraser Trenholm & Co. were in the centre of the city's commercial district at Alabama House, 10 Rumford Place. They managed the Confederate funds abroad and acted as the commercial and financial agent for the Southern Government making their premises effectively the 'Confederate Embassy'. This is now a Listed Building and was refurbished in the 1990s. Above the archway leading into the courtyard was a plaque bearing representations of President Jefferson Davis (who stayed at the Adelphi Hotel when he visited the city in 1868, three years after the civil war had ended), James Dunwoody Bulloch and Raphael Semmes. There are also several plaques in Rumford Place and Rumford Court that are a reminder of Liverpool's association with the Confederacy.

Fraser Trenholm & Company negotiated with the Birkenhead shipbuilding firm, Laird and Sons, to build a ship for the Confederate Navy. The CSS Florida was built in Liverpool and the CSS Alabama was built in Birkenhead. The last formal surrender of the war took place aboard the CSS Shenandoah in the original dry dock where the CSS Alabama was fitted out. This site is now preserved by order of British Heritage.

The Confederate Navy had their offices at 6 Rumford Place. Their agent, Commander James Dunwoody Bulloch, a nephew of Teddy Roosevelt, lived there , but was only known simply as James Bulloch, as his mission was highly secret and he needed to remain incognito. This was especially important as, round the corner in Tower Buildings, was the Union Consul with Thomas Haines Dudley and his force of private detectives. It is highly probable that, in 1862, Bulloch met with Raphael Semmes at No.6, to plan for the cruise of *CSS Alabama* which was hijacked by a confederate raiding party after she was completed.

Many of the buildings in Rumford Place are listed Grade II and have been renamed. Number 6 is Alabama House and 10 Bulloch House; both British and American flags are still flown there.

Bulloch was never pardoned for his actions and stayed in the city. He became a British citizen and set up business as a cotton trader. He is buried in Toxteth Park Cemetery and the headstone bears the inscription 'An American by birth, an Englishman by choice'.

See also: **Abercromby Square**; **Allerton Hall** and **Dickens, Charles**

St. GEORGE'S CHURCH
(The world's first iron church)

St. George's, Everton, was built between 1812 and 1814 to the design of Thomas Rickman and John Cragg. All the pieces of the church were cast in John Cragg's factory. He was said to be, understandably, something of a cast iron fanatic. The individual pieces for the church were taken to the site on horse drawn carts, where they were bolted into place. In all probability this was the, first use of large scale prefabricated construction and the worlds first iron church. The church was given an external

covering of sandstone to give it a more traditional appearance. The success St George's Church no doubt helped the speedy expansion of the export of prefabricated iron buildings from the Port of Liverpool.

The site of the church is claimed by some to be the highest land point in the city and it is in this vicinity that Prince Rupert made his first camp prior to the siege of Liverpool in June 1644.

St. GEORGE'S HALL
(The largest neo-classical building in Europe)

The foundation stone for St. George's Hall, St. George's Place, off Lime Street, was laid on 28th June 1838 in a ceremony to celebrate the coronation of Queen Victoria taking place on the same day. At the time no plans existed for the building, and a competition was held for architects to submit designs. A second competition was also underway for the design of a new assize court, Liverpool having become an assize town in 1835. In the event, both competitions were won by the young and relatively unknown architect, Harvey Lonsdale Elmes who also designed Allerton Towers.

St. George's Hall is on the site of the first Liverpool Infirmary and was built for the city's Triennial Music festivals. The actual construction started in 1842 and continued until 1854. The completed 420 feet (128m) long building opened with a three day musical event in September 1854. Queen Victoria visited Liverpool in 1851 when the hall was under construction and described it as being worthy of ancient Athens. Lonsdale based the design of this monumental hall on a Greek temple and its position was chosen as the building's height, elevated by its high podium, would help it to dominate its surroundings. It lived up to its design as a splendid reflection of the prosperity of the city which, at the time, was arguably the fastest growing city in Europe.

Elmes died in 1847 and didn't see the completion of his designs. In 1851 Charles Robert Cockerell took charge of the architecture. He changed the interior design including the Small Concert Hall, also referred to as the Golden Concert Room.

St. George's Hall, one of the finest neo-classical buildings in the world, was originally intended just for music festivals, but as Elmes had also been commissioned to design new law courts and for financial reasons, the courts were built adjacent to each end of the Great Hall. During the time the courts were in use 132 men and 7 women received the death penalty. The interior of the building is dominated by the Great Hall, which is quite large, being 169 feet (51.5m) long and 74 feet (22.56m) wide. It was Cockerell's idea to cover the floor with 30,000 magnificent hand-crafted Milton tiles depicting tritons, sea nymphs and boys on dolphins, as well as the city's coat of arms. As they are so valuable the sunken central section is covered for the vast majority of the time though a viewing window has been installed so the beauty of the tiles can be appreciated by visitors.

St. George's Hall also boasts the world's first air conditioning system. It was constructed in 1851 to the design of Dr. David Boswell Reid. Fresh air was drawn in before being washed to remove any pollutants prior to heating or cooling. Stale air was extracted through the roof. The system was specifically designed not to take air from the east side of the building as there was a cemetery close by.

When the hall was opened it contained the largest pipe organ in the United Kingdom though St. George's lost this claim to fame in 1871, with the building of a larger one for the Albert Hall. The organ was originally powered by steam engine and hand pump, but in 1931, when it was enlarged from 100 to 120 stops it was converted to electro-pneumatic action. The Hall continued to house the second largest organ in the UK, until another larger one was built for our own Anglican Cathedral. It does, however,

remain the third largest in the UK. The addition of the organ, with its 7737 pipes, was another of Cockerell's innovations but it did not fit Elme's original plans so marble columns had to be removed to accommodate it. They were later used to enhance the entrance to Sefton Park.

There are 12 statues placed around the perimeter of the Great Hall representing:

- **Reverend Jonathon Brooks**, Senior Rector and Archdeacon;
- **Sir William Brown**, a Liverpool cotton Merchant and benefactor of the Free Public Library, after whom William Brown Street was named;
- **William Ewart Gladstone**, four times Prime Minister;
- **Samuel Robert Graves**, merchant and shipowner;
- **Reverend Hugh M^cNeile**, curate of St. Jude's and St. Paul's;
- **Joseph Mayer**, principal founder of Liverpool museum;
- **Sir Robert Peel**, founder of the modern Conservative Party;
- **William Roscoe**, slavery abolitionist and patron of the arts;
- **Edward Stanley**, scholar, statesman and former Prime Minister;
- **Frederick Stanley**, 16th Earl Of Derby and owner of Knowsley Hall;
- **George Stephenson**, inventor and railway pioneer;
- **Edward Whitely**, a solicitor who held local public office.

On the south end of the hall was, until 1984, Liverpool's only criminal court, which has subsequently been moved to the Queen

Elizabeth II Law Courts. Many famous trials were heard here, with that of Florence Maybrick in 1899, being one of the most well remembered. Florence was found guilty of murdering her husband, James by soaking flypapers in arsenic and was duly sentenced to death. Her death sentence was reprieved when it was discovered that her husband had been self-administering the poison and she served 15 years imprisonment. After her release she returned to her native America, retuning only once to England to see the Grand National at Aintree Racecourse.

William Schwenck Gilbert worked as a barrister in the courts until he gave it up to collaborate with Arthur Sullivan to create their famous series of comic operettas.

A regular visitor to St. George's Hall was the well known author, Charles Dickens, who held many of his readings and theatrical performances in the Small Concert Hall. It was here that he gave the world's first public reading of 'A Christmas Carol'. Before Dickens's final departure for America he was made an honorary member of the Literary and Philosophical Society and a grand banquet in his honour was held in St. George's Hall with people paying to see Dickens and his guests partake of the feast. It was reported that there were 600 feasting with 500 viewing.

St. George's Hall is Grade I Listed and recently underwent extensive restoration to return it to its former glory in time for 2007, the city's 800th birthday. Included in the restoration schedule were several historic rooms, the Small Concert Room, the North Entrance, areas of the Great Hall and the Crown Court and cells. In addition to this chandeliers were repaired and the floor of the Great Hall was partially glazed to enable visitors to see the magnificent hand-crafted Milton tiles. The Willis organ had its 7,737 pipes dismantled so that the original leather bellows could be repaired. A visitor's centre was also created. The Hall was officially re-opened by HRH Charles, the

Prince of Wales on 23rd April 2007, St. George's Day, when he described it as 'a jewel in the city'.

At the top of the steps leading up to the main entrance is a portico of sixteen Corinthian columns, each 60 foot (18.29m) high. At the base of the steps, on St. George's Plateau, is Liverpool's Cenotaph, commemorating all those who have fallen in the service of their country. On the plateau there are also equestrian statues of Queen Victoria and Prince Alfred by T. Thorneycroft (1870) and a memorial to the Battle of the Atlantic, which had its headquarters in Western Approaches in Exchange Buildings. Looking as if they are guarding the plateau and hall are four recumbent lions marking the formal entrance. They were designed in 1855 by C.R. Cockerell and carved by W.G. Nicholl. Like the statues on the plateau, the lions are Grade II Listed.

At the rear of the hall is a refuge for weary city workers who can spend their lunch breaks in the tranquil surroundings of St. John's Gardens.

☎ 0151 233 3000

See also: **Anglican Cathedral**; **Dickens, Charles**; **Grand National**; **Knowsley Hall**; **St. John's Gardens**; **Sefton Park**; **Western Approaches** and **William Brown Street**

St. JAMES' MOUNT AND GARDENS
(The original cemetery to the Anglican Cathedral)

St. James' Mount was first laid out in 1767 and now has the Anglican Cathedral within its grounds. The original lodge for the garden still stands on Parliament Street, though access is gained via a tunnel adjacent to the north end of the cathedral or by a ramp situated between the south end and Upper Parliament

Street. There used to be two windmills on the site, but in 1800 the last of these was removed.

The site of the garden started life as a quarry for the stone used to build many of the city's prestigious buildings. By 1825 the quarry was exhausted and was then put to use as the cemetery of St. James' Church, with nearly 60,000 bodies being interred there. After the last burial took place in 1936 the cemetery gradually fell into a state of disrepair and, in 1972, the 10 acre (4 hectares) plot was finally converted into a public garden. Many headstones were re-sited or removed, but other features were retained. Amongst these are the ramps used by horse drawn carriages taking coffins down to over 100 catacombs. The ramps had to have high sided walls to prevent the hearses sliding off and dropping the coffins.

While stone was being quarried in 1773 a spring was discovered. Since that date it has continued to run with water and has never run dry. This chalybeate spring (containing iron salts) was believed to have health-giving properties and became known as the Liverpool Spa. It was believed that drinking the water was a cure for nervous disorders, eye problems and rheumatism.

There is a local legend regarding the spring and Kitty Wilkinson, inventor of the public wash house. As a result of her association with water the legend claims that the spring came into being after Kitty Wilkinson was buried near the site. As she died in the 19th century and the spring dates back to the 18th century this tale is obviously untrue. What is a fact is that in its time the spring has caused bones in the catacombs to loosen and even wash away. In the 1970s one local schoolboy had the misfortune of discovering a human skull that had been set free by the force of the water from the spring.

The Grade I Listed Oratory, a mortuary chapel designed by John Foster Junior, was completed in 1829 to replace the original chapel. At the gates of the Oratory is the first piece of public art by the celebrated artist, Tracey Emin. Her 'Roman Standard' is a tribute to the Liver Bird, the symbol of the city. The sculpture is also known locally as 'Bird on a Stick', a good description as, this slender work of art is easy to miss.

The gardens also contain the mausoleum of the Sir William Brown, after whom William Brown Street is named, and that of the Liverpool MP William Huskisson. He was the first person in the world to be killed in a railway accident. He managed get himself knocked down by *The Rocket* at the opening of the Liverpool to Manchester railway on 15th January 1830 and eventually died from his injuries.

See also: **Anglican Cathedral**; **William Brown Street** and **Wilkinson, Kitty**

St. JOHN'S GARDENS
(A city centre park)

St. John's Ornamental and Memorial Garden, opened in 1904, was laid out by Thomas Shelmerdine, the Corporation Surveyor, and is thought to be based on an original plan by the sculptor George Frampton, who provided some of the works now on display there. It lies to the rear of St. George's Hall and takes its name from the church that once stood on this site. The gardens slope away from the Hall towards the entrance of Queensway, the first Mersey Tunnel for road users. The garden, which was credited with Green status in 2003, has formal lawns and flowerbeds, dissected by symmetrical pathways and has been nicknamed 'Liverpool's al fresco Valhala' as it contains statues and memorials to many notable Liverpudlians.

Some of the statues are the work of eminent Victorian sculptors and, as a reflection of their historic and architectural importance, the monuments, garden, gate piers and terrace are now all listed. The Grade II Listed statues include:

- **William Gladstone** – four times Prime Minister by Sir Thomas Brock
- **Canon T. Major** – the founder of Liverpool's child charities by George Frampton

- **Monsignor James Nugent** – who took care of the orphaned children of Liverpool by F.W. Pomeroy

There are many plaques and Memorial trees in the garden. Look out for the one in French and English dedicated to prisoners of the Napoleonic War who died in captivity. It bears the inscription:

'**To her sons who died in captivity in Liverpool in 1772/1803 and whose bodies lie here in the old cemetery of St John The Baptist. France ever grateful**'

At one point in the history of the gardens bands used to play in the lunch hour during the summer months, but this quaint tradition ceased many years ago.

See also: **Parks and Gardens**; **Queensway** and **St. George's Hall**

St. LUKE'S CHURCH
(The 'Bombed Out Church')

After you've finished your sight seeing and shopping in Church Street take a stroll along Bold Street where, at the end you

will see what is left of St. Luke's Church, known locally as the 'Bombed Out Church'. It was designed by John Foster in 1802 and later reworked and completed in 1831 by his son, also called John.

In 1941 it became an unfortunate casualty of the Blitz. All that remains of the original church is the shell of the nave, the chancel and the tower. The building was declared to be beyond repair and, after some work to make it safe, it was left as a memorial to the casualties of the Blitz of Liverpool. St. Luke's, a Grade II Listed Building, stands in its own garden which has been cultivated to provide a place of peace and calm in the busy city centre where it remains a very familiar landmark. Here you can see the Irish Famine Memorial by Eamonn O'Docherty, commemorating the potato famine of 1845-1852, a natural disaster which saw many Irish families emigrate, particularly to Liverpool.

See also: **Church Street**

St. NICHOLAS' CHURCH
(The Parish Church of Liverpool and the oldest Anglican Church in the city)

It is thought that by 1257, some 50 years after Liverpool had been granted its charter from King John, a small stone chapel had been built close to the site of the present day St. Nicholas' Church, Chapel Street. It was known as the Chapel of S. Mary del Key. With the expanding population, a larger place of worship was soon called for and in 1355 the construction of a new chapel, dedicated to Our Lady and St. Nicholas, patron saint of sailors, was started. This church was added to, repaired and expanded over the following centuries.

Until 1767, when a dock was constructed on what is now the site of the Liver Buildings, the River Mersey reached the church wall at high tide. From 1758 to 1772 the river was defended by a battery of guns on an extension of the burial ground. The original tower collapsed in 1810, falling on to the unfortunate crowd below and killing 25 people, 21 of them being children. The present tower was erected by 1815 and the building remained unchanged until December 1940, when it was gutted by fire during one of the many war time raids on the city. The tower, vestries and adjoining offices are all that remain of the old church.

The present day Grade II Listed Building was designed by Edward C. Butler, with some major changes to the original church. One of these being that, contrary to universal tradition, the altar is in the west of the church, below the tower, rather than the east. Usually the focus of a church is on the pulpit, but here it is on the sanctuary. The church was consecrated in 1952.

In the entrance vestibule, the narthex, are five display panels that illustrate the history of the church and parish. The glass screens that separate the narthex from the nave are to the design of David Peace, whose work can also be seen in Westminster Abbey. Whilst admiring his handiwork, see if you can spot the engraving of a teddy bear and A.A. Milne's Piglet.

In the rood is the figure of Jesus Christ with Our Lady and St. John carved from the old oak bell frame of the tower. In the Maritime Chapel of St. Mary del Key, facing the altar is the bronze statue by Liverpool artist Arthur Dooley, showing Our Lady standing on the prow of a ship. If you would like to see additional religious sculpture by this artist take a trip to Princes Road Methodist Centre and admire the crucifix on the exterior wall.

The lantern tower is 53m (175ft) in height and used to be the most prominent landmark on the waterfront until the large buildings were erected at the Pier Head. This made it the last landmark that sailors would see as they left for the high seas and the first landmark to be sighted on their safe return. The tower is topped with a 1.3m (43ft) gilded copper weather vane in the shape of a sailing ship that had also graced the original tower. In 2005 an appeal was launched to restore the crumbling tower and it was decided to rename it Landmark Tower. The churchyard became a public garden in 1891 and is dedicated to James Harrison, whose shipping company still has offices facing it. The statue of Christ entering Jerusalem, Christ on an Ass, was sculpted by Brian Burgess and the Blitz memorial is the work of the sculptor Tom Murphy.

As you stand at the door to the church take a look at Mersey Chambers that stands in The Old Church Yard. There you will see a little known Liver Bird perched high up and looking out to sea.

See also: **Liver Birds**, **Liver Building** and **Monuments and Statues**

St. PETER'S CHURCH
(With its pre-Raphaelite stained glass windows)

The people of Woolton once worshipped in All Saints Church, Childwall, and this practise continued until the beginning of the 19th century. As the population of the village increased in the early 1800's, the need for a larger and more local church became apparent. The foundation stone of St. Peter's Church, Church Road, Woolton, was laid on 22nd July 1825 by the future 13th Earl of Derby, resident of Knowsley Hall and the completed church

was opened in 1826 with the parish being formed in 1828.
St. Peter's Church was soon seen as being far too small for the
parish it was serving so, the Grecian style church was demolished
and the new neo-Gothic style church was built on the same site.
This opened in 1887 and is now a Grade II* Listed Building.

The church tower, with its ring of eight bells is the highest point
in Liverpool being approximately 75 metres (246 feet) above
sea level. The church boasts many fine stained glass windows,
mainly by Charles Kemp but, should you visit, you will see two
windows by the famous pre-Raphaelite artist, William Morris
who also made windows for All Hallows Church.

See also: **All Hallows Church** and **Knowsley Hall**

SANCTUARY STONE
(A place of safety for those in financial difficulties)

If you're walking down Castle Street, away from the Victoria
Monument towards the Town Hall, pause when you're about
three quarters of the way along by the Natwest Bank, and keep
a look out for a plaque on the left. It indicates the position of a
green Sanctuary Stone close by, set in the road. There had been
a second sanctuary stone in Dale Street but this was removed
100 years ago. These two stones are said to have marked the
precincts of the old Liverpool fairs.

In medieval times any one in debt could stand in the area
between the two stones and be safe from their creditors.

See also: **Town Hall** and **Victoria Monument**

SCIENCE MUSEUM
(A must for families and children)

The Catalyst Science Museum, Mersey Road, Widnes, (near Liverpool), is the only science centre (and museum) solely devoted to chemistry and the use of the products of chemistry in every day life. Catalyst is not part of National Museums Liverpool, but is funded by a partnership between chemical firms, government and the European Union.

The Science Museum offers family-orientated fun attractions with an educational focus, reflecting the National Curriculum. Schools particularly enjoy the four interactive galleries with over 100 different exhibits, including 'Scientrific' and 'Birth of an Industry'. A scenic glass lift takes visitors to the roof-top Observatory where they can enjoy panoramic views across Cheshire. There is a shop with a wide range of scientific toys, souvenirs and gifts, and the Elements Café. Parking is free.

☎ 0151 420 1121

SEFTON PARK
(Liverpool's Hyde Park)

The land that is now occupied by Sefton Park and its surrounding houses was originally part of the considerable Royal Deer Park of Toxteth. In 1886 Liverpool City Corporation purchased it from Lord Sefton for the sum of £250,000. Covering some 200 acres (81 hectares), Sefton Park was designed by a Liverpool architect, Lewis Hornblower and the Gardener in Chief of Paris, Edouard André, so that it resembled natural landscape. They won the competition to design the park in 1867 and were rewarded with a prize of 300 guineas (£315).

The park, once referred to as Liverpool's Hyde Park, makes use of two branches of a Mersey tributary to create a spinal watercourse and contains distinctive curved paths and driveways with many indigenous British trees. There are rock features and grottoes among the woodland clumps, helping to create a spacious landscape. The park is surrounded by a road, but a weakened bridge means that it is no longer possible to drive completely around it.

Among Sefton Park's many features are:

- **The Boating Lake,** this 7 acre (2.8 hectares) water feature is fed by two streams, the Lower Brook or Lower Jordan, which runs south from Old Nick's caves Mossley Hill Caves and the Upper Brook or Upper Jordan which flows through Greenbank Park and enters Sefton Park beneath the iron bridge;

- **The Aviary Café;**

- **Cleopatra's Needle**, This needle was built with two drinking fountains, each bearing the inscription:

'WHOSOEVER DRINKETH OF THIS WATER SHALL THIRST AGAIN: WHOSOEVER DRINKETH OF THE WATER THAT I GIVE HIM SHALL NEVER THIRST'

This obelisk was erected in dedication to Samuel Smith, a councillor and cotton broker who popularised Indian cotton;

- **Eros,** a Grade II Listed replica of the Shaftsbury Memorial by Sir Alfred Gilbert;

- Marie Curie's **Field of Hope**, the sight of millions of daffodils every spring draws residents from across the city during spring;

189

- **The Palm House,** a magnificent Grade II* Listed Victorian glass house. This was a gift from Henry Yates Thompson, the grand-nephew of Richard Vaughan Yates of Princes Park fame;

- **Peter Pan,** a Grade II Listed bronze statue by Sir George Frampton. This famous statue was donated to the park by George Audley of Birkdale and it was unveiled on 16th 1928 in the presence of Sir James Barrie, the creator of Peter Pan,

- An **iron bridge,** spanning the **Leafy (Fairy) Glen**;

- **Tennis courts.**

The buildings, monuments, statues, grotto, tunnel, bandstand and drinking fountains are nearly all Grade II Listed.

The Park was officially opened to the public on 20th May 1872 by the third son of Queen Victoria, Prince Arthur, and the event included a procession of nearly eighty carriages. A purpose-built grandstand accommodating 5,000 was provided for spectators and the event was reported in the Illustrated London News.

Sefton Park was envisaged as a welcome escape for the populous from the overcrowded and squalid streets of Liverpool and, in its hey day, it led the way in providing club houses and pavilions to cater for the needs of people's pastimes. Sadly few of these are in existence today.

As with Calderstones Park and Princes Park the Trans-Pennine (Route 561) passes through part of the park.

In January 2008 a multi-million pound project started on the regeneration of the park. In addition to the restoration and improvement of the watercourses, work being undertaken

included the restoration of Eros, the bandstand and the building of a new jetty.

See also: **Calderstones Park**; **Palm House**; **Parks and Gardens**; **Princes Park** and **Sefton Park**

SLAVERY REMEMBRANCE DAY
(To remember the victims of the Transatlantic Slave Trade)

Slavery Remembrance Day is an annual event held on 23rd August to commemorate the lives and deaths of millions of enslaved Africans and their descendants who were central to the rise of Britain as an industrial power.

All the activities surrounding Slavery Remembrance Day are thought-provoking and, in spite of commemorating such a sad period of history, are enjoyable, including events ranging from cultural food stalls and family fun to music and drama performances showcasing black culture and heritage. All are welcome.

An African chief and community leaders take part in a traditional African libation ceremony calling upon ancestors to bless the event. This involves the pouring of water or wine in a special pattern while homage is paid to the ancestors.

There are often other events leading up to the day, including the Slavery Remembrance Day Memorial Lecture, which is usually presented by an eminent historian, author or playwright.

☎ 0151 478 4543
🖳 www.liverpoolmuseums.org.uk

See also: **Festivals** and **International Slavery Museum**

SMALLEST HOUSE IN ENGLAND
(An incredibly small domestic dwelling)

This tiny house, 95 High Street, was built around 1850 and is only a short distance from Picton Clock and the Mystery. The modest dwelling couldn't have taken long to construct, as it was a mere 6 feet (1.83m) wide and 14 feet (4.27m) deep.

The last tenants to occupy the house vacated it in 1925 and it remained empty until 1952. It was taken over by the owners of the neighbouring public house, the 'Cock and Bottle' and the side wall was knocked through so that the building became an integral part of the pub. In 1998 the owners of the Cock and Bottle had the external appearance of the house restored.

The Cock and Bottle is next to Wavertree Town Hall, built in 1872 to serve as the headquarters of the Wavertree Local Board of Health, when Wavertree was a town in its own right. It wasn't until 1895 that Wavertree was eventually absorbed by the city of Liverpool. Like many suburbs of Liverpool, but unlike the city itself, Wavertree was mentioned in the Doomsday Book. The emblem of the former township can still be seen above the main doorway.

When the house was in use, it must have been very cramped inside, especially as some of the families who lived there are said to have been fairly large, having as many as eight children. The occupants did, however, have the fortune not to need a time piece as, if they needed to know the correct time, all they had to do was lean out of the front room window and look at Picton Clock Tower.

See also: **Mystery** and **Picton Clock Tower**

SPEKE HALL
(A splendid example of a Tudor manor)

Speke Hall, one of the finest Tudor manors in Britain, dates back to 1490, when the Norris family built their home 8 miles away from the tiny fishing village of Liverpool. Over the years, Liverpool has changed and so has Speke Hall, with various additions and alterations being made. The interior of this famous rambling timbered house spans many periods from Tudor to Victorian times.

The Great Hall is the oldest part of the house, dating back to early Tudor times, as does the Priest's Hole, an escape for Catholic clergymen hiding from the army. There are examples of fine Jacobean plasterwork and elaborately carved furniture. The Oak Parlour, along with some of the smaller rooms, reflects the influence of the Victorians, with examples of original William Morris wallpaper still evident in the building. There is a fully equipped Victorian kitchen and servants' hall which enables visitors to imagine what life was like for the workers behind the scenes.

Other attractions within this National Trust house include a 'thunderbox toilet' and a life size portrait of John Middleton, the Childe of Hale, in the Great Hall. If you're very lucky, you might even see the ghost of Mary Norris, the Lady in Grey. She is said to be doomed to wander the bedrooms of the Hall searching for her lost child who, some claim, she threw out a window after discovering that her husband had squandered all their wealth gambling. This story has not been historically verified and many believe it to be fictitious, It remains a good tale, especially as the Lady is said to have run down to the kitchen and stabbed herself to death after sending her offspring to a watery grave. Some of the guides have claimed to have seen a woman glide along before disappearing into the floorboards and the heavy

oak cradle in the Oak Bedroom rock mysteriously, as if pushed by an unseen hand. As the cradle is not originally from Speke Hall, it cannot be associated with any of the tales regarding the spectre.

Speke Hall, with its dry moat, has landscaped gardens and woodland walks that provide magnificent views of the River Mersey Basin towards Wales. A five minute walk from the house will bring you to Home Farm, a restored Victorian farm building where on selected days of the week a restored Nornsby Ackroyd engine is put in operation. There is also a children's play area and an orchard.

James Abbott McNeill Whistler, famous for his portrait of his mother, often stayed at Speke Hall and produced many sketches of the house which can be viewed in the Walker Art Gallery.

The site of Speke Hall was mentioned in the Doomsday Book and for many centuries the Speke estate provided oak for the construction of Royal Navy ships at Liverpool shipyards.

Speke Hall is closed to the public from December to March

☎ 0151 427 7231
🖳 spekehall@nationaltrust.org.uk

See also: **Childe of Hale** and **Walker Art Gallery**

SPIRIT OF LIVERPOOL
(Based on Minerva, the Roman goddess of wisdom)

As you stand outside the Walker Art Gallery on William Brown Street, look up and you will see an imposing statue upon its roof. If you ask about the statue that adorns the roof of the gallery,

many people will tell you that it depicts Britannia, but that is a fallacy. Others may claim that, as on the dome of the Town Hall, it is Minerva. This too, is incorrect, although it is based on her. The statue is in fact the 'Spirit of Liverpool', sculpted by John Warrington Wood in the 1870s.

It is an allegorical piece of work with the immense royal woman wearing a crown and laurel wreath on her head. Instead of a throne, she is sitting on a bale of cotton, representing Liverpool's industry and trade. Symbolising domination over the sea, she is holding a trident in her right hand and a ship's propeller in her left. At her feet are a compass, a painter's palette and a setsquare. Look carefully by her left hand and you will see a Liver Bird.

The original statue had to be taken down in 1966 as it was considered to be structurally unsafe and there was a strong possibility that large portions of it might fall. During 1993 and 1994 the 41 ton (1016kg) replica that adorns the roof of the gallery was carved from a piece of Chinese marble. The original statue is now housed in the Conservation Centre.

See also: **Liver Birds**; **Town Hall**; **Walker Art Gallery and William Brown Street Conservation Area**

STANLEY PARK
(The jewel of the north end of the city)

Stanley Park is often considered to be the most noteworthy of all the parks in the city because of its layout and the architecture of the buildings within it. The 45 hectare (111acre) park was opened in May 1870 by the City's mayor.

The park was designed by Edward Kemp. His design included large scale bedding schemes featuring many fountains, formal

gardens, a conservatory, ornamental lakes and a grand sandstone terrace interspersed with majestic shelters. It is claimed that on clear day the Pennines can be seen from the terrace. Over half of the park consisted of open grass areas which could be utilised for sports. Kemp even included 'Rotten Row', a horse riding track, but in 1907 it was converted to a cycle track.

In 2007, restoration work was started to return the park to its Victorian grandeur following Kemp's 1866 plans. This regeneration included the restoration of the lakes and the Grade II Listed Isla Gladstone Conservatory, which was constructed by the same firm responsible for Sefton Park's Palm House. Isla Gladstone was a local artist and textile designer in the Arts and Crafts movement of the turn of the last century and was famous for her floral prints. She was a member of the family which included William Gladstone, former Prime Minister, who was born and brought up in Rodney Street.

See also: **Parks and Gardens**; **Rodney Street** and **Sefton Park**

STEBLE FOUNTAIN
(A gift to the people of Liverpool)

Next to the Wellington Column on the corner of William Brown Street and Lime Street is the Steble Fountain, so named because it was a gift to the city from Colonel R.F. Steble who, from 1874-1875, was Mayor of Liverpool. The fountain was designed by W. Cunliffe and consists of a bronze centrepiece depicting the four seasons standing in a circular stone basin. Steble Fountain is Grade II* Listed.

See also: **Wellington Column**

SUDLEY HOUSE
(The home of Britain's only surviving merchant art collection)

The exact date and architect of Sudley House remains somewhat of a mystery but it is known that it was built for Nicholas Robinson, who was later to become Mayor of Liverpool. Robinson moved into the house in 1823 and after he died his two daughters continued to live there until their death in1833. The house was then purchased by George Holt, a merchant and member of a wealthy Liverpool family of ship-owners, who moved into the building in 1884. He made many alterations during his time there including moving the main entrance, creating a garden veranda and building a tower when he had the western end extended.

Holt had been collecting paintings since the late 1860s, concentrating initially on English landscapes but, starting with the acquisition of Millais' 'Vanessa' in 1885, he moved on to purchase portraits also. After Holt died his daughter, Emma, lived there until she too died in 1944 and the house and its contents were bequeathed to the city, becoming part of the National Museums Liverpool.

A visit to Sudley House has been described as a step back in time. Today, after major refurbishment, Sudley House remains one of the few Victorian homes with many of its original features intact and houses Britain's only surviving merchant art collection. The refurbishment included the addition of a new Toy Zone display of dolls and a children's area along with an education suite, a temporary exhibition gallery and a tea room. Visitors are able to view paintings by Gainsborough, Landseer, Reynolds and Turner. This Grade II Listed house also displays other works from the Walker Art Gallery including furniture by George Bullock.

Sudley House, Mossley Hill Road is open from 10a.m. to 5p.m. every day of the week and throughout the year Sudley House

offers special events and tours. There is no charge for admission but please be aware that parking facilities are limited.

☎ 0151 207 0001
💻 www.liverpoolmuseums.org.uk

See also: **National Museums Liverpool** and **Walker Art Gallery**

SUMMER POPS
(A celebration of music)

For several years, the site of the former Kings Dock was the venue of the Liverpool Summer Pops. With no purpose-built and suitable accommodation, the event took place within a very colourful, though temporary, tent structure close to the waterfront.

The Summer Pops have been very successful, attracting top rate, world famous, performers. They cater for everyone's tastes with pop, jazz and classical performances, including, of course, works played by the celebrated Royal Liverpool Philharmonic Orchestra.

The event continues to grow in strength and attracts more high profile artists every year. From 2008, the Summer Pops have taken place in the Echo Arena Liverpool, which was constructed on the same site, next to the Albert Dock.

See also: **Albert Dock**; **Echo Arena Liverpool**; **Festivals**; **Philharmonic Hall** and **Waterfront**

TATE LIVERPOOL
(The major centre for contemporary art in northern England)

Situated in the historic Albert Dock is Tate Liverpool, the first Tate gallery to be opened outside of London. This is quite fitting as its sister gallery, the Tate London, was a gift to the nation by the Liverpool sugar magnate, Sir Henry Tate.

This award winning gallery houses the National Collection of Modern Art in the North and is one of the largest galleries of contemporary and modern art outside the capital. It displays works from the Tate Collection and hosts special exhibitions, including pieces loaned from all around the world.
The displays and exhibits of contemporary and modern art from 1900 to the present day include photography, printmaking, and performance, in addition to paintings and sculpture. Throughout the year the Tate Liverpool is the venue for a variety of events including introductory tours and lectures. There are family events every held Sunday afternoon.

The Tate Liverpool is one of the main venues for the Liverpool Biennial, the UK's largest festival of contemporary visual art. In 2006, it was recognised as the most visited modern art gallery outside of London, and, when Liverpool was celebrating its 800th birthday in 2007, it was chosen as the venue for the Turner Prize, the first time this prestigious event took place outside of London.

Entrance to the Tate and all events are free of charge.

☎ 0151 702 7400
🖳 www.tate.org.uk/liverpool

See also **Albert Dock** and **Liverpool Biennial**

TENNIS TOURNAMENT
(An international event)

The month of June is a delight for tennis fans as, since 2002, Calderstones Park has been the venue for Liverpool's Annual International Tennis Tournament. The knock-out competition is the main attraction of this festival, which also offers wider mini-tennis events.

During the tournament week, nearly two thousand children from across Merseyside and Cheshire receive two hour specialist tuition classes from professional Lawn Tennis Association coaches, totally free of charge. The eager students are taught the basics of tennis including hand to eye coordination in addition to team and confidence building. During their break they are able to watch professional matches on the centre court. In addition to this fantastic opportunity they have the chance to see tennis legends such as Bjorn Borg, Martina Navratilova, Pat Cash, Goran Ivanisevic, Monsour Bahrami and Illie Nastase, all of whom have been known to play at this prestigious event.

See also: **Calderstones Park** and **Festivals**

THEATRES
(For an evening's entertainment)

There is no need to venture out to London or Manchester for a memorable evening's entertainment when, here in our vibrant city, we have many excellent theatres which offer performances that can rival any West End production.

Throughout the years Liverpool has always had countless theatres and music halls but, as in other major cities, many have long since gone. Listed below are the major theatres in production as we go to press.

Empire Theatre*
Everyman Theatre*
Neptune Theatre*
Playhouse Theatre*
Royal Court Theatre
Unity Theatre
See also: *Individual entries

TITANIC MEMORIAL
(A tribute to heroic engineers)

Liverpool, as home of the White Star Line, commissioned a memorial to the engineers of the ill-fated *RMS Titanic*. The heroic engineers remained at their posts to keep the electrical equipment and pumps working in an effort to keep the ship afloat for as long as humanly possible while passengers boarded the lifeboats. They undertook this task fully realising that they were placing their own lives in mortal danger.

Not many people realise that many of the crew on the *Titanic* were natives of Liverpool, including members of the orchestra that continued playing as the ship went down in an attempt to keep passengers calm.

The British Titanic Society still hold yearly meetings in Liverpool.

During the construction of the monument, the design was changed to include sailors lost during the First World War. It stands at the Pier Head, adjacent to the Liver Building, looking out across the River Mersey. The memorial bears the following inscription:

IN HONOUR OF ALL HEROES
OF THE MARINE ENGINE
ROOM THIS MEMORIAL WAS
ERECTED BY INTERNATIONAL
SUBSCRIPTION
MCMXVI

See also: **Buildings Worthy of a Second Look (White Star Line Building)**; and **Liver Building**; **Mersey, River and Pier Head**

TOWN HALL
(Home to the Lord Mayor)

In the heart of the Castle Street Conservation Area lies the Town Hall of Liverpool, one of the finest 18th century town halls in the country and one of the oldest historic buildings in the city. The high dome of this Grade 1 Listed Building Liverpool is topped with a statue of Minerva, Roman goddess of wisdom, taken from the Greek goddess Athena, though many, as with the Walker Art Gallery, mistakenly believe it to be Britannia. The 10ft (3.05m) statue is covered in gold leaf and is the work of Charles Felix Rossi, sculptor to King George IV.

There have been three town halls on the site of or in close proximity to the present building. The first was built in 1515, the second in 1673 and in 1749 the first stone of the present town hall was laid. The building was completed in 1754, but a short while later, in 1794, it was gutted by fire. Over the following years it was gradually repaired and restored. Further restoration work had to be undertaken between 1993 and 1995.

The main rooms in the Town Hall are:

- The Main Ballroom with each of its chandeliers weighing in excess of one ton and containing 20,000 pieces of crystal;

- the Small Ballroom boasting three cut glass chandeliers, each over 100 years old;

- the Dining Room with two great marble vases at each end of the room;

- the West Reception Room containing a full length portrait of Margaret Beaven, the first woman Lord Mayor of Liverpool;

- the Centre Reception Room providing access to the balcony, where Royal appearances and civic proclamations are made;

- the East Reception Room with its fine Regency furniture and portraits of ex-Mayors;

- the hall of Remembrance with the Roll of Honour of the 13,000 Liverpool men who fell during the First World War;

- the Council Chamber which seats 160 council members who meet on the first Wednesday in each month.

This stunning building is lit by crystal chandeliers and is full of works of fine art. The Town Hall can accommodate many people in all of its various rooms, including the Council Chamber and, should you have reason to celebrate or just want to party, rooms can be hired to suit your needs. The Town Hall remains one of the premier venues for weddings, breakfasts, lunches, dinners, conferences, meetings and exhibitions etc.

In September 1928 the Lord Mayor and a parade of distinguished citizens left the Town Hall on its way to the Pier Head, where Liverpool was officially married to the sea.

At the rear of the Town Hall is Exchange Flags, home of Liverpool's memorial to Admiral Horatio Nelson.

See also: **Nelson Memorial**; **eXchange Flags, Pier Head** and **Walker Art Gallery**

ULLET ROAD UNITARIAN CHURCH
(Possibly the most elaborate non-conformist ensemble in the country)

Work began on the Unitarian Church, Ullet Road, in 1896 and it opened in 1899, replacing the Renshaw Street Unitarian Chapel. After the congregation had moved to Ullet Road, the Renshaw Street chapel was closed and its site was later laid out as Roscoe Gardens.

This Grade I Listed Building was designed and constructed by Thomas Worthington and Son of Manchester. It has red brick stone dressings and a slate roof. Toward the south of the building are the vestry and the library, which have the original panelling, fire place and bookcases. The vestry's domed vault is adorned with Gerald Moira's painting of 'The Four Cardinal Virtues' while the vaulted ceiling of the library has Moira's 'The Pursuit of Truth'.

Like All Hallows Church, Allerton and St. Peter's Church, Woolton this building has stained glass windows by the celebrated pre-Raphaelite artists, William Morris and Edward Burne-Jones. The church is considered to be the most elaborate ensemble in the country.

In addition to its own plaque the church bears memorial plaques to William Roscoe and Joseph Blanco White, both of whom are also commemorated with plaques in Roscoe Gardens.

Opening times are by appointment.

☎ 0151 733 1927
🖳 ulletroad@unitarian.fsnet.co.uk

See also: **All Hallows Church**, **Roscoe Gardens** and **St. Peter's Church**

UNIVERSITIES
(All three of them)

Liverpool has three universities.

The oldest of these establishments, the University of Liverpool, also referred to as Liverpool University, can trace its history back to the end of the 19th century.

Liverpool John Moores University, named after the founder of the Littlewoods Empire, is the largest. Its history can be traced back to 1823 when it started life as a small college.

Liverpool Hope University is the youngest in the city and one of the newest in the country. Its history goes back to the mid 19th century and the establishment of two Colleges of Education for women.

Students who choose to move to Liverpool to undertake their studies often decide to stay here after graduation. In fact Liverpool has more graduates staying on than any other city.

See also: **Liverpool Hope University**; **Liverpool John Moores University** and **University of Liverpool**

UNIVERSITY OF LIVERPOOL
(One of the UK's leading research institutions)

During the 19th century, several attempts were made to create established colleges of higher education within the city, but it wasn't until 1881 that a Royal Charter incorporating University College Liverpool was obtained. This was only made possible with the generous support from business, professional and other sectors of Liverpool who raised sufficient funds to allow the endowment of a professorship.

The University College, one of the very first civic universities, opened its doors in January 1882 to its 45 day students, with a high proportion of them being local. Progress was rapid and in 1884 the Liverpool Royal Infirmary Medical School was incorporated into Liverpool University College, which now became part of the Federal Victoria University College. The year 1903 produced another Royal Charter and an Act of Parliament, which allowed the constitution of the University of Liverpool, permitting the University College Liverpool to confer its own degrees.

The present day university boasts seven faculties: Arts; Engineering; Medicine (incorporating the School of Dentistry); Science; Social and Environmental Studies, Liverpool School of Tropical Medicine and Veterinary Science. The number of students is now counted in tens of thousands.

To the people of Liverpool, mention of the university immediately conjures up a picture of the 'red brick' Victoria Building, historically the university's administrative centre. The term 'red brick' was first used by one of the university professors to describe the civic universities, built mostly toward the end of the 19th century. This, of course, means that Liverpool can claim to be the home of the original red brick university. In July 2008 the

new Victoria Gallery & Museum was formally opened within the building.

This epitome of Victorian university architecture on Brownlow Hill was opened in 1892, then the centre of a modest group of university buildings. It was designed by the Liverpool architect Alfred Waterhouse who also designed the former Liverpool Royal Infirmary, now taken over by the university, and the North Western Hotel, which is now student accommodation for the Liverpool John Moores University.
With the growth and expansion of the university over the years it now forms part of the 35 hectare (86.5 acre) campus which includes the stately Abercromby Square. Its recent developments include the Management School, opened in 2002 and a new Biosciences Centre which opened in 2003 for research, teaching and new biotech businesses.

The university is associated with eight Nobel Prize laureates in the field of science and medicine:

Sir James Chadwick, physicist
(1935, discovery of the neutron);

Professor Charles Glover Barkla, physicist
(1917, X-ray research);

Professor Har Gorbind Khorana, physiologist
(1968, the chemistry of the genetic code);

Professor Rodney Porter, physiologist
(1972, structure of antibodies);

Sir Robert Robinson, chemist
(1947, research in plant dyestuffs);

Sir Ronald Ross, physician – the first British recipient of a Nobel Prize for Medicine
(1902, discovery of the vector for malaria);

Professor Joseph Rotblat, physicist
(1995, efforts towards nuclear disarmament);

Sir Charles Sherrington, physiologist
(1932, the functions of neurons).

In 1902 Professor Oliver Joseph Lodge, later to be Sir Oliver, used X-ray photography to show a bullet that had found its way into a boy's wrist. This was carried out in the university's Physics Department and was the first time in the country that an X-ray was used for surgical purposes. Amongst other things, he invented the loudspeaker and the vacuum tube. He was the first person to transmit a radio signal, performing this task in Cambridge one year before Marconi. Whilst in Liverpool, he developed a coherer leading to the development of radio tuning. He also invented electric spark ignition for the internal combustion engine, which his sons later developed into the sparkplug. Sir Oliver was an ardent believer in an after-life and claimed that he would prove its existence by making public appearances after his death.

Whilst working as a lecturer in the university's medical school, Liverpool-born physician Richard Caton discovered the existence of electrical brain signals. He accomplished this by probing directly into the exposed brains of animals and in 1875 he published his results. He later went on to become Lord Mayor of Liverpool from 1907 to 1908 and, from 1921 to 1924, Pro-Chancellor of the university.

In the late 1940s Liverpool University had a synchrocyclotron built, giving them the most powerful particle accelerator

outside of America. This was built under the guidance of James Chadwick (later to be knighted), who had been bestowed with a Nobel Prize for his discovery of the neutron.

There are many other claims to fame that can associated with the university. When he was Professor of Bacteriology, Allan Downie was instrumental in the eradication of smallpox and the Honorary Lecturer in Anaesthesia, Dr. Robert Minnit developed the use of gas and air in childbirth. A slightly lesser claim to fame is that John Alexander Brodie, Liverpool City engineer and inventor of the goal post net, used to lecture on road design and traffic sanitation.

The University of Liverpool is one of Britain's leading research institutes and is a member of the prestigious and groundbreaking Russell Group. The university's motto is 'Haec otia studia fovent', which means, 'these days of peace foster learning'. The university offers over 230 first-degree courses covering 103 subjects.

The Liverpool School of Tropical Medicine, a registered charity, is an international post graduate school of excellence affiliated to the University of Liverpool. It was founded on 12th November 1898 with a donation of £350 from Sir Alfred Lewis Jones, a Liverpool shipowner. His generosity launched the Liverpool School of Tropical Diseases, the first of its kind in the world. While he was working at the school, Professor Ronald Ross, later to be knighted, investigated the gastrointestinal tract of the anopheles mosquito and in the course of doing this discovered the malarial parasite. This laid the foundation for fighting malaria and Professor Ross was duly honoured by being awarded the first British Nobel Prize. Following his discovery, scientists at the school went on to develop the first drugs to treat this debilitating disease. In October 2005 Bill Gates, of Microsoft fame, donated £28 million, doubling the

size of the school and helping it focus on the control of diseases associated with poverty. The school has also been conferred with the Freedom of the City. The university also has a large medical school which is associated with the Royal Liverpool University Hospital.

The university also possesses Ness Botanic Gardens and a Veterinary Field Station at Willaston, both in the Wirral Peninsular on the other side of the Mersey. It collaborates with a variety of colleges and organisations and is also affiliated with the Proudman Oceanographic Laboratory, University College Chester, the Centre for Manx Studies, Douglas, Isle of Man and The Cayman Islands Law School. The University's latest addition is the Victoria Gallery and Museum.

Working in partnership with the Xi'an Jiaotong University, the University of Liverpool opened a new university in 2006, situated in the ancient city of Suzhou, 90 km (56 miles) west of Shanghai in the Suzhou Industrial Park. It continues a close collaboration with Liverpool in both research and teaching and students have the opportunity to come to the city to complete their studies and obtain a University of Liverpool degree. It was the first university in Britain to make such an undertaking.

🖥 www.liv.ac.uk

See also: **Abercromby Square**; **Ness Botanic Gardens** and **Victoria Gallery & Museum**

VENTILATION TOWER
(A fine example of Art Deco architecture)

George's Dock Building at the Pier Head is the main and arguably the most magnificent of the ventilation towers serving

the Queensway tunnel. It was designed by Herbert J. Rowse, who also designed the other ventilation shafts, the tunnel mouths, lamp standards and the tunnel interior. He also designed India Buildings and the Philharmonic Hall

The tower is decorated in Art Deco style, as Rowse was trying his best to avoid the influence of Greek and Roman architecture. The ventilation tower was badly damaged during the Second World War, but was rebuilt, largely by Rowse, between 1951 and 1952. The grandeur of the tower is enhanced with the addition of the two basalt statues, *Night* and *Day*, by the sculptor Edmund C. Thompson, representing the tunnel being open at all times.

See also: **India Buildings**; **Mersey Tunnels**; **Philharmonic Hall** and **Queensway**

VICTORIA GALLERY & MUSEUM
(A new museum in the city)

The famous University of Liverpool Victoria Building, Brownlow Hill, designed by the architect, Alfred Waterhouse in 1892, initiated the phrase `redbrick university'.

Formally opened in July 2008, the building's £7million transformation houses its remarkable Art and Heritage collections and the refurbished Leggate Theatre can also be used for gallery and exhibition-related events. The Victoria Gallery & Museum (VGM) brings back to life the Victoria Building, one of the city's architectural masterpieces, whilst creating a unique venue and visitor attraction in the city. A new museum not to be missed.

See also: **University of Liverpool**

WALKER ART GALLERY
(The National Gallery of the North)

The Walker Art Gallery, William Brown Street, can trace its history back to 1819, when William Roscoe, a prominent Liverpudlian of his time, became bankrupt. The Liverpool Royal Institute acquired 37 paintings from his private collection. The Institute had a gallery built next to their premises in 1843 for the display of these and other works of art and this was to become the basis of the city's art gallery. The institute continued to collect and display, with exhibitions being held at the William Brown Library and Museum. In 1852, an Act of Parliament was passed permitting the establishment of a public library, museum and art gallery within the city.

In 1873 Andrew Barclay Walker, a Liverpool brewer and alderman, donated a massive £20,000 towards the building of a new art gallery. As he was not known as a patron of the arts, it is thought that this gesture of generosity may have been an attempt to improve his public image as, at that time, the temperance movement was rather popular and his industry was held in some disdain. The resulting building is the Walker Art Gallery.

Liverpool's Walker Art Gallery was designed by Cornelius Sherlock and H. H. Vale. The foundation stone was laid in 1874 by Prince Alfred, Duke of Edinburgh and the gallery was opened in 1877 by the 15th Earl of Derby, the resident of Knowsley Hall. The gallery was an instant success and within a few years the attendance grew to more than 2,000 visitors each day. In 1884 an extension to the gallery was built to help display the gallery's rapidly growing collection and, once more, Walker paid the entire cost of construction, some £11,500.

Before you climb the steps of the gallery, look up to see the magnificent 'Spirit of Liverpool' that adorns its roof. Flanking

the steps leading to the entrance are statues of Raphael and Michelangelo. Local legend claims that the artist who worked on the sculpture of Michelangelo thought that the great man's surname was Angelo and that he was the christened Michael, hence the incorrect spelling on the base of the effigy.

Situated on William Brown Street, the heart of the city's cultural area, the Grade II* Listed Walker Art Gallery has one of the most impressive art collections in Britain. The main areas of interest include:

- Italian and Dutch paintings (1350-1550);
- European art (1550-1900);
- 18th and 19th century British art including a major collection of Victorian and pre-Raphaelite works;
- Prints, drawings and watercolours;
- 20th century works.

The collection, which spans seven centuries, includes works by artists such as Rembrandt, Poussin, Degas, Lucian Freud, David Hockney, Gilbert and George. It also houses one of the most significant sculpture collections outside of London. The gallery's collection is so large that it cannot all be displayed at the same time, though some of the works are displayed in other establishments owned by National Museums Liverpool. Many of the works of art owned by the gallery have been on display in the city for over 200 years.

Works of art from the Walker collection are loaned outside the city, with some of them being displayed at 10 Downing Street amongst other places.

Ben Johnson's Liverpool Cityscape 2008 was completed in the gallery in 2008 and will remain there until it moves permanently to the Museum of Liverpool.

The Walker Art Gallery acts as one of the major venues for the UK's largest festival of contemporary visual art, the Liverpool Biennial. It is open every day from 10am to 5pm and entry is free of charge.

☎ 0151 207 0001

🖳 www.liverpoolmuseums.org.uk

See also: **Knowsley Hall**; **Museum of Liverpool**; **National Museums Liverpool**; **Spirit of Liverpool**; **William Brown Street Conservation Area** and **Roscoe Gardens**

WATERFALL
(Not quite what you'd expect)

Liverpool has several fountains with the Steble Fountain being the most famous. In complete contrast to this traditional water feature, we also have the 'Piazza Waterfall', by Richard Huws. Better known locally as the 'Bucket Fountain', it is made up of twenty stainless steel containers of various sizes mounted on bronze posts. The containers fill slowly with water from concealed pipes, before periodically tipping their load into the large black-tiled tank at the base of the structure.

The sight and sound of this fountain in Beetham Plaza off Drury lane, keeps spectators, both young and old, fascinated for hours upon end. Unfortunately, it was allowed to dry out and was not used for a period. It was sorely missed by the people of Liverpool, but the 1966 structure has now been returned to its full glory and is, once again, enjoyed by all who visit or chance upon it.

See also: **Steble Fountain**

WATERFRONT
(A World Heritage site)

UNESCO approved Liverpool's bid for World Heritage status for its waterfront in July 2004, putting it in the same league as the pyramids of Egypt, the Taj Mahal and the Great Wall of China. The bid was based on Liverpool as a Maritime Mercantile city, reflecting its importance as a commercial port at the time when Britain's global influence was at its height.

In total, six areas of the city make up the World Heritage site, including the commercial district of the city, an area of warehouses along with merchants' houses around Duke Street, and the cultural quarter around the William Brown Street Conservation Area. The waterfront site includes the Albert Dock along with many other historic docks and the world famous Three Graces that adorn the Pier Head.

Liverpool's Waterfront boasted the first integrated dock system in the world. When Canning Dock was opened in 1715 it was the first wet dock in the world. The docks also had the first tram system in the world, with the vehicles being drawn along wooden rails by horses. It once boasted the largest floating structure in the world at the Pier Head. The docks still contain the world's largest brick building, the Stanley Dock Tobacco Warehouse.

In 2007 a new cruise liner terminal at Princes Dock was formally opened by HRH the Duke of Kent. The terminal enables the world's great cruise ships to berth as they, once again, return to the Mersey. Rather appropriately, the QEII, one of the most famous ships in the world, berthed at the new terminal on her 40th anniversary tour.

See also: **Albert Dock**; **Pier Head**; **Three Graces** and **William Brown Street Conservation Area**

WAVERTREE LOCKUP
(A place to sleep off the excesses of the night before)

Moss's Liverpool Guide of 1796 described Wavertree as 'a pretty village' and went on to commend the local inn and tavern. At that time Wavertree was already a popular destination for outings from Liverpool, with people coming to fairs held on the local green, where they could see things such as morris dancers, bull baiting, boxing and wrestling.

At the time, there was a problem with the drunkenness of visitors to Wavertree and it was decided to build a lockup for the intoxicated. The penitentiary was erected not far from Monks' Well in 1796, the same year as Moss's Guide. This makes it the second oldest jail in Liverpool. Everton Lockup was built in 1787, making it a mere nine years older.

The lockup, by Picton Clock Tower at the end of High Street, was built out of local sandstone and would appear to have been used on a regular basis. During holiday times, the lockup was sure to be full. The fact that a cart was specially purchased for transporting the inebriated gives you an idea of the size of the local problem of over-indulgence. Before the lockup's construction prisoners were held at the local constable's own house.

For some obscure reason the lockup is also known as the Round House, but is, in fact, based on an octagon. The pointed roof and weather vane were later additions.

It is said that the building was used as a temporary mortuary for cholera victims and also to keep unfortunate victims isolated before they died. In the mid nineteenth century it was used to give shelter to destitute Irish families on their way to the countryside surrounding the city.

The lockup is now kept closed, but is opened one day a year for public viewing. It is a Listed Building and the 'village green' on which it stands is the only piece of Common Land in the city.

See also: **Everton Lockup** and **Monk's Well**

WELLINGTON COLUMN
(Looking down on the city)

In the cultural centre of the city, at the corner of William Brown Street and Commutation Row, there is a fluted Doric column standing next to the Steble Fountain topped with a bronze statue of the Duke of Wellington. This monument to the hero who defeated Napoleon is an exact copy of the Melville monument in Edinburgh. It was designed by George Anderson Lawton of Glasgow and it is reputedly cast from the metal salvaged from guns captured at the Battle of Waterloo. On each of the four sides of the plinth is a relief with the south side depicting the glorious charge of the Battle of Waterloo.

See also: **Steble Fountain** and **William Brown Street Conservation Area**

WEST DERBY COURTHOUSE
(One of the oldest buildings in Liverpool)

Queen Elizabeth I, the Duchess of Lancaster and West Derby, commissioned the building of this Courthouse to serve the West Derby Hundred (an ancient division of a county). It dates from 1586 and is believed to be the only freestanding court building to contain its original courtroom fittings. The building is a rare example of a manorial and hundredal courthouse.

Those found guilty at a court hearing would either be fined or sent to the stocks. The original wooden stocks were situated next to the courthouse, so that convicted criminals could start their punishment straight away. When the stocks were replaced, the new ones were situated next to the Yeoman's house, opposite the courthouse dating from the same time. You could expect to be put in the stocks if you were convicted of being intoxicated, unlike those caught in Wavertree who were put in the local lockup. You could even be put in the stocks for swearing. Those found guilty at a court hearing could also be fined.

The building, on Town Row, Liverpool 12, was closed for some considerable time and fell into a state of disrepair, even suffering an attack from mason bees burrowing into the sandstone to build their nests. The Courthouse has been restored and is now open to the public, where they have the opportunity to see re-enactments of ancient court hearings.

This was not the first courthouse in West Derby. Over 1000 years ago, the Vikings started a 'Wapentake' court. West Derby, like many other districts, is older than Liverpool and is mentioned in the Doomsday Book. The name comes from a Viking word meaning 'place of the wild beasts'.

See also: **Wavertree Lockup**

WESTERN APPROACHES MUSEUM
(The headquarters for the Battle of the Atlantic)

During the Second World War, Western Approaches, situated in Rumford Street, was the headquarters of the operations for the Battle of the Atlantic. Here they struggled to stop the U-boat menace, preventing the much needed supplies and troops from

North America reaching the relative safety of Liverpool Bay.

Combined Operations, which controlled the Western Approaches, was originally based in Plymouth, but in 1941 Prime Minister Winston Churchill had it moved to Liverpool. It was originally under the control of Admiral Sir Percy Noble but, in 1942 he was succeeded by Admiral Sir Max Horton who was responsible for instigating a complete revision of the system of organising convoys and their escorts. His work in this capacity was so successful and vital to the eventual outcome of the war that, when he died in 1951, King George VI ordered his body be brought back to Liverpool for a State funeral and burial at the Anglican Cathedral. Horton House, part of the Exchange Buildings, is named in his honour.

Known locally as the 'Citadel' or 'Fortress', the Western Approaches complex was designed to be both bomb proof and gas proof. To achieve this end, it was built with a 7 foot (2.1m) thick roof and walls of various thicknesses, some being up to 11 feet (3.35m) deep. It consisted of 100 rooms with a total floor area of 50,000 square feet (41,806m^2). From this base, enemy convoys and submarine wolf packs were monitored by the Royal Navy, Air Force and Royal Marines to help merchant shipping keep the nation supplied with food and raw materials.

Probably the most important area in the building was the room where the Enigma Decoding Machine was kept. This had been recovered along with the necessary code books after the sinking of a German U boat. With the Enigma Decoding Machine the allies were able to discover the enemy's plans by decoding their communication transmissions.

Winston Churchill, code name 'Former Navy Person', spent a lot of time here and had his own direct telephone line to Whitehall. To ensure total security, the box containing Churchill's telephone

had a guard posted outside it and another guard was posted outside the room itself. This is on display in the museum and there is only one such other example in existence today.
Some war time statistics relevant to Liverpool:

- 1000 convoys entered Liverpool;
- Liverpool was the second most bombarded city during the war;
- Between August 1940 and January 1942 4000 Liverpool people were killed and 200,000 houses were destroyed;
- Liverpool was bombed more heavily than any other provincial city in Europe;
- The Luftwaffe dropped about 20,000 bombs on the port of Liverpool;
- 6500 Liverpool homes were destroyed;
- 125,000 Liverpool properties were seriously damaged;

WILKINSON, KITTY
(Pioneer of the Public Baths and Wash House)

As a young girl in 1794, Kitty Seaward and her family came over from Ireland and, like many others, were hoping for a better life. Things went disastrously wrong from the very start. The ship they were travelling on was caught in a storm and her baby sister was swept out of her mother's arms and into the raging sea. The baby died along with her father in his vain attempt to save his daughter.

After trying and failing to make ends meet in Liverpool, Kitty's mother was eventually put in the workhouse. Luckily, Kitty was able to find herself work in a Lancashire cotton mill and, when able, she returned to the city to rescue her mother. They lived in just the one room, but, even in these very cramped conditions, Kitty was still able to set up a school for some of the poor children of the city, with up to 90 pupils taking their lessons on

her bare floor. Reluctantly, Kitty was forced to close the school as a result of her mother's increasing violence, due to mental instability.

Kitty took on many demeaning jobs, one of which was shovelling up horse manure and another working in a nail factory, where she was paid the hard-earned sum of 3d (3 pence in pre-decimal coinage, equivalent to 1¼p) for every 1200 nails she produced. By this time she had met and married a French prisoner of war. They had two children, but Kitty's bad luck continued and she was soon to be widowed. Then, when Kitty was 38, she re-married. Her new husband was Thomas Wilkinson and the newly married couple began to take in orphans and the homeless.

When an epidemic of cholera broke out in the city, Kitty set up a wash-room in her kitchen, as she was fortunate enough to have access to running water. She did this with a disregard for her own health and safety for the benefit of the sick and dying in the belief that it would prevent the spread of the disease. Records show that she was prolific in her work. In a single week she washed and dried: 34 bedspreads; 110 blankets; 60 quilts; 158 sheets and 140 dozen (1680) clothes. She was helped by the Liverpool District Providence Society and donations from the wealthy merchant Rathbone family. The success of their venture led to Kitty and her husband being appointed to run the first Corporation public wash house in Frederick Street. Her work was so successful that the idea of public baths and wash houses spread quickly round the world.

In recognition of her work Queen Victoria presented Kitty with an engraved silver tea service. The last wash house in Liverpool closed down in 1995. The truly outstanding Kitty Wilkinson is commemorated in a stained glass window in the Lady Chapel of the Anglican Cathedral.

There is a local legend that the spring in St. James's Mount and Gardens came into being when Kitty Wilkinson was buried there, but there is no truth to this tale as the spring predates Kitty's death by a good few years.

See also **Anglican Cathedral** and **St. James's Mount and Gardens**

WILLIAM BROWN STREET CONSERVATION AREA
(The heart of the city's cultural area)

William Brown Street was one of the principal coach roads to the east of the country. In those days it was on an area of heath land known as Shaw's Brow. It was occupied by just a few cottages and was partially enclosed by fields, interspersed with windmills and lime kilns until the mid 19th century when the area was redeveloped into the formally planned locale we see today. The lime kilns were used for firing the famous Liverpool Pottery and gave their name to Lime Street.

The William Brown Street Conservation Area forms the major cultural region of Liverpool and the site of the city's major public buildings. The most impressive of these buildings is St. George's Hall, acclaimed as the best example of neo-classical architecture in Europe with St. George's Plateau at its front and St. John's Gardens to its rear.

On the northern side of the conservation area are the former County Sessions Court, the Walker Art Gallery, Central Library, the World Museum Liverpool and the former College of Technology, making William Brown Street the only street in the country that is comprised of museums and art galleries.

Also included in the conservation area are: Lime Street Station; the former North Western Hotel, now accommodation for students of Liverpool John Moore's University; the Empire Theatre: the Steble Fountain: the Wellington Column and the entrance to the Queensway Tunnel.

William Brown was a local Member of Parliament who, in 1855, donated the princely sum of £6,000 towards the building of a new museum and library. The Town Council added a further £10,000 towards the scheme. When the project encountered financial difficulties, William Brown donated a further £35,000 to ensure its completion. It is said that this was a gift in celebration of Liverpool's 650th birthday, an act of altruism for which he received a knighthood. The establishment was called the William Brown Museum and Library and Shaw's Brow was renamed in his honour. His grave lies in the grounds of St. James' Mount and Gardens.

See also: **Central Library**; **Empire Theatre**; **Liverpool John Moores University**; **Queensway**; **St. George's Hall**; **St. James' Mount and Gardens**; **St. John's Gardens**; **Steble Fountain**; **Walker Art Gallery**; **Wellington Column** and **World Museum Liverpool**

WILLIAMSON TUNNELS
(A series of excavations by the Mole of Edge Hill)

Under the streets of the Edge Hill district of Liverpool are a series of tunnels, some being up to a massive 40 feet (12.2m) in width. They were the work of Joseph Williamson (1769-1840), known locally as the 'Mole of Edge Hill' or the 'Mad Mole of Edge Hill'. A lesser used title was the 'King of Edge Hill'.

Williamson did rather well for himself in the tobacco and snuff firm of Richard Tate. He married Tate's daughter and eventually bought the firm. In the early 1800s, he built houses in the largely undeveloped Edge Hill area and it was at this time that he had his workforce of men begin his tunnels. The entrance to this collection of intriguing tunnels can be found in Smithdown Lane.

Local legend has it that the building of the tunnels was an act of philanthropy and that he was using his wealth to keep local men in employment. Whatever it was, he kept building his tunnels. When soldiers returned from the Napoleonic Wars, they too were employed by Williamson to save them from being jobless. The fact that Joseph Williamson may have been a benefactor of the poor is supported by tales that he would have workers move a pile of rocks from one place to another and then back again for no apparent reason. This may have given the labourers a living wage, but they must have found their work rather confusing and frustrating.

Joseph Williamson was, apparently very secretive about his tunnels. It has been suggested that he may have been a member of an extreme religious sect that believed the world was about to face Armageddon and he had the tunnels built so that his group could survive underground. Their supposed plan was to wait until the forces of 'Good' and 'Evil' had well and truly battled things out, so that they could emerge and start a new life, hopefully with 'Good' having been victorious.

Joseph Williamson once invited a host of people to a meal in one of his underground tunnels. On entering, the guests saw that the meal would be meagre, consisting of simple fare, such as beans, and many left in disgust. Williamson announced to those who remained that he now knew who his true friends were and promptly led them to another part of the labyrinth offering them a sumptuous banquet.

In the 1830s Robert Stevenson was building a tunnel to Lime Street Station and one story alleges that a hole appeared underneath the path where his navvies were cutting. They had unexpectedly come upon some of 'The Mole's workers. It is said that Williamson and Stevenson met and examined each others' endeavours, with Stevenson being quite complementary about Williamson's singular achievements. Apparently, when Stevenson's workers dug through into Williamson's tunnels it caused quite a stir as they thought they had inadvertently dug into hell.

Over the years many of the tunnels were forgotten about, but some of the tunnels are now part of a regular guided tour. It is not known how many tunnels Williamson built or where they all went, however it is known that after his death all construction work halted. The Friends of Williamson Tunnels are currently working on making more tunnels accessible and safe for visitors.

In October 2005 Joseph Williamson's grave was discovered in a car park near Canning Place Police Headquarters. The Friends of the Williamson Tunnels had been searching for the exact location of the grave for ten years and the site, now on the fringe of the Grosvenor "Liverpool One" retail development, has been turned into a garden with a commemorative plaque.

☎ 0151 709 6868
🖳 www.williamsontunnels.co.uk

See also: **Buildings Worthy of a Second Look (Lime Street Station)**

WORLD MUSEUM LIVERPOOL
(Home of Britain's first public planetarium)

The city of Liverpool has been more fortunate than most others, as since 1853 it has always had a museum. The original museum consisted of just two rooms in a building on Duke Street, which also housed a public library. As the 13th Earl of Derby, who lived in nearby Knowsley Hall, was the main benefactor of the museum, it was appropriately referred to as the Derby Museum.

The museum proved to be very popular and, with 150,000 visitors in the first seven months of its existence, it became obvious that Liverpool Town Council needed to find much larger premises. William Brown, a wealthy Liverpool merchant, banker and politician, provided the land and finances to construct a purpose-built museum and library not far from St. George's Hall. The museum is situated in William Brown Street, the road named in honour of this local benefactor. The building that housed the old museum became Central Library.

The neo-classical building was first opened to the public in 1860 and, at that time, only featured exhibitions from the Earl of Derby's collection. Private collectors started to donate to the museum and, as the port Liverpool had ships bringing intriguing objects from all over the world, the curators were soon able to add considerably to the collections, expanding the museum.

During the 1941 May Blitz of the Second World War, the museum was hit by an incendiary bomb and the resulting fire left the building as a burnt out shell. Fortunately a great many of the most valuable and rarest objects had been moved away from the city centre as a precautionary move. The museum remained closed for 15 years and after that time only a section was able to be reopened. As the museum gradually came back into full use, its various collections expanded, now totalling over a million

objects. Most of these cannot be put on permanent display, as the building is not large enough to allow for this. The museum, the largest and oldest of the National Museums Liverpool, was renamed World Museum Liverpool on 29th April 2005 and has a new atrium and gallery spaces to give visitors an opportunity to see more of the objects and make use of the latest interactive and technological facilities.

The exhibitions include:

• **The Natural World**, featuring historic botanical and zoological exhibits along with colonies of live insects. Visit the aquarium to see fish and underwater creatures from around the world or the bug house with its interactive activities. Discover the world of animals, minerals, plants and rocks, using the hands-on exhibits at the award winning Clore Natural History Centre. Part of the botanical collection of William Roscoe, who is commemorated in Roscoe Gardens, are held in the museum;

• **The Human World**, where you can find out about the cultures of Africa, the Americas, Oceania and Asia. The museum's ethnological collection is one of the best in the country. See the exhibitions of British Antiques, Numismatics, Ancient Egyptian Artefacts, the Near East Collection or the Classical Collection. Learn about the past and present in the hands-on Weston Discovery Centre;

• **The Earth**, the museum's Geological Collection will keep you informed about palaeontology (with a collection of over 40,000 fossils including a complete skeleton of Megaceros Giganteus), rocks (with approximately 7,500 specimens from Britain and around the world) and minerals (with about 20,000 different specimens including rare meteorites and cut gemstones);

- **Space and Time**, where you can discover the world of astronomy, with around 200 items on display, including many telescopes. You can also view the collections covering Physics Teaching, Oceanography, Scientific Instruments, Public Science Education, Meteorology and Space Science. Why not take an imaginary journey through space and discover the secrets of the universe by visiting one of the Planetarium's daily shows. The museum houses Britain's first public planetarium which now makes use of the Liverpool Telescope, owned and operated by Liverpool John Moores University, for live image data.

A new attraction at the museum is the Treasure House Theatre, which provides a changing programme of shows, talks and performances to enhance your visit and help you learn more about the magnificent and varied collections.

World Museum Liverpool is open every day from 10am to 5pm and all exhibitions and activities, including the Planetarium, are free of charge.

☎ 0151 207 0001
🖳 www.liverpoolmuseums.org.uk

See also: **Knowsley Hall**, **Liverpool Telescope**; **National Museums Liverpool**; **Roscoe Gardens** and **William Brown Street**

EXCHANGE FLAGS
(A place of commerce)

Exchange Flags lies to the rear of Liverpool's Town Hall and is often missed by visitors to the city. The buildings surrounding the square have been built and rebuilt several times. Its name derives from the fact that merchants and ship-owners would conduct their trade in the open air of the square, rather than use

the offices in the buildings themselves. This tradition reflected the very earliest days of trade, conducted on the quayside when ships docked laden with their cargoes and merchants exchanged bills bearing the name and flag of their ships.

In the centre of the square is the Grade II* Listed Nelson Memorial and on the wall behind is the Newsroom Memorial to the men who fell in the First World War.

See also **Nelson Monument** and **Newsroom Memorial**

YE HOLE IN YE WALL
(The oldest pub in Liverpool)

If you've visited the Town Hall and are in Dale Street, one of the original seven streets of the city, why not take the opportunity of popping along to Hackins Hey, where you will find a local inn named Ye Hole in Ye Wall. Dating from 1726 this is the oldest public house in Liverpool, standing on the site of a 17th century Quaker meeting house. The Quakers who frequented the house would probably not be amused to find out what was eventually built on this site.

Hey is an old word meaning an enclosed field. A great deal has changed since this hostelry was named.

See also: **Town Hall**

ZIG ZAG
(An unusual staircase)

If you happen to be on Church Street, turn into the Liverpool One shopping development and take a walk along Paradise

Street where you will see a rather unusual staircase. Situated in the space between two large buildings is The Zig Zag, a staircase leading to restaurants on the terrace above, nicknamed 'The Zig Zag Galleria'. From the terrace you can look down one of Europe's busiest streets, South John Street. For the less energetic reader, there is an escalator system.

See also: **Church Street**

INDEX